ART OF THE AMERICAN WEST

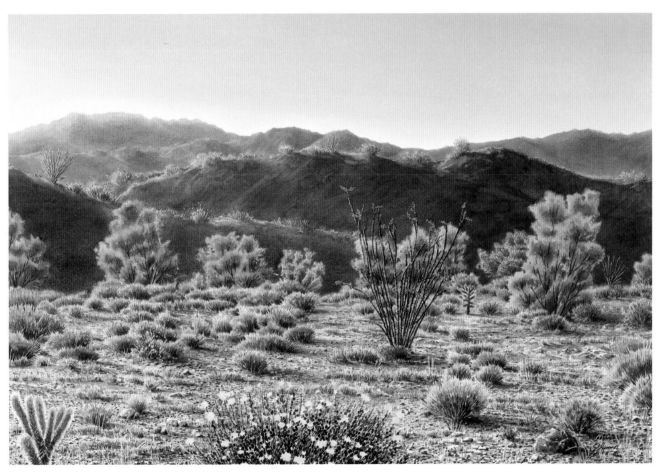

Joseph Salamon, *Desert Dawn*,19.75" × 28" (50 cm × 71 cm) Watercolor on Arches 400 lb. cold press

First published in the United States of America by:
Quarry Books, an imprint of
Rockport Publishers, Inc.
33 Commercial Street
Gloucester, Massachusetts 01930-5089
Telephone: (978) 282-9590
Fax: (978) 283-2742

Distributed to the book trade and art trade in the United States by:
North Light, an imprint of
F & W Publications
1507 Dana Avenue
Cincinnati, Ohio 45207
Telephone: (800) 289-0963

Other Distribution by:
Rockport Publishers, Inc.
Gloucester, Massachusetts 01930-5089

ISBN 1-56496-473-6

10 9 8 7 6 5 4 3 2 1

Designer: Sawyer Design Associates, Inc.
Cover Photograph: Linda Loeschen

Printed in China.

ART OF THE
AMERICAN WEST

GLOUCESTER MASSACHUSETTS

QUARRY

BOOKS

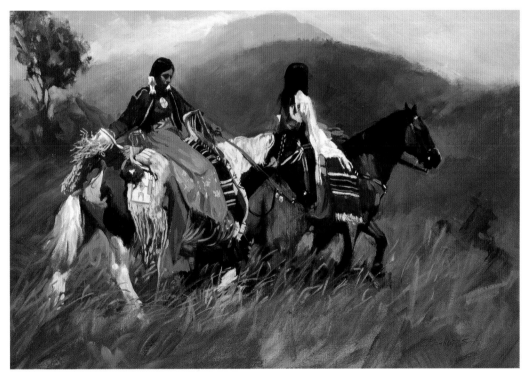

Betty Billups, *Heading Home*, 22" × 28" (56 cm × 71 cm) Oil on linen

Caroline Linscott

with Julie Christiansen-Dull

INTRODUCTION

The West is an icon for America, a great adventure filled with insurmountable hardships, with diversity, and union. The Western Frontier beckoned to seekers of freedom and wide open space. The vastly different terrain, from Midwest, to Southwest, to Northwest, lays the framework of the westward journey. The many Native American peoples, cowboys, pioneers, and immigrants lived fast and hard; their legends, cultural and spiritual differences, and facets of life, are woven into the fabric of the West. Through the images of contemporary artists, we pulled together bits and pieces of the western story. Landscapes, native plants and animals, native peoples, cattle drives, and historical events make a rich patchwork quilt, sewn together with the threads of hardship and adventure.

Native American artists blazed the trail for the earliest western art; telling their life story on rocks, caves, tepees, pottery, blankets, and clothing. Many artists preserved the heritage of the West—from George Caitlin's early recordings, to Charles M. Russell's spirited paintings, to Frederic Remington's historical art, to Frank Tenney Johnson's nighttime scenes. Western movies and television shows crafted a mosaic of the western hero, in Hoppalong Cassidy, Roy Rogers, the Lone Ranger, Matt Dillon in Gunsmoke, and John Wayne—the hero of all ages.

Collected from hundreds of today's artists, the art included in this book spans several media: watercolor, oil, pastel, pencil, scratchboard, etching, acrylic, gouche, mixed media, and collage. From realistic to abstract, to stylized impressionism, the art tells the vibrant western story. From all backgrounds and nationalities (Navajo, Cherokee, Spanish Vaquero, Mexican, Czechoslovakian, Hungarian, Chinese, Peruvian, German, Italian, Canadian,

Norwegian, Scotish), the artists represent a quilt of diversity woven together by their love of western art. The subject matters vary as much as the artists and their media. The war at the Alamo, Custer in a slightly shredded uniform, and soldiers protecting their country are interfaced with a quiet Blackfoot child nurturing fox kits. Pioneers crossing the prairie, cowboys, rodeos, gentle women, loose women, children, treasure seekers, powwows, medicine men, Indian women, war parties, mountain men, and the railroad form the quilt. The horse ("sacred dog" to Native Americans) is an integrating symbol for the west. Brought by the Spaniards, it changed the Indian's way of life, provided travel for pioneers, adventure for explorers, and a living for cattlemen. The buffalo, once almost extinct, stands as the awesome Native American icon. From wolves to moose, and eagles to doves, western animals present nature's beauty. Landscapes lead the viewer on an unforgettable journey, from the vast plains west of the Missouri River, across the Rockies to the pueblos of New Mexico and the cactus-filled Arizona deserts. Along the rivers, over the rugged Sierras, to the forests of Oregon, the viewer reaches an end at the mustard-clad cliffs of the Pacific Ocean. This diverse, yet unified, quilt of the American West presents the art of passionate men and women who treasure and preserve their country.

Caroline Linscott
Julie Christiansen-Dull

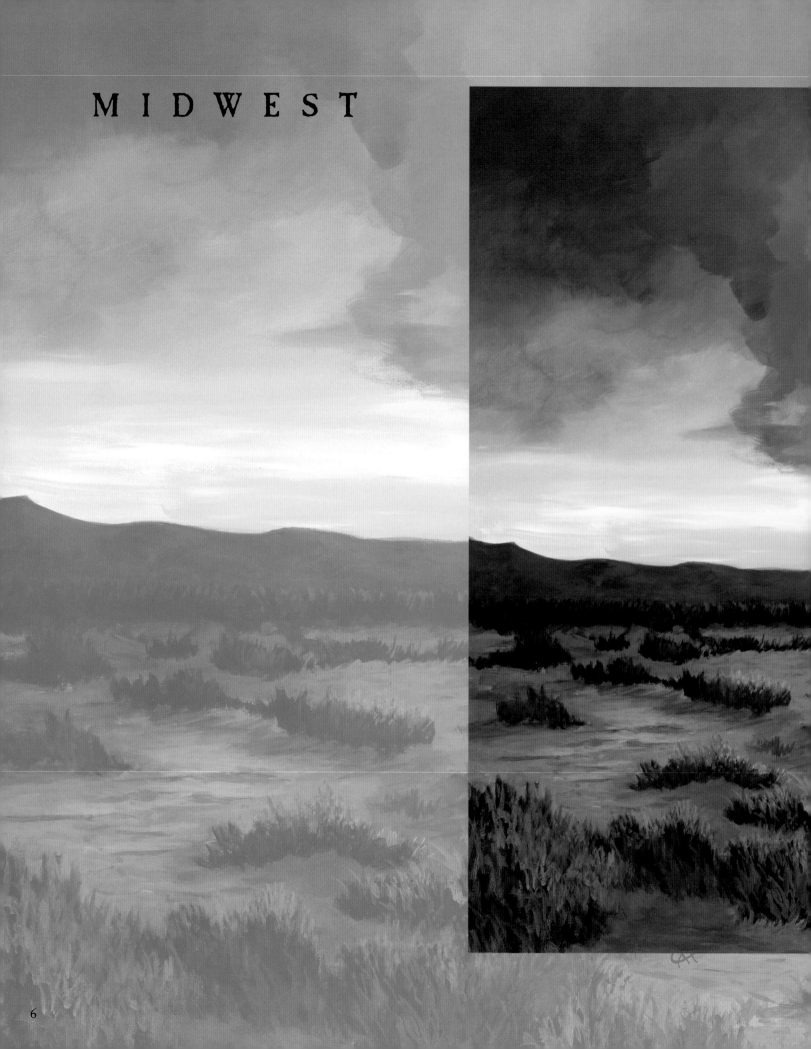

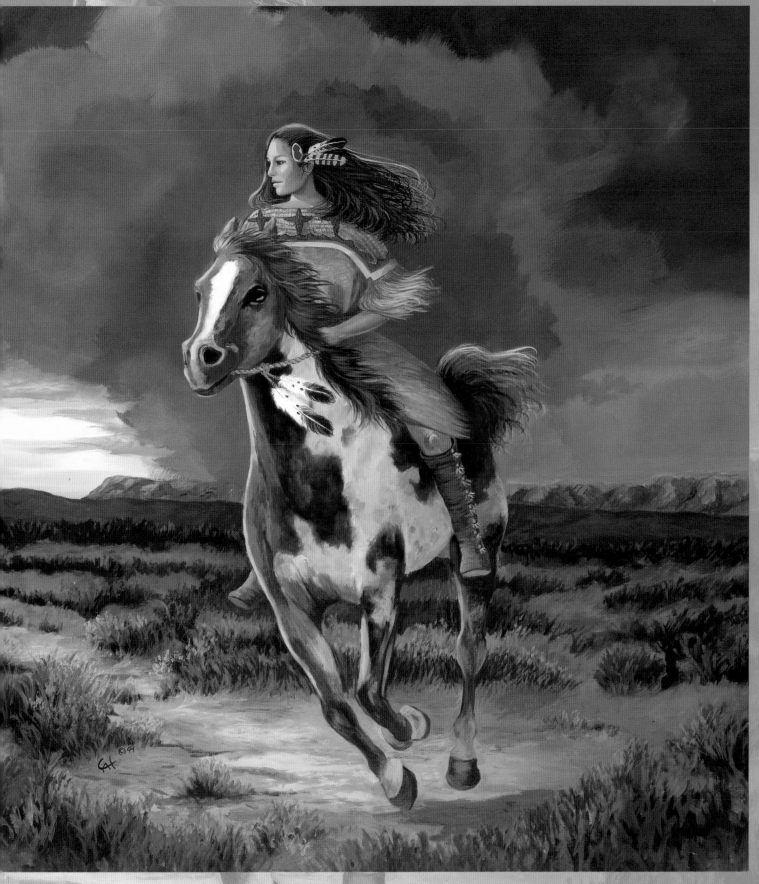

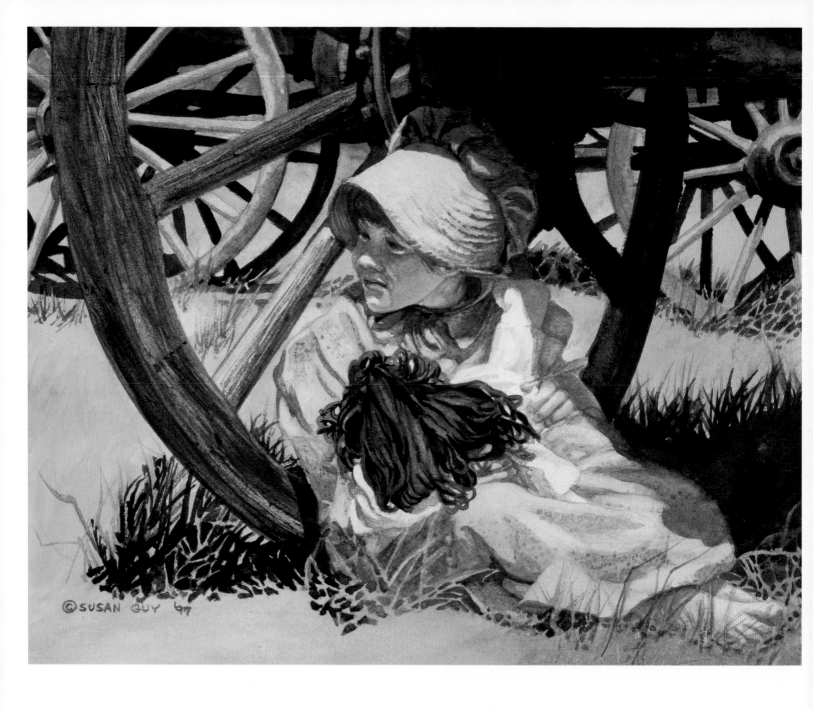

Susan Guy

Hiding Place
8" × 10" (20 cm × 25 cm)
Watercolor on Crescent cold press
watercolor board

The little girl and her doll rest in the
shade during a midday stop on the west-
ward trek across the plains. The repeated
circular shapes of the wagon wheels and
the plaintive girl's face symbolize the
hardships of the journey. Drawn to light
and shadow patterns, the artist has caught
the positive and negative shapes on a
windswept landscape.

Valerie Trozelle

Where the Buffalo Roam
12" × 16" (30 cm × 41 cm)
Pastel, fine sandpaper

During the time of the great buffalo, the Plains Indians maintained a rare balance between nature and humankind. They geared their life to the migrating herds, taking only what they needed to survive. Woven into Indian legends, the buffalo was the spiritual force of the prairie world. With the fine tuning of pastel, Trozelle captures the fierce expression of the mighty buffalo and the layered details of its fur.

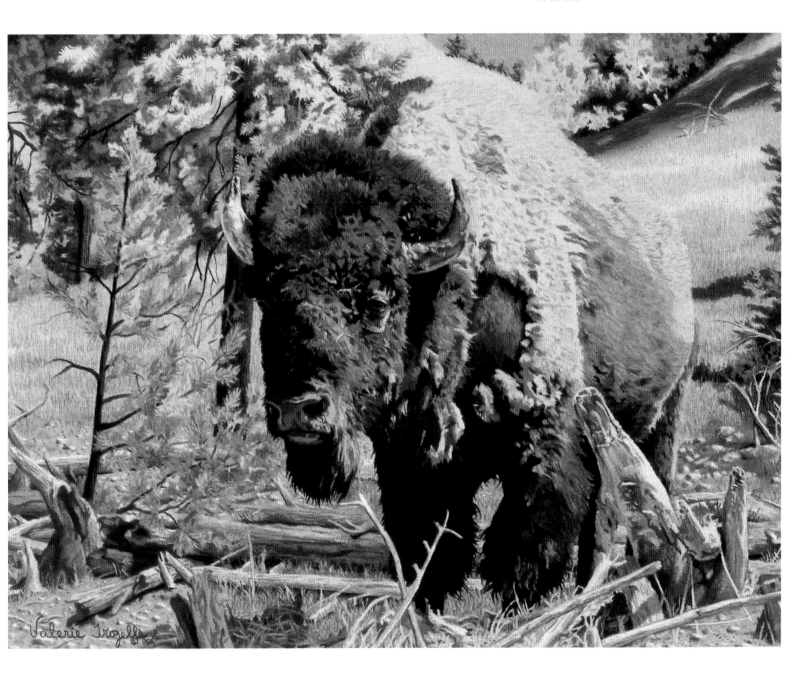

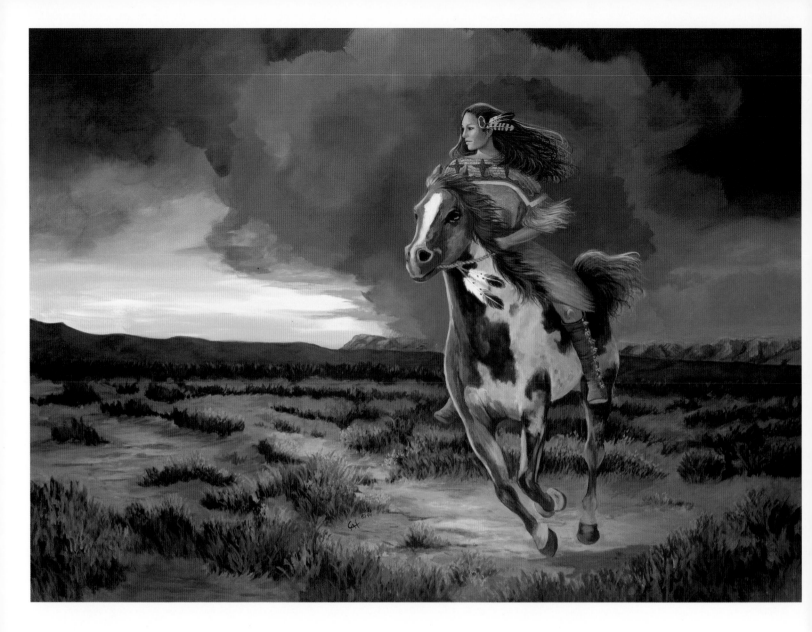

Cat Corcilius

Red Thunder
36" × 48" (91 cm × 122 cm)
Acrylic on canvas

Red Thunder depicts a fire on the American Prairie. Fierce and unpredictable, prairie fires, often started by lightning, move swiftly and are deadly to both animal and man. The young Sioux girl rides her horse at full gallop to warn her people. The Sioux mastered this sure-footed horse after its introduction by Spanish explorers. The paint is the most prized of all horses among the Plains tribes; it is this girl's prized possession and salvation.

Luann K. Bond

Wilderness Gourmet
24" × 18" (61 cm × 46 cm)
Oil on Masonite

This mountain man of the early 1800s relied on his wilderness skills for survival. An early morning hunt provided the ingredients for delicious "gourmet" dining. Bond's inspiration comes from "Doc," born a century too late, who often poses for her. He built his own home from logs he cut himself. He brain-tans his buckskins, and is a self-sufficient man—an individualist in a modern world. Mountain dinner: start slow-burning fire with large dry log. Pluck goose skin. Skewer duck on sharp stick and hang over fire. Cut rabbit in pieces and fry on hot flat rock. Add wild onions. Serve with ice-cold stream water. Bon appetit!

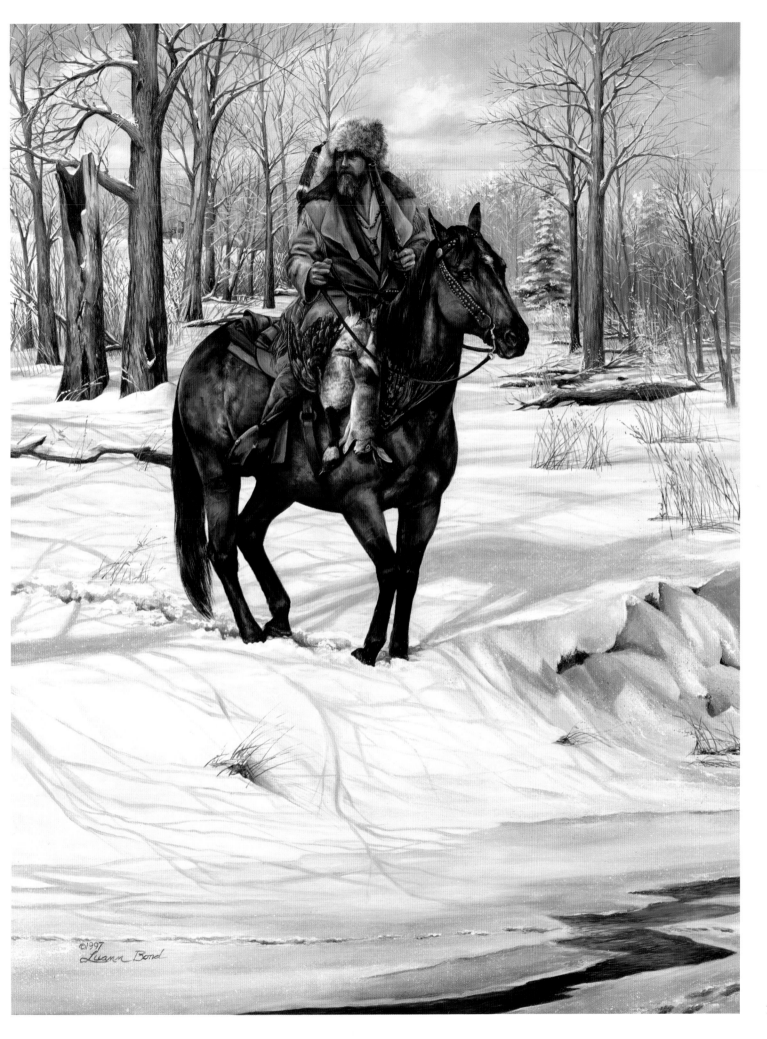

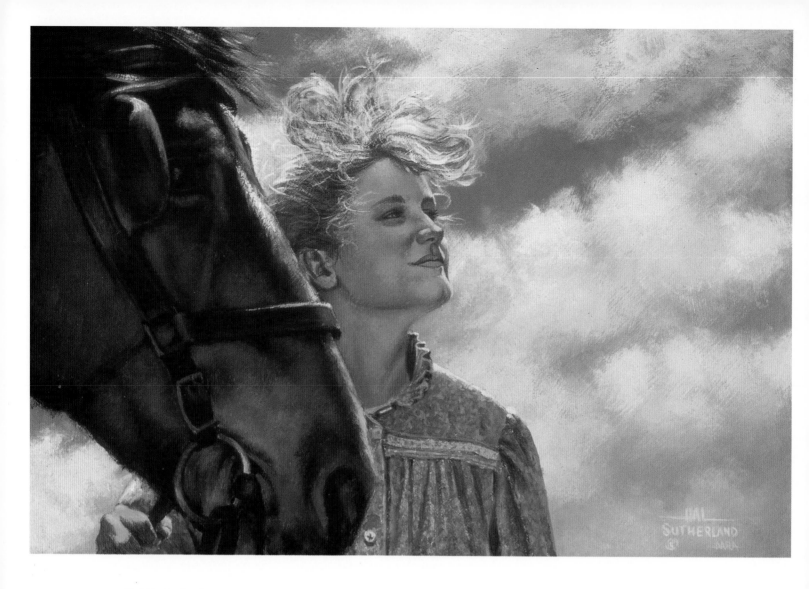

Hal Sutherland

Pioneer Day
8" × 12" (20 cm × 30 cm)
Acrylic on Masonite

The courage of the pioneers is difficult to measure. An inner spirit gave them courage to face every day with the determination and hope to realize their individual dreams. Exploring historical journals of the pioneers' great migration, provides Sutherland with a deep interest in the hardships they endured to fulfill their dreams. "For we, as a proud people, it is vastly important to convey the pioneer's struggle to the coming generations, to remember and hold dear what they accomplished for all of us."

Clyde Heron

Cheyenne Medicine Man
24" × 20" (61 cm × 51 cm)
Oil on linen

Born and raised in the heart of the Chickasaw Nation and blessed with a Chickasaw friend since childhood, Heron admires the Cheyenne of the Great Plains. The Medicine Man's bundle contains the following: a holy deer-tail switch to brush off the patient; a medicine rattle made of a buffalo bladder and tail; ground roots in a small skin; a pouch of sage leaves; an eagle claw fetish; the fetish stone, an old arrow point; and a wrapped sinew bone used as a pipe. The herbal potions were perhaps more effective than the "civilized" doctors of the period. After decades of decrying the medicine man, it is ironic that many of the leaves, roots, and herbs are now the vogue. "Heck, thanks to my friend, I have been using them for nigh-on-to seven decades myself...and holdin' my own pretty well."

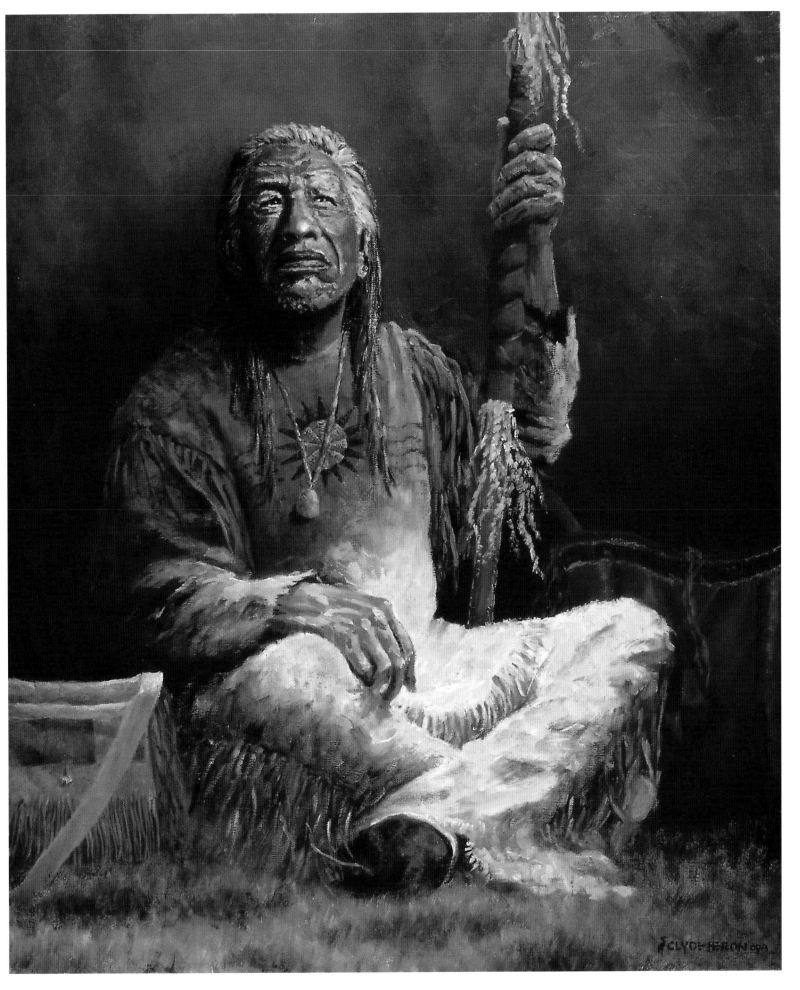

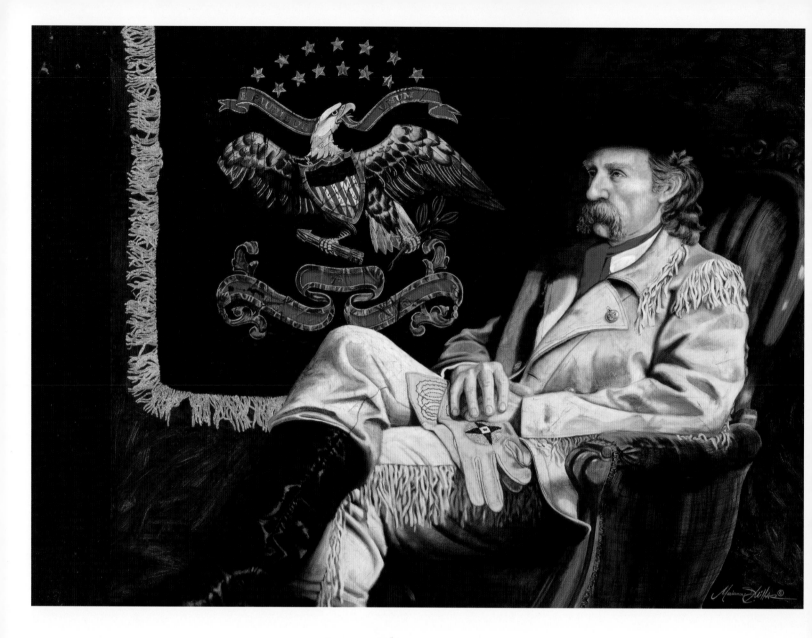

Marianne Millar

Oh Morning Star, Son of the Dawn
40" × 48" (102 cm × 122 cm)
Acrylic on canvas

To the Indians, Custer was "the Chief of Thieves," "Long Hair," "Hard Backsides," or "the Son of the Morning Star." To the settlers and his troops he was a battle-tested soldier, or an arrogant fool who wasted the lives of his men. Lieutenant Colonel George Armstrong Custer, of the 7th Calvary, ended his career at the infamous Battle of the Little Bighorn, destroyed by Cheyenne and Sioux warriors in one hour. Portrayed by Millar in buckskin attire, Custer's noble but slightly shredded silk standard suggests the life of the man. The Crow name, "Son of the Morning Star," plays on the Biblical verse in Isaiah that chronicles the fall of the seductive and prideful Satan, the Archangel, the "morning star" who fell from heaven, as did Custer.

Jack Schmitt

Everything Done Skillfully and Carefully
21" × 29" (53 cm × 74 cm)
Watercolor on Arches 300 lb. rough

This authentic recreation of an 1880s
dental office shows the finest equipment
available at the time. The artist used
multiple transparent washes to give the
illusion of warm sunlight bouncing around
the room. Schmitt is well known for his
complex compositions and intricate details.

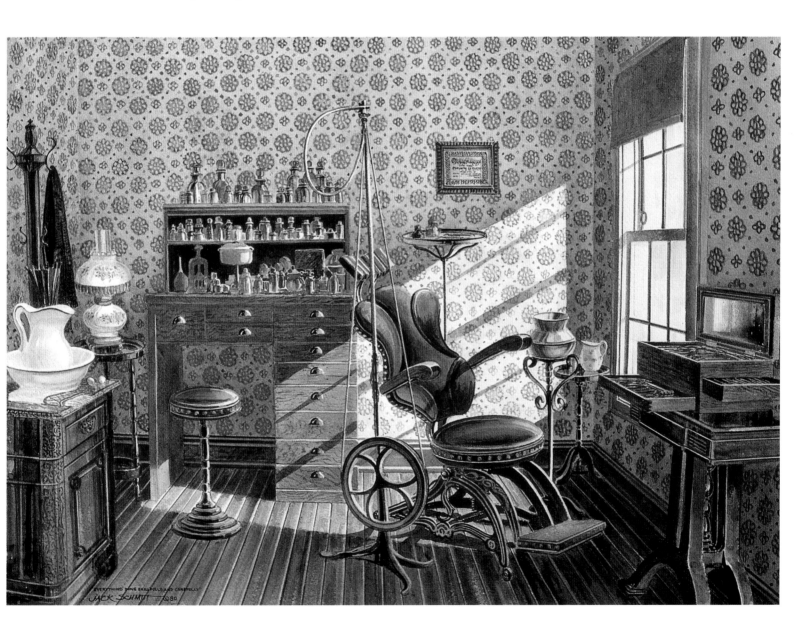

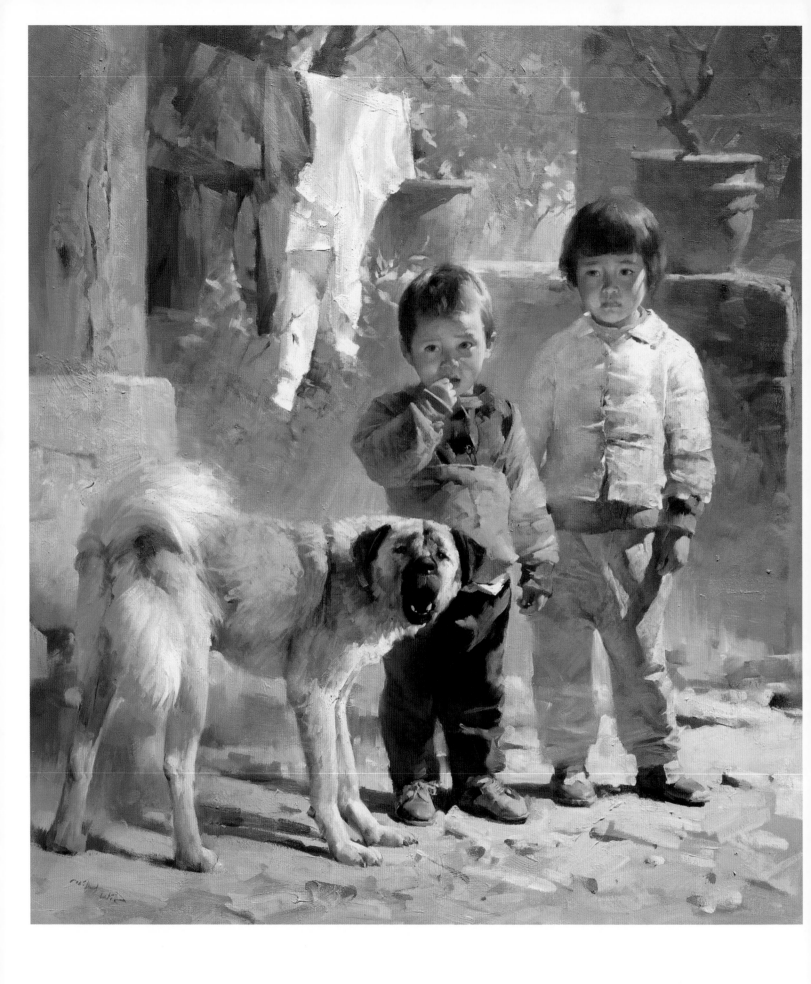

Mian Situ

Children of Lijiang
36" × 32" (91 cm × 81 cm)
Oil on canvas

The immigrant Chinese played an important role in the building of the American West. Paying for their passage as indentured workers for seven years, most worked to build the railroads that linked East to West. They brought to this country a heritage of quality workmanship, in hard labor as well as art, philosophy, herbal medicine, and a link to the ancient Chinese culture. Situ chooses subjects from China, where he lived for thirty years. After coming to the United States, he lived in mountain areas away from the big cities where the people closely resemble the hard-working early immigrant Chinese.

K.M. Walizer

Mo' Coffee
20" × 24" (51 cm × 61 cm)
Oil on linen canvas

Coffee is the lifeblood of hard-working cowboys. It quenches their thirst and warms them on cold mornings and evenings. These chuckwagon cookies (cooks) keep large, hot coffee pots going twenty-four hours a day at a gathering in Oklahoma. Many ranch hands down a half-gallon in one sitting. Cookies keep the Old West traditions alive with "pot rack" open fire cooking. "Their food is the best I've ever tasted. Their sourdough starter sits on my stove, right now." Walizer paints field sketches and finishes the large painting in the studio. Rags and paper towels give straw and grass a natural "brushy" look. A palette knife softens the background.

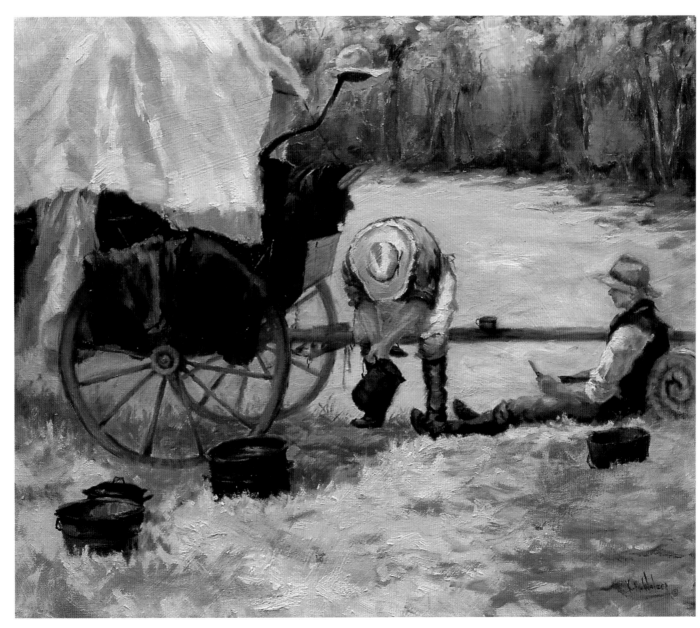

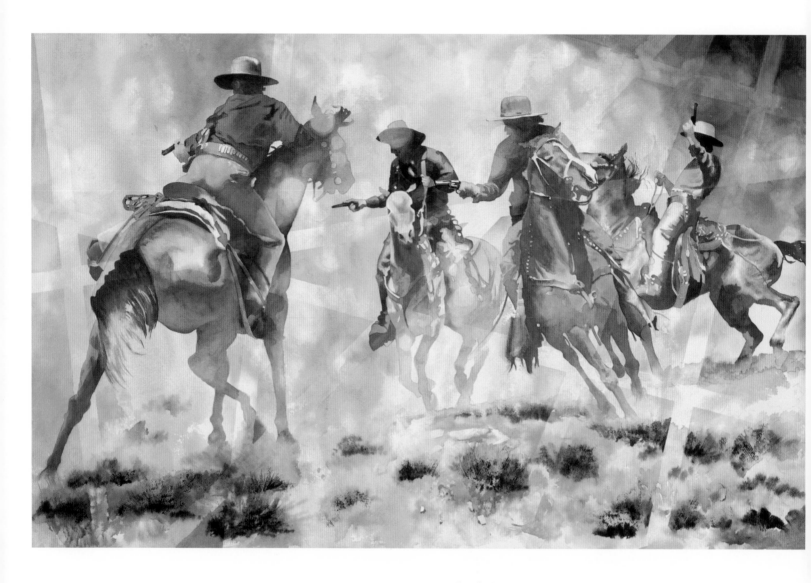

Linda Loeschen

Box Canyon Ambush
30" × 45" (76 cm × 114 cm)

Watercolor on Arches 140 lb. cold press

A single-action shooting competition in Colorado inspired Loeschen to paint a statement of yesterday and today. Cornered in a box canyon with no way out these cowboys fight an ambush. Masking areas with tape to develop hard edges across her painting, she creates lines as symbols of the modern world encroaching on the Old West. The wild and unrestrained life of these rough riders is boxed-in as we often are in modern times.

Ann Hanson

Shell Creek Crossing
14" × 23¹/₂" (36 cm × 59 cm)
Pastel on Canson Mi-Tientes

Shell Creek starts high in the Big Horn
Mountains and flows through Shell Valley,
passing through the Flitner's Diamond Tail
Ranch, before dumping into the Big Horn
River. Stan and Mary drive their cows
across Shell Creek, where Hanson watches
from a hill, unobserved. "The calves are
funny in their first dunking. The older
cows wade calmly, making only a few rip-
ples." Drawn to the intense color contrast
between the cool water and the warm sien-
na animals, Hanson paints with pastels.
"They have no inherent texture like paint;
pastels become shiny, like metal, woven
like fabric, or gritty like cement and rock,
depending on the surface you apply
them to."

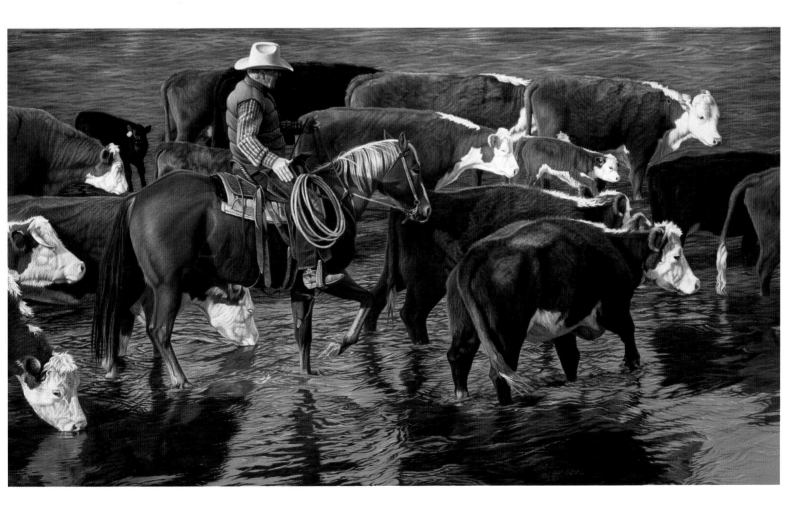

Clark Louis Gussin

Feather Pickup
24" × 30" (61 cm × 76 cm)
Oil on panel

In 1990, Gussin, a two-tour Vietnam veteran, helped his friend, Leon Chiefelk at the Sundance Ceremony on the Pine Ridge Reservation in South Dakota. When Leon shared his people's customs with Gussin, the friendship nurtured a deep understanding and love for the people he paints. Gussin now helps in the Red Road to Sobriety Movement, which reflects his born-again Christian values. In *Feather Pickup*, Native American children re-enact the feather pickup ceremony of their elders. When a sacred eagle feather is dropped, a "whip" man (powwow security guard who is an American veteran) picks up the valuable eagle feather. Then he gives a testimony of his combat experiences.

Denton Lund

Dreamcatcher
24" × 18" (61 cm × 46 cm)
Oil on layered canvas

Living in the mystique of the Black Hills, South Dakota, Lund integrates Native American images into a *montage*. Each item (tepees, horses, feathers, warriors, geese, and eagles) has its own distinct identity and appearance, but reveals additional qualities when fused with the other elements in the composition. "The montage technique embodies my philosophy of life." A composition of singular, unique, and identifiable elements, reveals one's life landscape when it blends and connects singular elements.

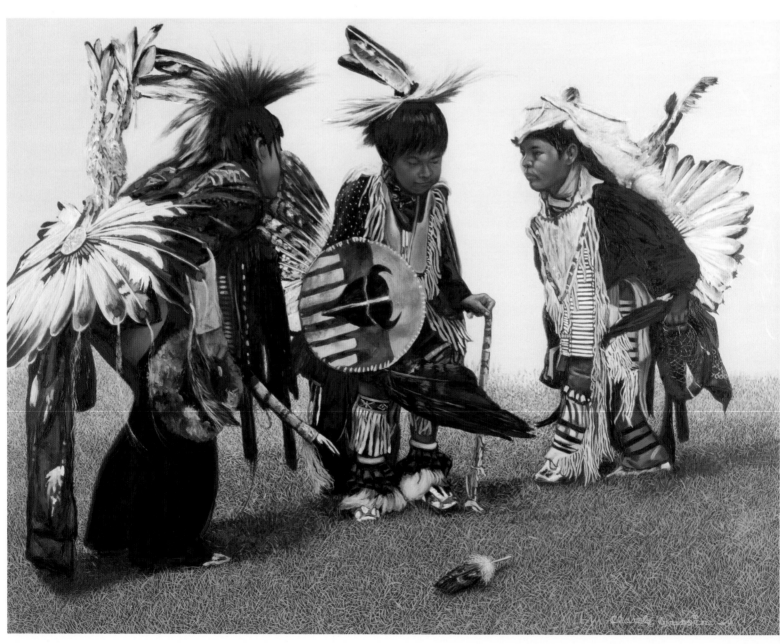

Dreamcatcher

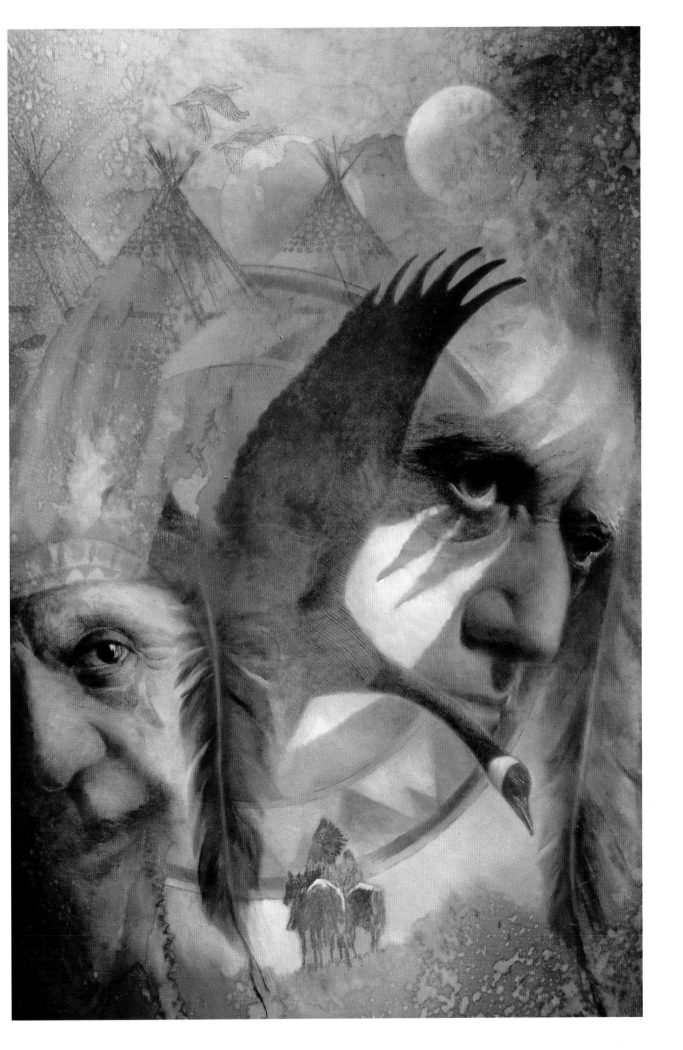

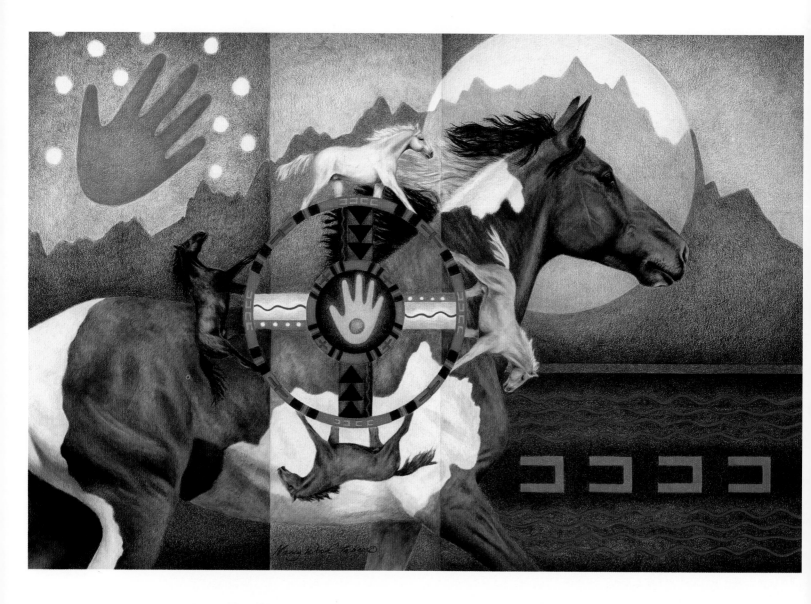

Nancy Wood Taber

Wheels of Change
16" × 23" (41 cm × 58 cm)
Colored pencil on crescent rag matboard

Taber's myth explains the painting: "Horse comes to free the two-leggeds from their earthly bonds; to carry them to realms of unlimited possibilities. By tilling the soil of Mother Earth and the mind, Horse prepares a fertile place for physical and spiritual growth. To journey with Horse is to travel the *Wheels of Change*." The message of cooperation among races (multi-colored horses) moves one into an enlightened world (horse moving toward the eastern rising sun and enlightenment). The mountains, sun, and water depict physical and spiritual balance between the human handprints and animal hoofprints.

Gregory Rodriguez

Blue Maiden
18" × 14" (46 cm × 36 cm)
Oil on single-primed Belgian Linen

A young woman cross-stitches during a recent fair in Bristle, Wisconsin. Skillful sewing, stitching, and quilting were necessary for early American women to clothe their families. Rodriguez's technique is purely direct (alla prima). He works on oil-primed Belgian Linen, tinted gray or earth tones to offset the stark whiteness of the canvas. Bristle brushes apply impasto washes; sable brushes are used for finer lines. He uses his fingers or a palette knife to manipulate the surface with a limited palette of colors.

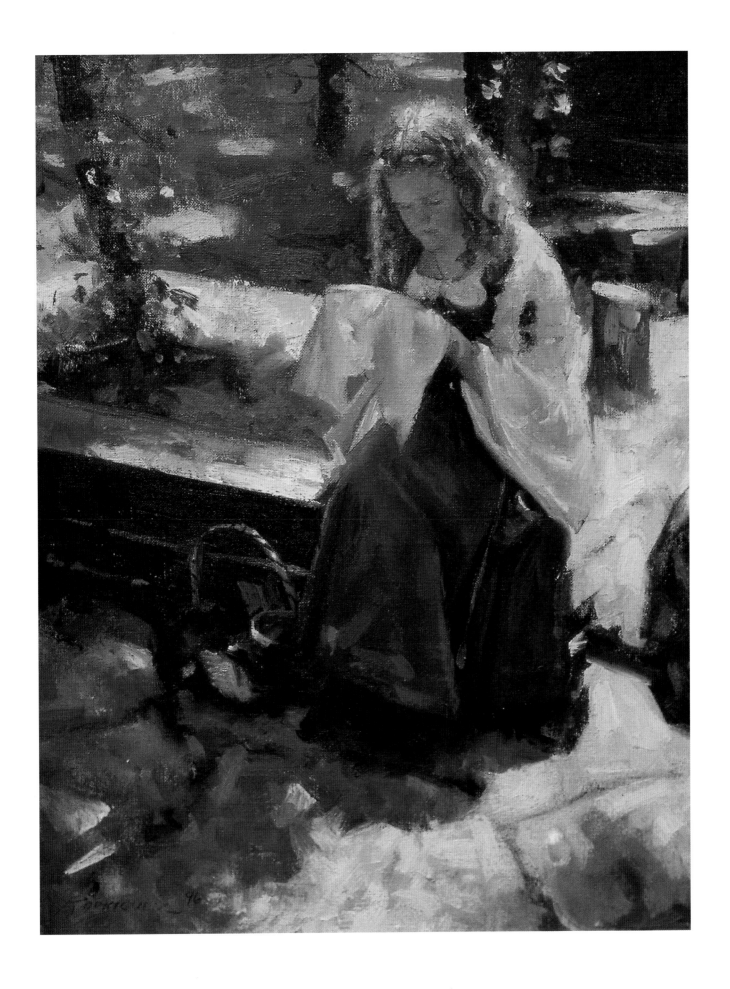

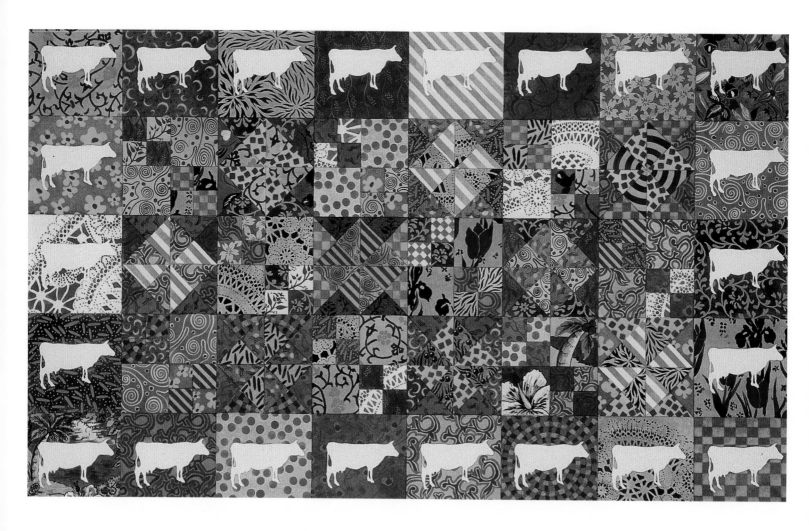

Molly Hutchings

Cow Quilt
12 ³/₄" × 20" (32 cm × 51 cm)
Watercolor and gouache on Arches 140 lb.
cold press

Hutchings's goal is similar to that of the original quilters—to make beautiful patterns, using watercolors rather than cloth. The geometry, order, precision, and symmetry of quilting are important parts of her creative process. Combining historical patterns with contemporary icons from her life, allows Hutchings to synthesize imagery from different sources into a cohesive whole. The juxtaposition of rich fabric patterns against incongruous images deepens the artist's experience.

Becky Joy

You Lookin' at Me?
24" × 30" (61 cm × 76 cm)
Oil on canvas

Becky Joy conveys the typical look of a cow's curiosity and nobility on a wind swept midwestern landscape. She maintains the freedom and simplicity of the cow by painting it against a simple background. Using a palette knife and quick brushwork, she captures the rough texture of the hair and grass. Joy's paintings possess a boldness of color and a clear, strong definition of line.

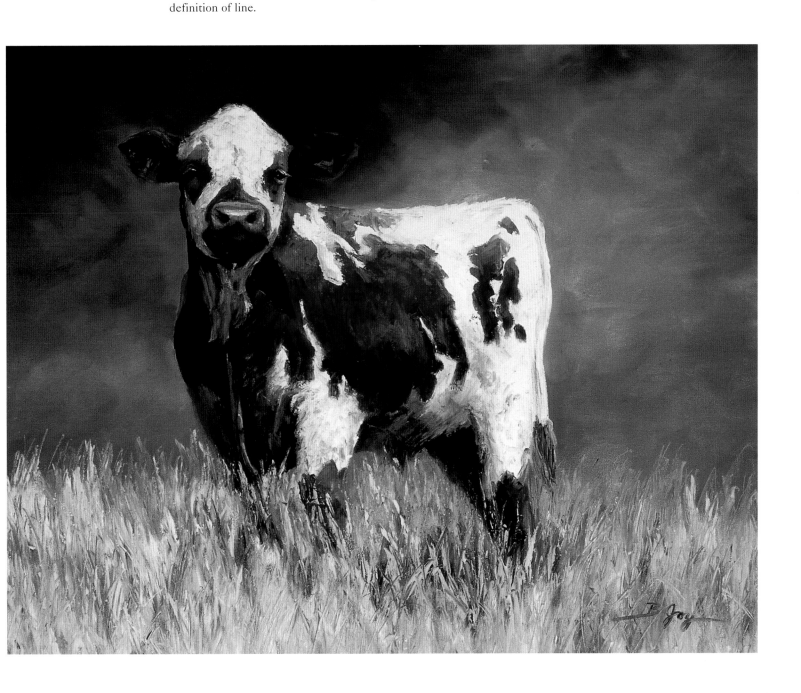

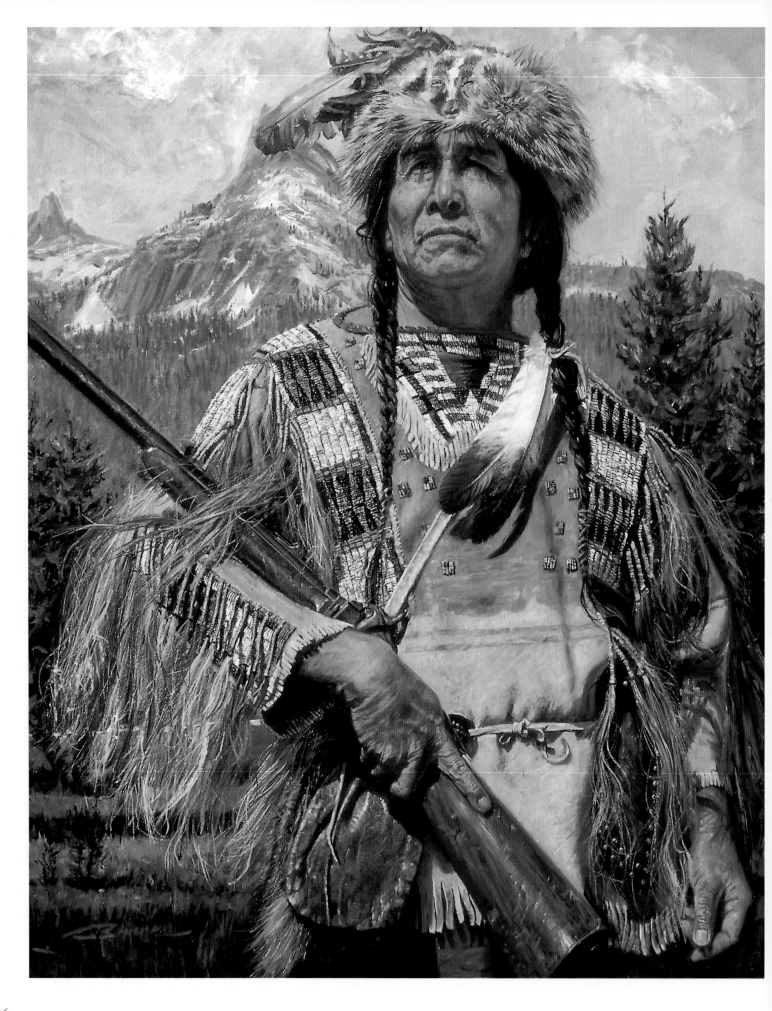

John Bruce

At One With All Things
24" × 30" (61 cm × 76 cm)
Oil on canvas

The Sioux Medicine Man stands before
the sacred Black Hills of the Dakotas.
Harold Hammond, a native Sioux, wears
the Sioux men's society shirt when he con-
ducts religious ceremonies in sweat lodges
all over the world, an attempt to bring
awareness to the Native American culture.
The sweat bath purifies the body and soul
before communication with the Spirit.
Heated rocks from Mother Earth are
placed in a sacred fireplace, water is
poured over the rocks, the steam cleanses
the body and carries messages to God.
After rubbing sage and sweet grass over
the body while chanting sacred songs, the
believer is in the proper condition to be
forgiven and start anew.

Margo Petterson

"But I want to be a Cowboy"
16" × 12" (41 cm × 30 cm)
Oil on canvas

Petterson's romantic painting of the Old
West typifies a softer view of the times.
She creates an intimate moment between
mother and son in a small midwestern
town. The little boy already has the urge
to be a cowboy. The mother is probably
saying, "Not yet, son." The use of strong
complementary colors, burnt sienna and
thallo blue, give rise to a painting that
sings with color and shadow. The fore-
ground and background have been inte-
grated by softening the same complemen-
tary colors.

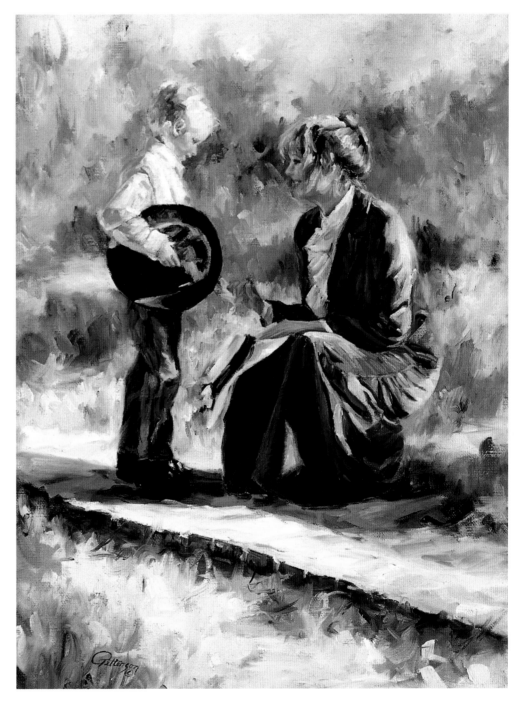

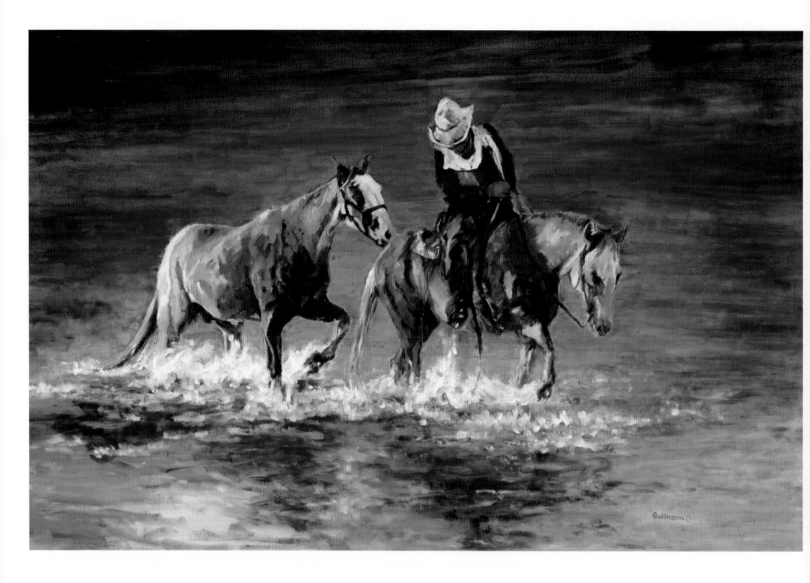

Linda Gulinson

Crossing the Cheyenne
24" × 36" (61 cm × 91 cm)
Oil on canvas

The Cheyenne River flows out of the great Missouri River, joining the Belle Fourche River as they flow through the South Dakota plains country. With Wounded Knee to the east and the Black Hills to the west, the Cheyenne carves a path southwest. On a nearby ranch, late on a summer day, the cowboy and his horses return home from a long day's work. Gulinson was fascinated by the play of the warm light on the horses, rider, and water. The splashing of the cool river sparkles against the horse's warm sienna hide.

Denton Lund

Road to Riches?
36" × 24" (91 cm × 61 cm)
Oil on layered canvas

The northeast corner of Wyoming borders the Black Hills of South Dakota, an area rich with a history of cowboys, Indians, gunfights, and stagecoach robberies. On the old Deadwood Stageline, from Deadwood, South Dakota to Cheyenne, Wyoming, some bullion is still believed to be hidden. By the light of a kerosene lamp, three outlaws plan a robbery, but they have an eyewitness (a small mouse). Lund prepares his canvas by layering materials rather than using a traditional canvas, producing a greater sense of depth and vibrancy.

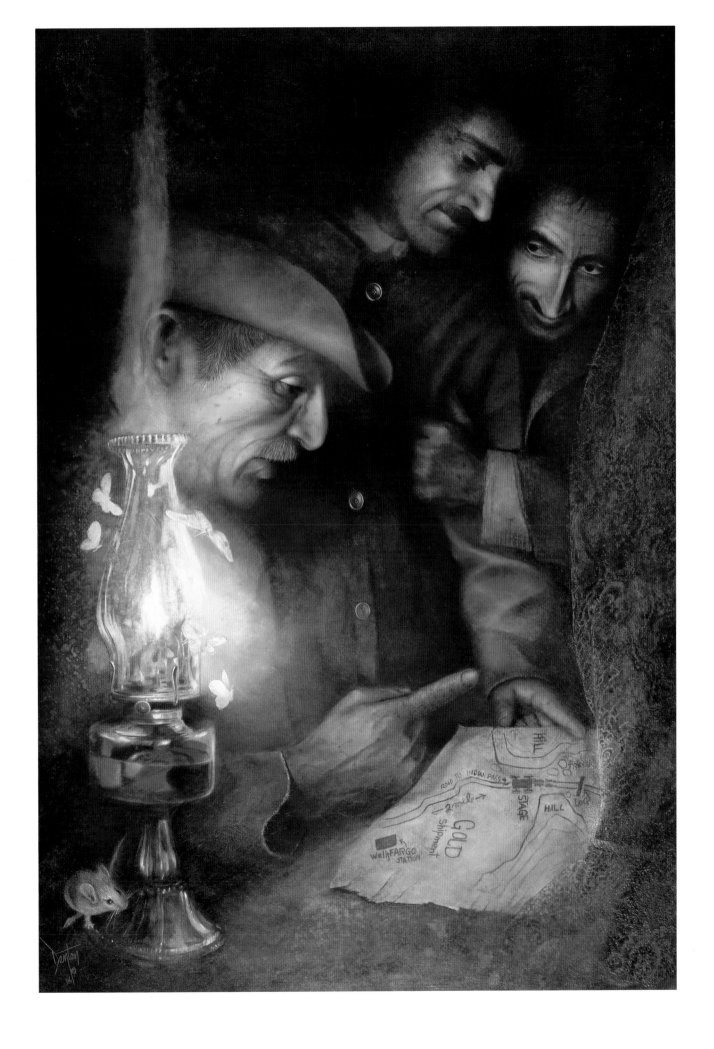

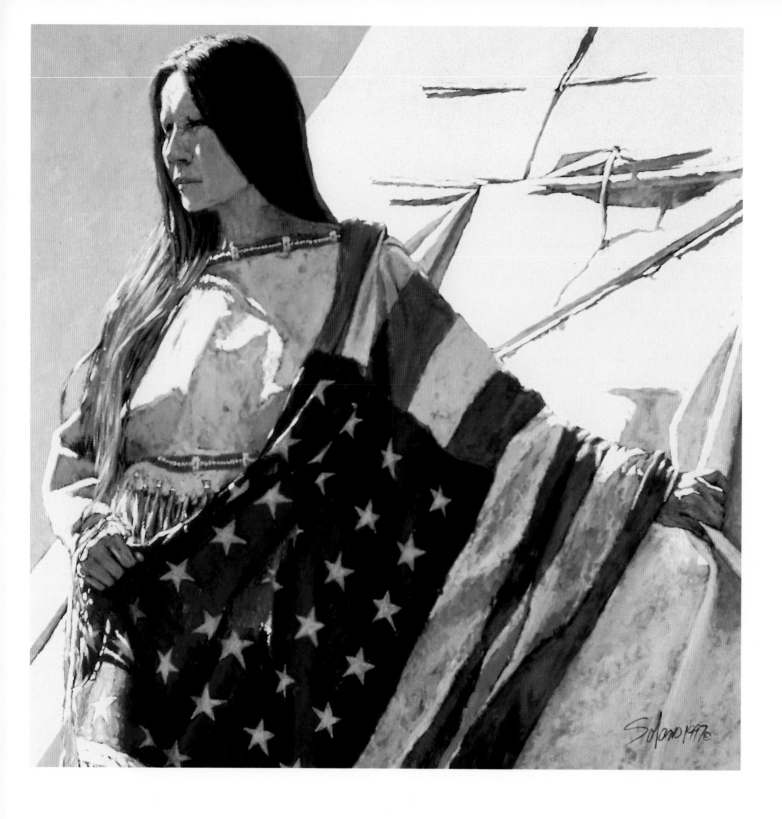

Nathan Solano

Victory Wrap
48" × 48" (122 cm × 122 cm)
Acrylic on canvas

After numerous combat missions in
Vietnam, Solano pursued a career as an
illustrator/art director and a photographer
of portraits, sports, and Native Americans.
His original acrylic of Babe Ruth hangs in
the Ruth Museum. Living in southern
Colorado on a bluff overlooking the
Arkansas River in Pueblo, he once photo-
graphed for the *Pueblo Chieftain*. His
painting, *Victory Wrap*, symbolizes the
timelessness of a woman who waits for
her warrior's return. The scene was set
in Delta, Colorado, at Dan Deuter's
Uncompahgre Artist Gathering, where
Sonja Holy Eagle from South Dakota
wrapped herself in a captured American
flag, a symbol of the suppression of
Native Americans.

Harold T. Holden

Trapped
24" × 34" (61 cm × 86 cm)
Oil on linen canvas

Southwest of Holden's place in northwest
Oklahoma, the cowboy throws a loop to
trap the calf's back legs. The cowboy
then drags the calf to a fire where he is
branded. Holden's action paintings depict
real working cowboys as they are today.
The continuing flow of burnt sienna
coloration in the grass, the calves, and
then the cliffs beyond, leads the eye
through the painting.

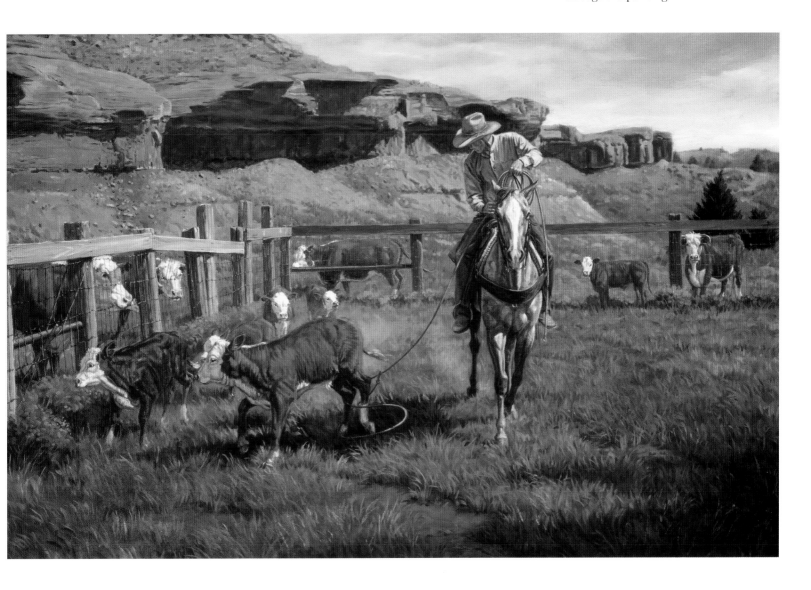

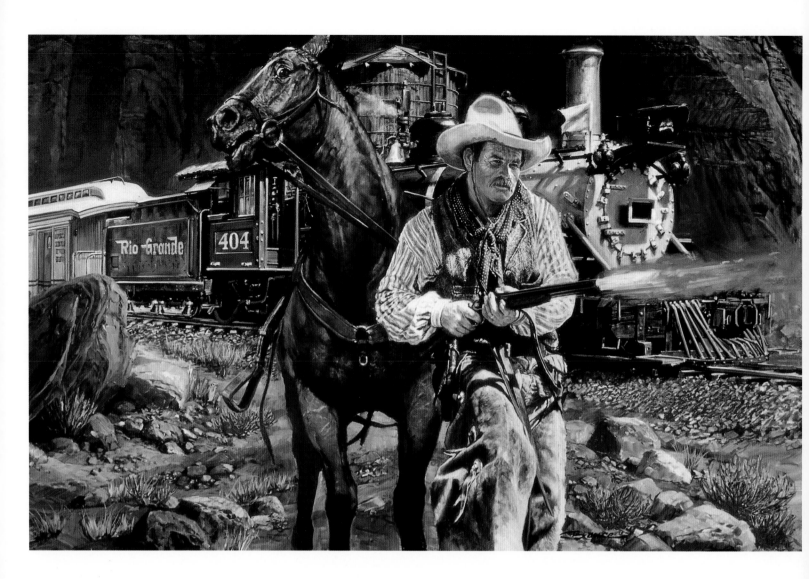

John Bruce

Working on the Railroad
24" × 36" (61 cm × 91 cm)
Oil on canvas

"Since I was a boy, I envisioned the lonely lawman defending right against all odds," Bruce says. *Working on the Railroad* illustrates the solitary figure of a railroad "cop" jumping off his horse in front of a train, blasting away at unknown train robbers. The model is Bruce's artist friend, Ken Schmidt, who wears 1800s garb to art shows. From illustrator, to art director, to freelance artist for Disney, John Bruce's career has spanned over thirty years.

Esther Engelman

Sky Blue-Pink
10" × 7" (25 cm × 18 cm)
Pastel on sanded paper

Inspired by the serenity of open fields
after a storm, Engelman focuses on the
puddles in a grassy dirt road. The magical
midwestern dusk is reflected in the water,
enhancing the view of the magnificent
sky. Working on sanded pastel paper,
Engelman creates textures that reflect
nature: grassy meadows, muddy roads, the
smooth stillness of water, and the grand
sky that touches the horizon.

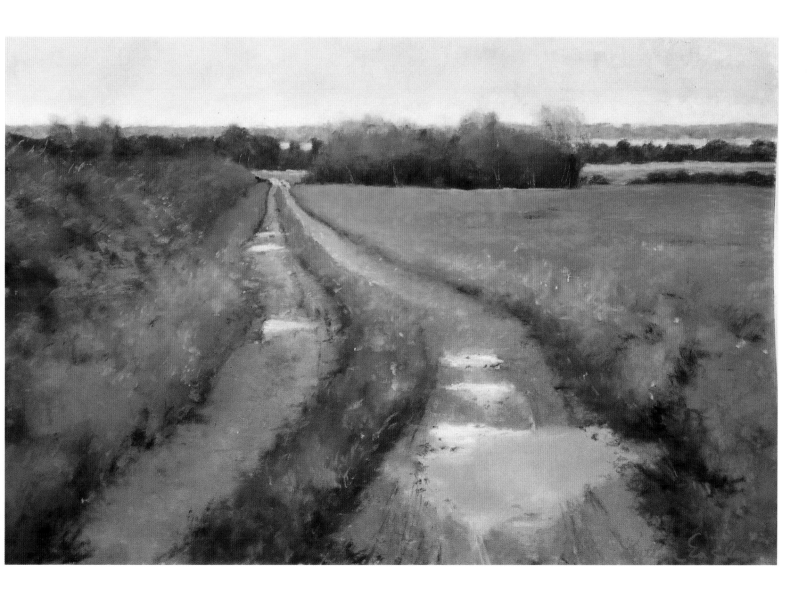

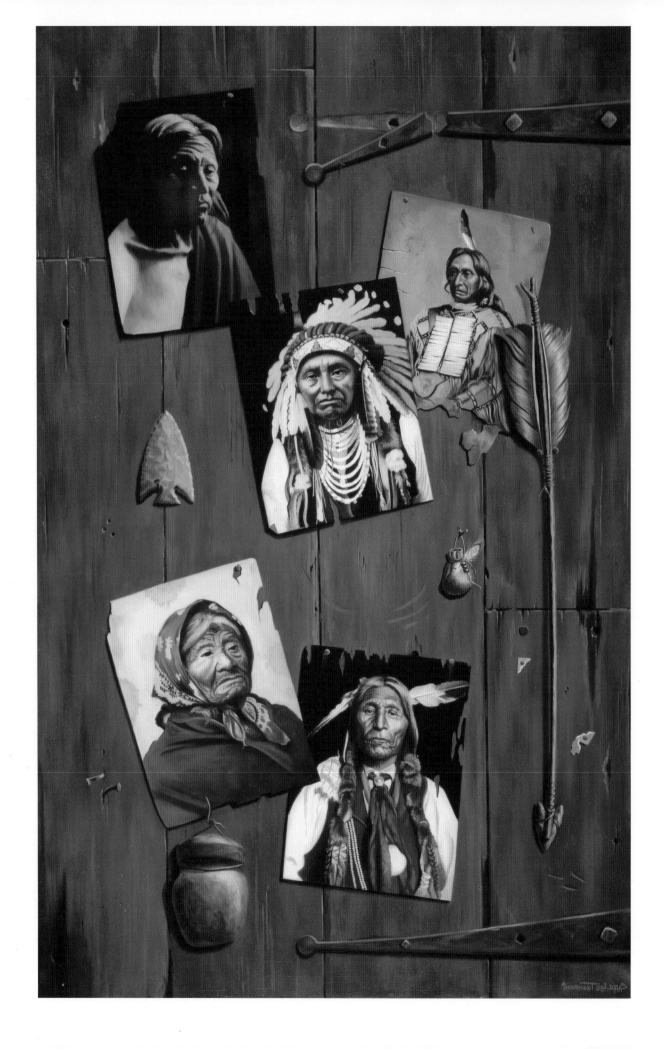

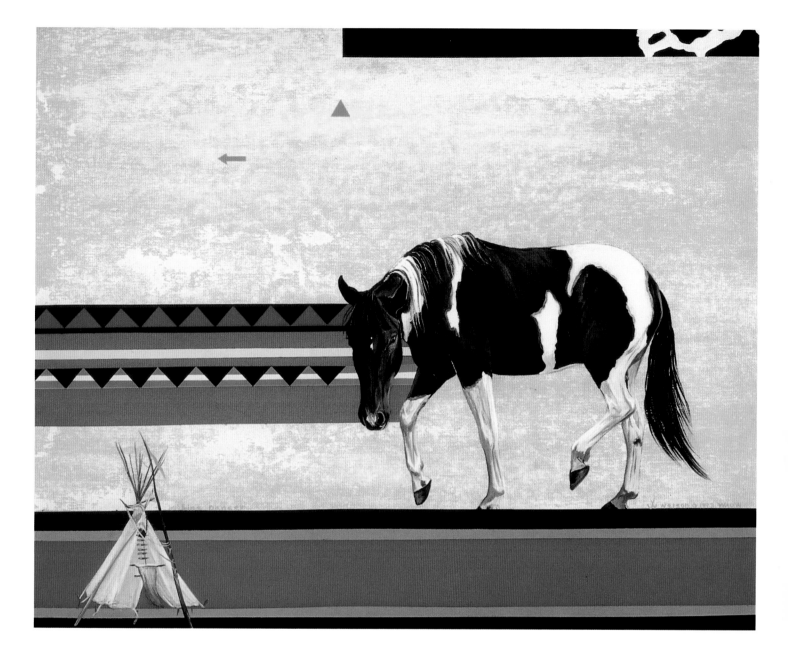

Carol Lee Thompson

Door to Wisdom
38" × 23" (97 cm × 58 cm)
Oil on rabbit skin, glue and lead on panel

Door to Wisdom is a trompe-l'oeil painting created to fool the eye. As a classical realist, Thompson follows the teachings of the Dutch Masters. She grinds her pigments, mixes her mediums, and prepares her panels and linen with rabbit skin, glue, and lead. This collage of renowned Native Americans is her personal statement, that their teaching is our door to wisdom. "If we had listened to their teachings, our planet would be better off culturally, environmentally, and spiritually." The portraits are: top left, Red Cloud, Oglalla Sioux; with headdress, Chief Joseph, Nez-Percé; top right, Big Head, an unknown Southwest trader; bottom left, Princess Angelene, Plains; bottom right, Wolf Robe, Southern Cheyenne.

Patricia Jolene Nelson

Line Dancer
16" × 20" (41 cm × 51 cm)
Acrylic on canvas board

An Oklahoma native, Nelson drew horses as a young child in her mother's cookbooks. Her horses also prance across the backs of old family photos. *Line Dancer* is a fantasy rendition of the pony doing the popular dance, "Line Dancing." Her tongue-in-cheek creation mixes Native American blanket designs and a tepee with the horse's accommodation to modern ways.

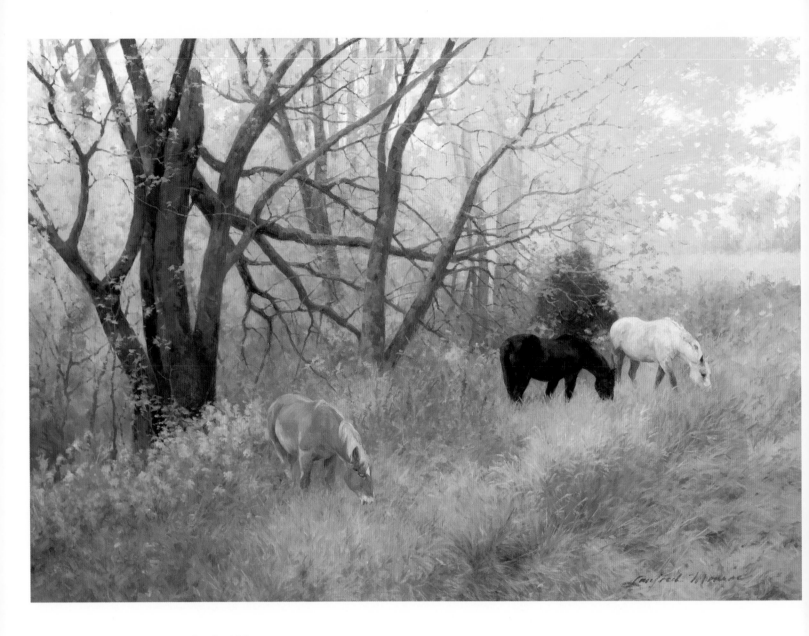

Lanford Monroe

The Broken Bough
30" × 40" (76 cm × 102 cm)
Oil on linen

Born in the artist's colony of Bridgewater, Connecticut, daughter of illustrator, C.E. Monroe, and portraitist, Betty Monroe, Lanford Monroe received her first art commission at age six. Learning art from her parents and neighbors Bob Kuhn and John Clymer, she eventually received a Hallmark Scholarship in Fine Art. She focuses on outdoor themes with atmospheric, moody landscapes. During an October visit through Missouri, Monroe spotted these horses in a pasture, against a backdrop of golden trees. The viewer can feel the coldness of the autumn day, and see the fog mist the background.

Judy F. Fairley

40 Miles a Day for Beans and Hay
15" × 12" (38 cm × 30 cm)
Tinted Esdee scratchboard

On a hot summer day, during a Seventh Cavalry re-enactment, the horse and soldier return from a day's ride. The sweat runs under the young man's blue wool uniform and drips from his horse's belly; they seem to hold each other up as they walk home. The title comes from a soldier's journal, describing life in the cavalry. Fairley uses a scratchboard technique, which dates to ancient times. After layering the china clay-coated board with ink, watercolor, or gouache, the picture is scratched out with a sharp tool. A rendering results as one scrapes through the layers of color.

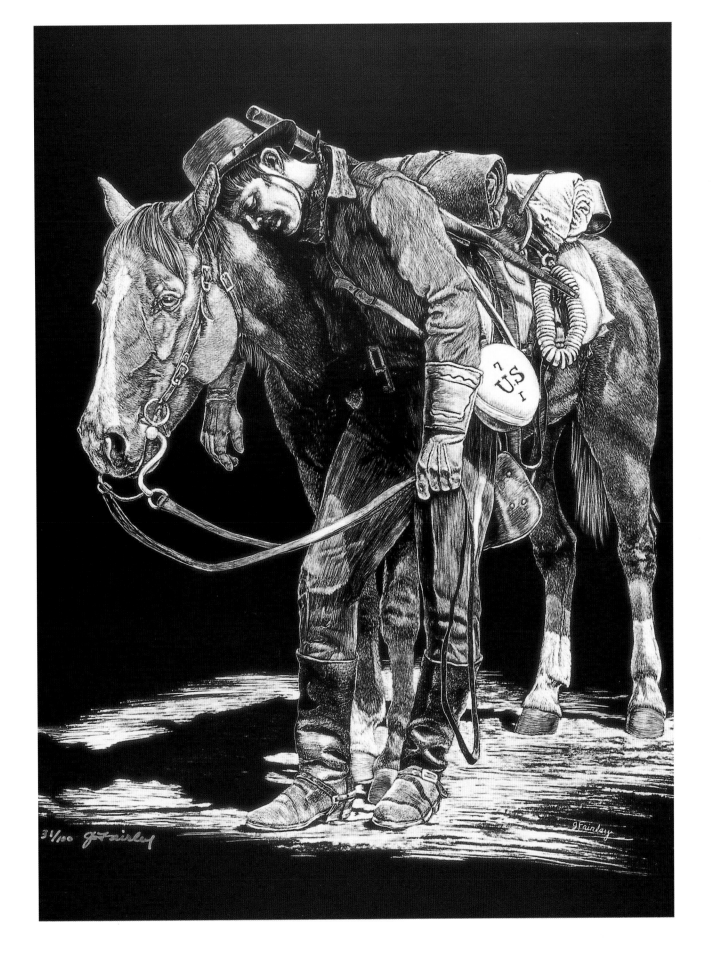

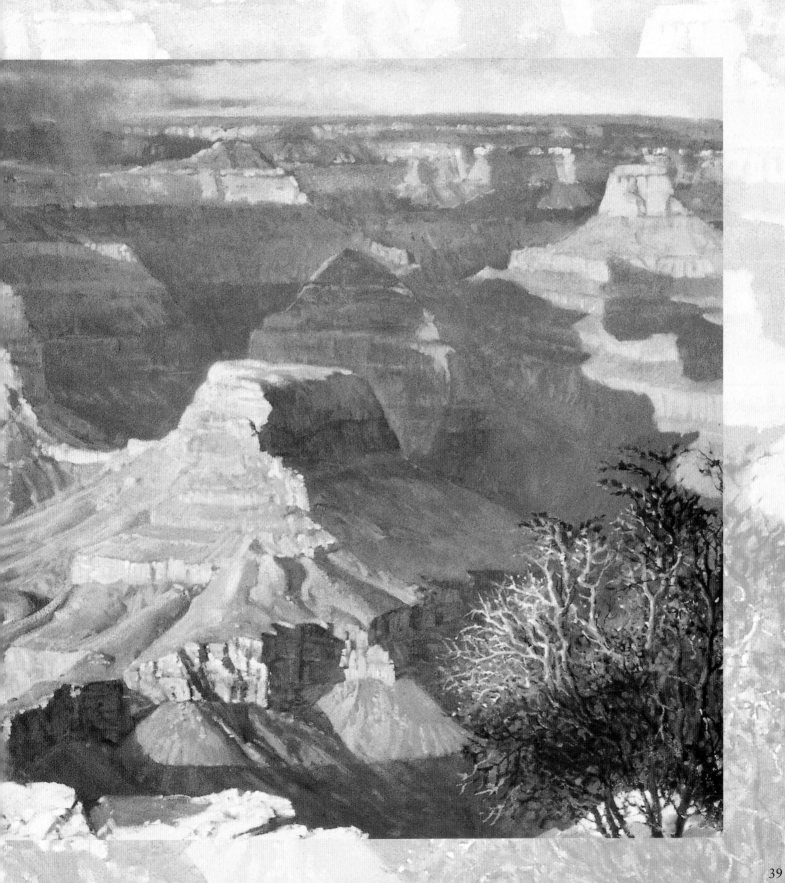

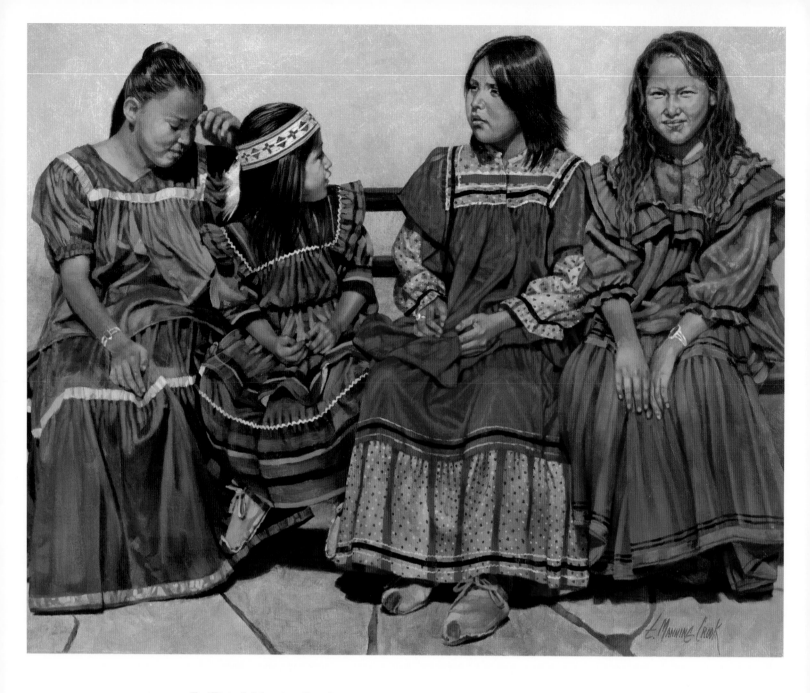

E. (Elaine) Manning Crook

Daughters of the Rainbow
16" × 20" (41 cm × 51 cm)
Oil on linen

The colorful Apache dresses worn by these San Carlos Reservation girls inspired Crook. She enjoys capturing moments in time that combine native symbolism and religious Indian gatherings, like the Apache Sunrise Ceremony. Using a technique practiced by many of the Old Masters, she underpaints and glazes color over color. This process brings depth and dimension to her paintings.

Tom Perkinson

Katsina with Butterfly
50" × 40" (127 cm × 102 cm)
Oil on canvas

Tom Perkinson paints in an intuitive manner, integrating southwestern Native American images and symbolism. Starting with multi-layered washes of color, the paint flows into shapes that appear to him as figures. He then develops the images around a central theme of balance and harmony between sharp edges, geometric forms, loose organic areas, and the central figure. He creates a glimpse of a spiritual world with mystery and self-discovery.

41

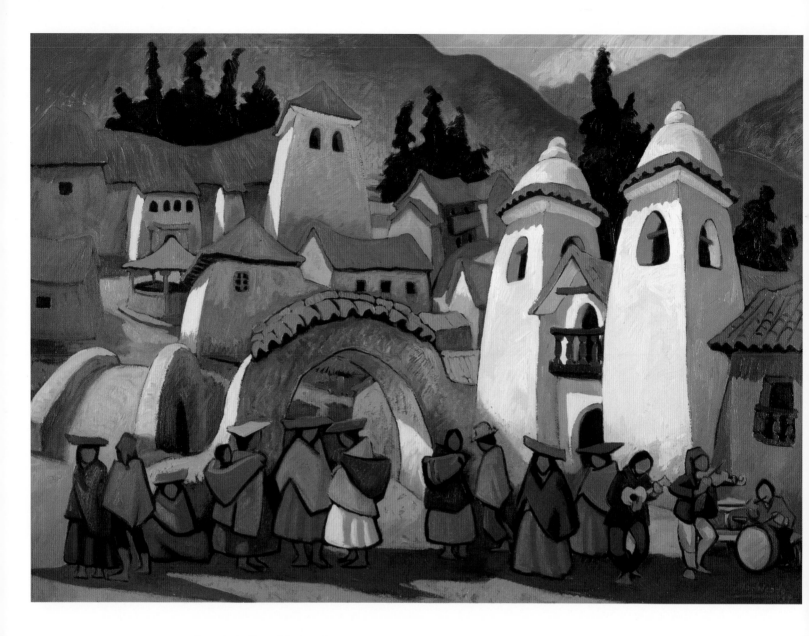

Juan de la Cruz Machicado

Checacupe Village
30.5" × 43" (77 cm × 109 cm)
Oil on canvas

Inspired by his father's mural of a bull that seemed to charge at him, Peruvian born Machicado started painting at age six. His passion for life is revealed through his use of vibrant colors. He says, "Life is simple and beautiful." He expresses the happiness of the Inca people living in small villages such as Checacupe. Celebrations, dances, myths, and legends are inspirations for Machicado. "I want to awaken people to energy and happiness, life and passion, so they want to really live."

Oleg Stavrowsky

Santa Fe Jam
24" × 18" (61 cm × 46 cm)
Oil on canvas

Stavrowsky captures the raucous spontaneity of the local Indian dances. With broad brush strokes of bright color he creates noise, movement, and intense emotion in his paintings. Although the saxophone is not used in Native American dances, he adds it as a modern touch to integrate the old with the new.

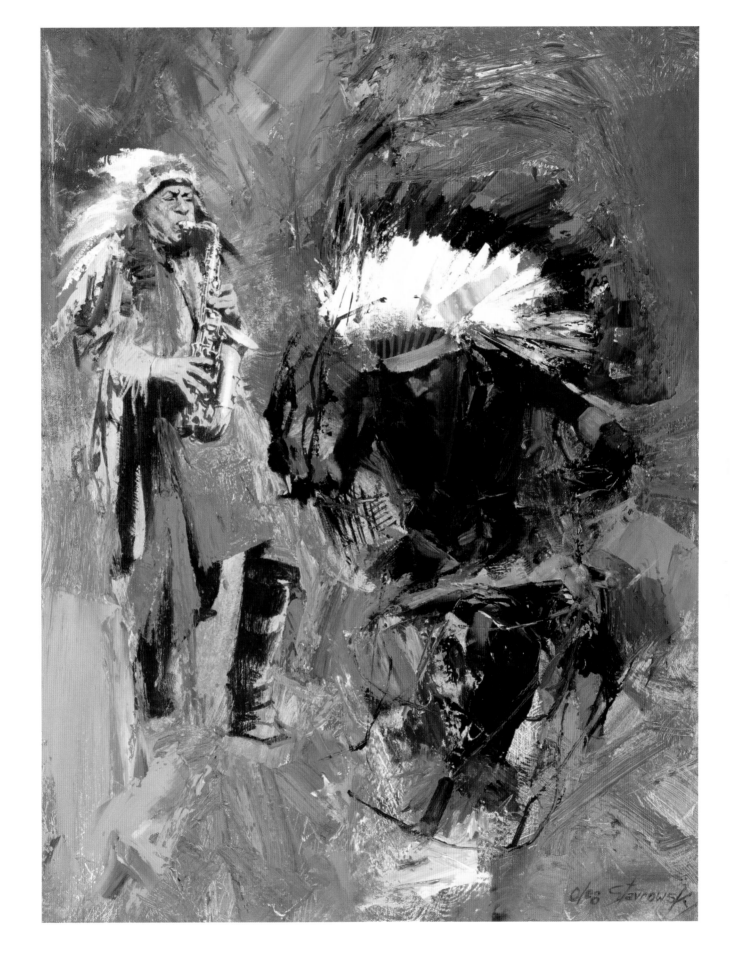

43

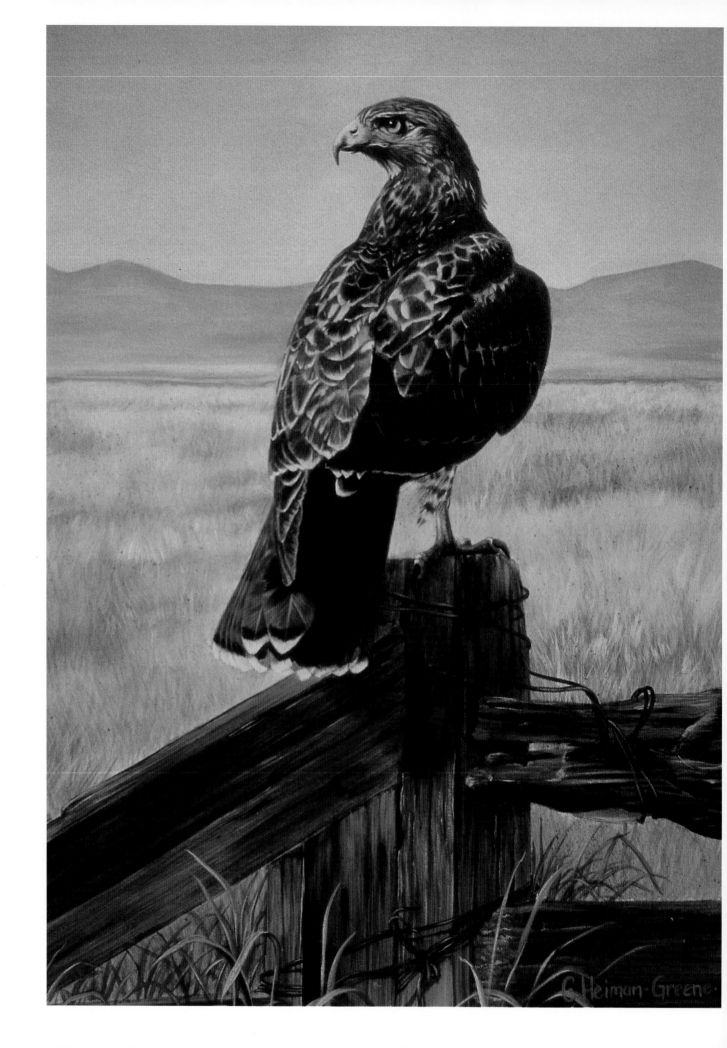

Joe Garcia

California Color
29" × 11" (74 cm × 28 cm)
Watercolor on Arches 140 lb. cold press

The California state bird and flower, quail and poppy, are rendered in this painting in rhythm, line, and color. The vertical composition of the poppies draws the eye toward the center of interest, the quail. Using wet-into-wet background, salt texture, and impromptu color application, Garcia then splatters with opaque pigment to create detail while maintaining the spontaneity.

Carol Heiman-Greene

The Great Wide Open
14" × 23" (36 cm × 58 cm)
Acrylic over graphite on Bristol paper
500 series, 4 ply

Painted with distinctive detail, the red-tailed hawk of the Southwest beckons as a spirit of the strength and beauty of the land. Heiman-Greene depicts the open, sometimes lonely, spaces of the west that touch our hearts. "This fence, with its beautiful aged patina and wired repairs reminds me of the strength and tenacity one must have to make an existence in the great west."

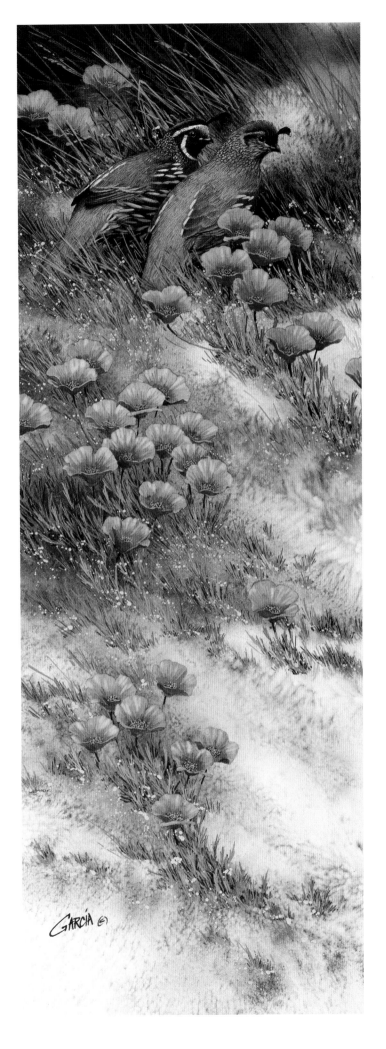

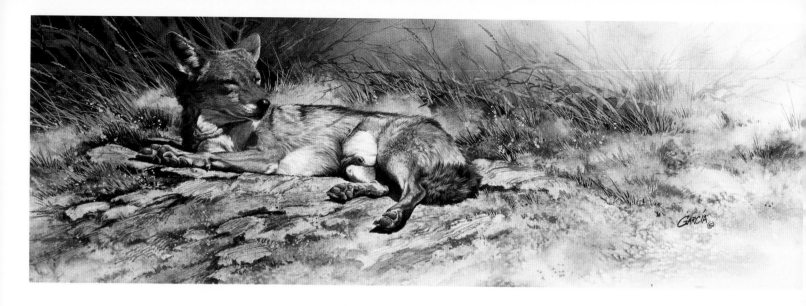

Joe Garcia

Break Time
11" × 30" (28 cm × 76 cm)
Watercolor on Arches 140 lb. cold press

The coyote is native to the southwest desert. In this painting Garcia has focused on the coyote first, locating the lights and darks of its fur texture, then the shadows to show depth and volume. The background is then flooded with water, and as the paper dries, warm and cool pigments are added. With a palette knife, Garcia creates the rocks in the foreground, and finally a fan brush and splattering develop the textures.

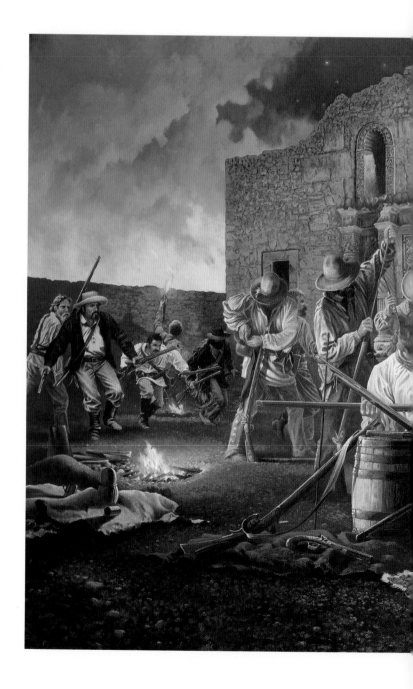

Richard Luce

For God and Texas
36" × 60" (91 cm × 153 cm)
Oil on linen canvas

At 5:00 A.M. on March 6, 1836, Santa Anna's Mexican troops stormed the Alamo. Although outnumbered, the 189 American defenders died, refusing to surrender. The sweet taste of freedom mattered more. Davy Crockett and the Tennessee Mounted Volunteers in Captain Harrison's company defended the wooden stockade in front of the chapel wall, the only wall not breached by the Mexicans. Luce, an Italian descendent from Florence, Italy researches his subject matters with avid interest before he paints. Ideas and insights from his reading come to life as he works realistic magic on canvas.

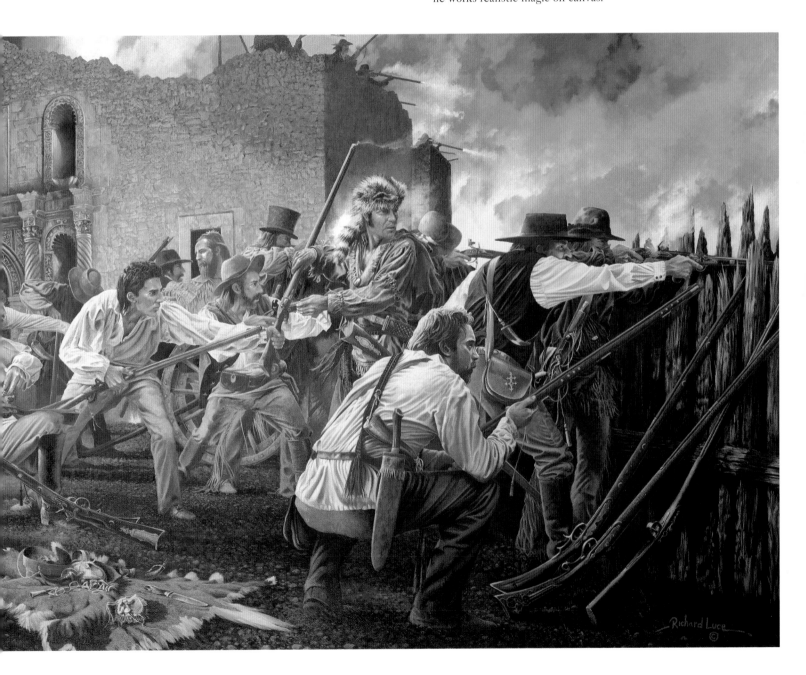

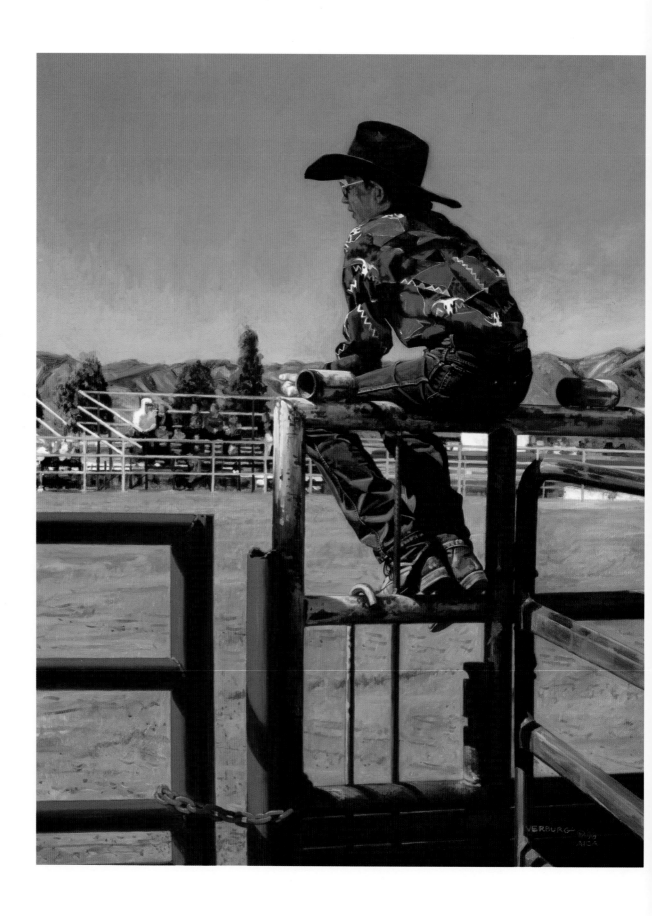

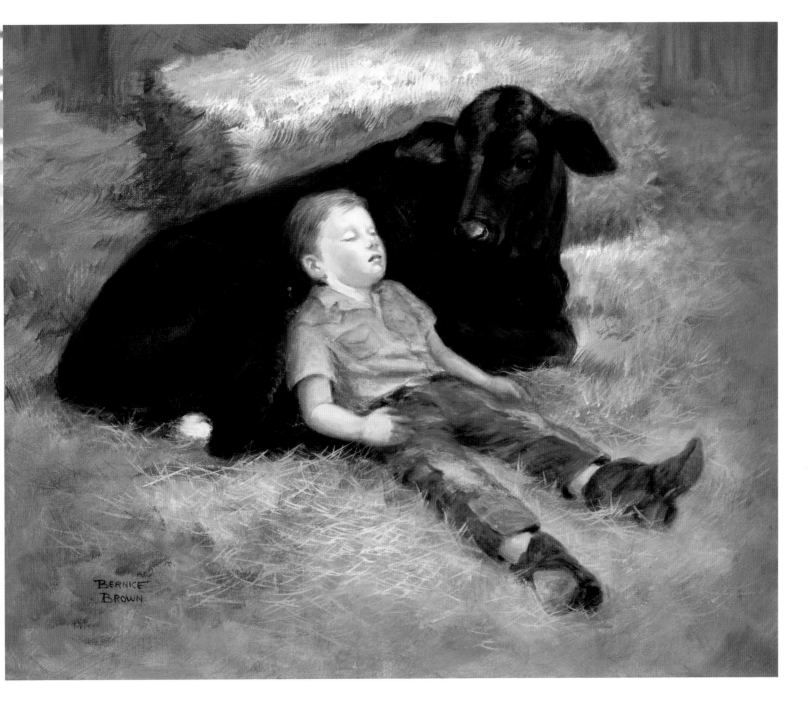

Paul VerBurg

The Edge of Imagination
36" × 26" (91 cm × 66 cm)
Oil on canvas

A temporary rodeo arena for the Goodyear Rodeo Days in Arizona sets the scene. Kelly Crystal, the stock contractor's teenage son sits on the rail in deep thought. He's just beginning a rodeo career, yet his family is in the midst of losing their contract with the rodeo ground, and this includes losing their home. VerBurg places Kelly against a clear blue sky to represent his youth and new experiences. The red and green colors, opposite yet complementary, symbolize a positive basis for the young life that spreads in front of him like the fresh-turned arena.

Bernice Brown

After the Judging
20" × 24" (51 cm × 61 cm)
Oil on linen canvas

As a judge for the Rodeo School of Art with the Houston Livestock Show and Rodeo, Brown often sees scenes such as this tired little boy and calf. Children who exhibit their animals at the annual Houston Livestock Show work hard to keep their exhibit in top condition. After the judges make their decision and the pressure is off, these youngsters (who have been up since before dawn) relax into a deserved rest. The calf and boy are clean and warm, in a comfortable place for a quick nap.

Stephen Juharos

Earl Van Deren's Drive to the Rim
30" × 40" (76 cm × 102 cm)
Oil on cotton canvas

Stephen Juharos, a native of Budapest, Hungary, painted at the early age of seven. He moved to the United States in 1949, after serving in the military from 1941–1945, to help free Hungary from German occupation. Juharos found peace and artistic beauty for forty years in Little Horse Park, outside Sedona, Arizona, where this painting was inspired. During the winters of the1940s Little Horse Park was used for cattle and horse herds. In the spring, the herds were taken to the northern forests and pastures, where they enjoyed a cooler summer. Earl Van Deren led the herds north through what was later named Schnebly Canyon.

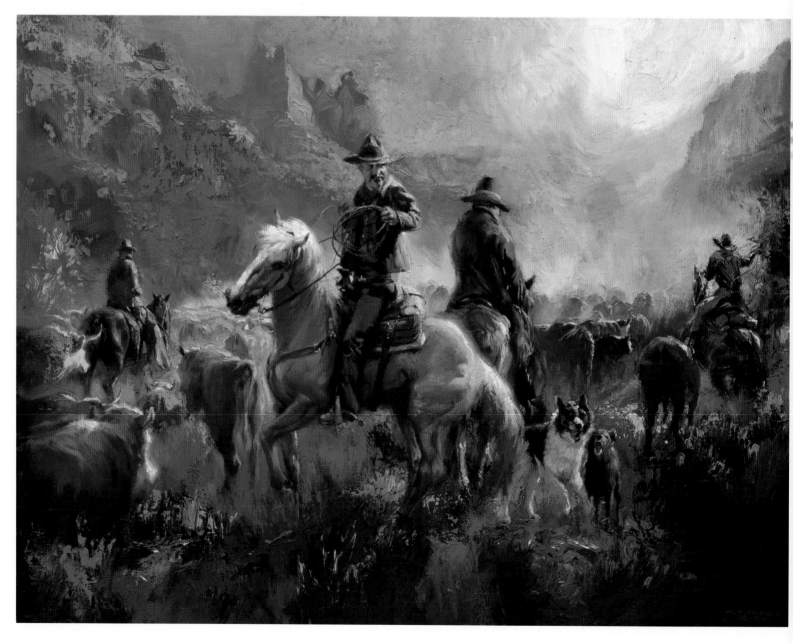

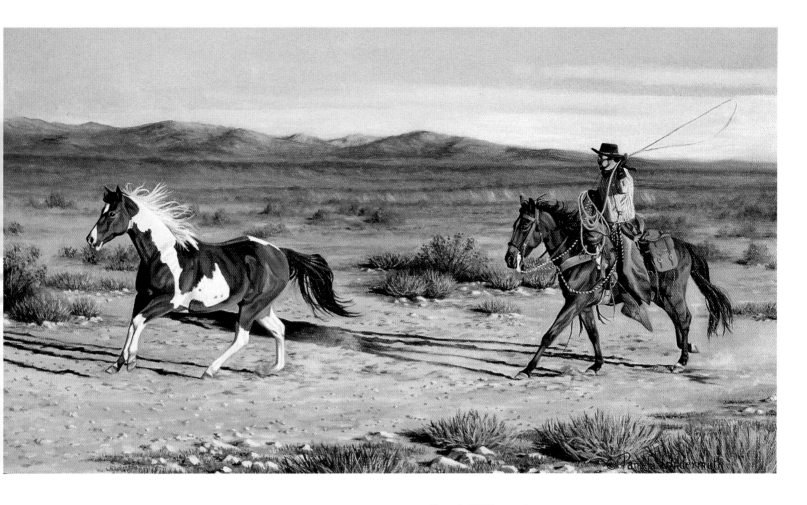

Pamela Wildermuth

Closing the Gap
11" × 20" (28 cm × 51 cm)
Oil on stretched canvas

Wildermuth is a fourth-generation Californian, a descendent of the vaqueros who worked on the vast Tejon Ranch. The blood of Spanish conquistadors, caballeros, Moors, and Indians coursed through the vaquero's veins. He reveled in wild chases through the flowered foothills of the Sierra Nevada, yet was reluctant to overrun his sure-footed mustang, a descendent of the fearless Andulsian barbs. Working long days in driving rain and scorching sun, he enjoyed swapping tall tales with his compadres around a campfire after a good meal.

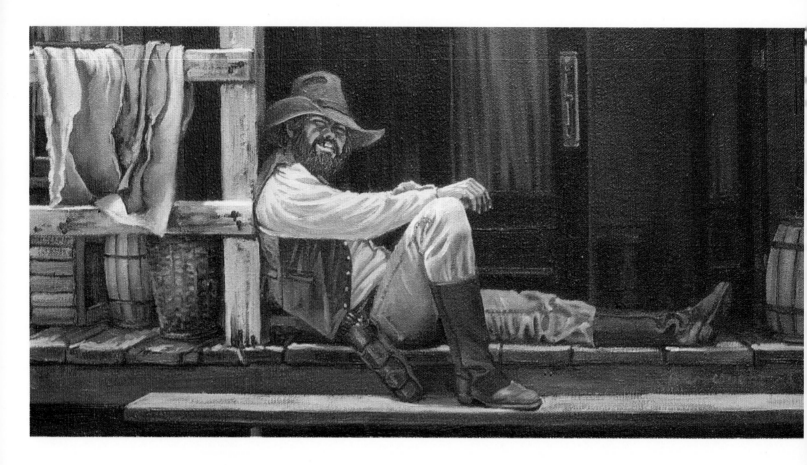

Joan Wright

Holiday Inn
15" × 30" (38 cm × 76 cm)
Oil on canvas

Wright's tongue-in-cheek depiction of
this character who roamed the Old West
dismantles the tendency to romanticize.
This cowpoke is a dirty, rotten scoundrel
sitting on the stairs of the one and only
Holiday Inn. Wright's careful texturing of
the rotting wood structure that surrounds
this lazy creature, emphasizes the irony.
Romantic hero? "Naw," says the artist.

Dorothy May Strait

*Apache Sunrise Services
(Becoming Womanhood)*
36" × 36" (91 cm × 91 cm)
Acrylic on canvas

Each year on the Apache Reservation in
Eastern Arizona, the tribe holds a puberty
ceremony for young Apache girls entering
womanhood. They gather tree branches
and begin preparations weeks in advance.
The tribe gathers before sunrise on the
morning of the ceremony. Facing into the
early sun, the spirit dancer gives thanks. In
this ancient tradition the elder men in the
background sing old Apache songs while
the others sway to the music and drums,
welcoming the girls to womanhood.

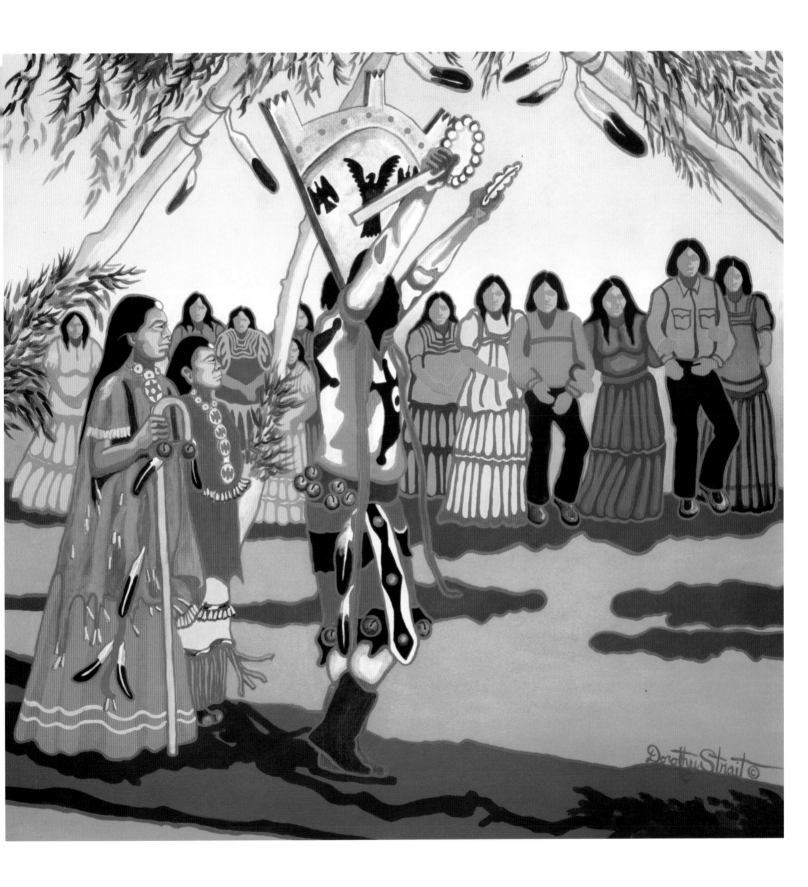

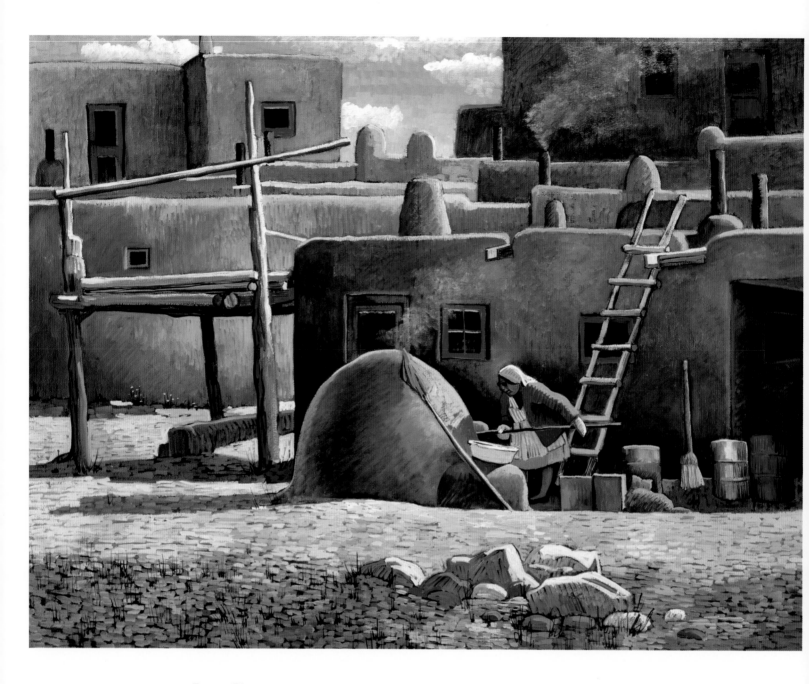

Donna Clair

Our Daily Bread
42" × 30" (107 cm × 76 cm)
Oil on Belgian Linen canvas

Taos, New Mexico was one of the first livable towns in America. Outside the main town, the ancient pueblo stands as a beacon of yesterday. The old ones still live in the geometrical adobe structures beside the trickling stream, celebrating rituals and traditions, and baking bread in the outside ovens, called hornos. Taking a break from her work, Clair often enjoys some of the fresh warm bread. She says of her paintings, "I spend days lying on a tepee platform watching the clouds above my Truchas' studio. What I really paint is the canvas in my head. It's an emotional preparation I call 'the dance with the easel.'"

Linda Tuma Robertson

Adobe Stairs
20" × 24" (51 cm × 61 cm)
Oil on canvas

Adobe pueblo structures line the streets and dot the piñon hillsides of Taos, New Mexico. Robertson captures the bright summer light reflecting from the adobe to the stately hollyhocks. The stairs draw the eye up to the adobe curve, and back to the hollyhocks. Her combination of realism and impressionism reveal a love and reverence for the vanishing wilderness of this country. "My desire is to paint a landscape displaying a fresh and honest impression of the land."

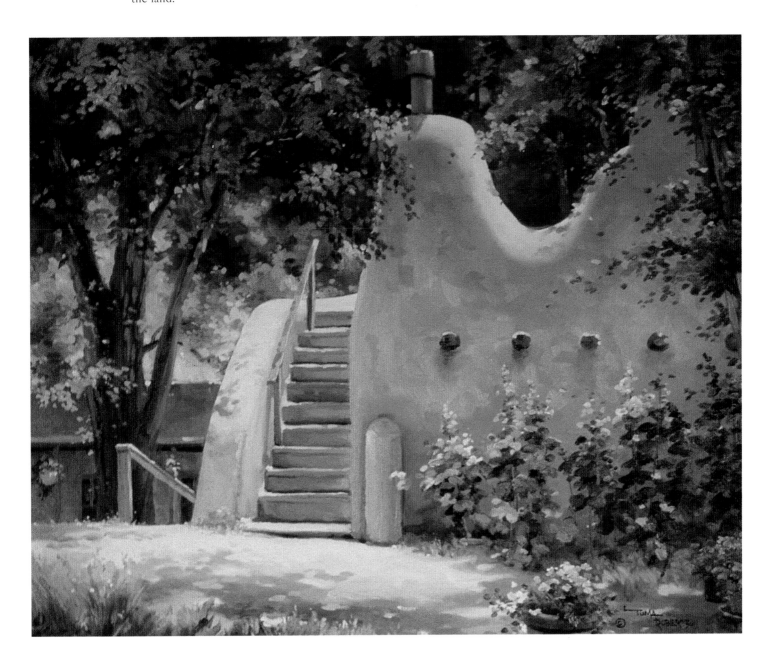

Sherry Blanchard Stuart

Her Brother's Keeper
16" × 20" (41 cm × 51 cm)
Oil on canvas

The strong light and dark patterns on the paint horse, the trees in the background, and the beauty of the Native American children inspired Stuart. The tenderness between the children also symbolizes the close protectiveness among Native American tribe members.

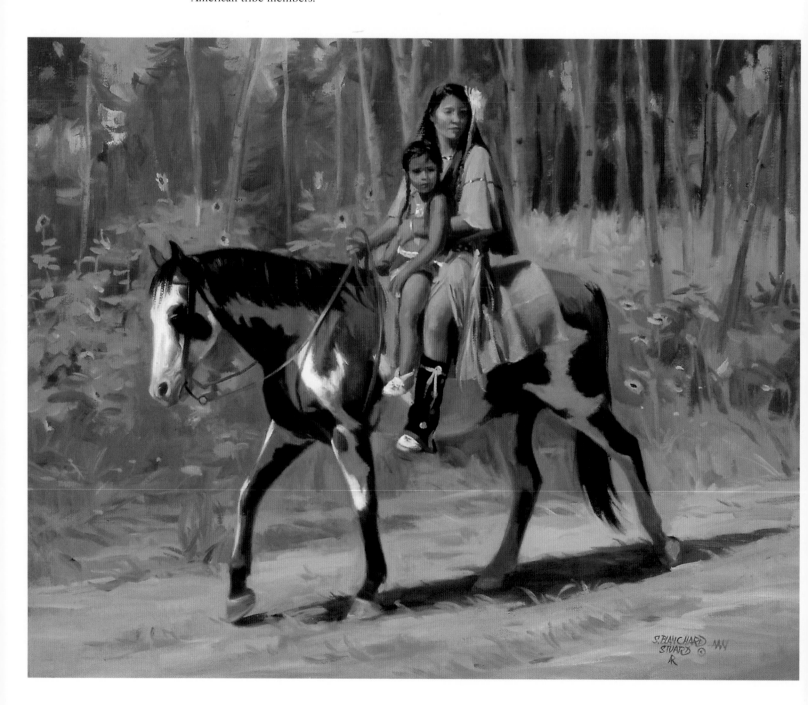

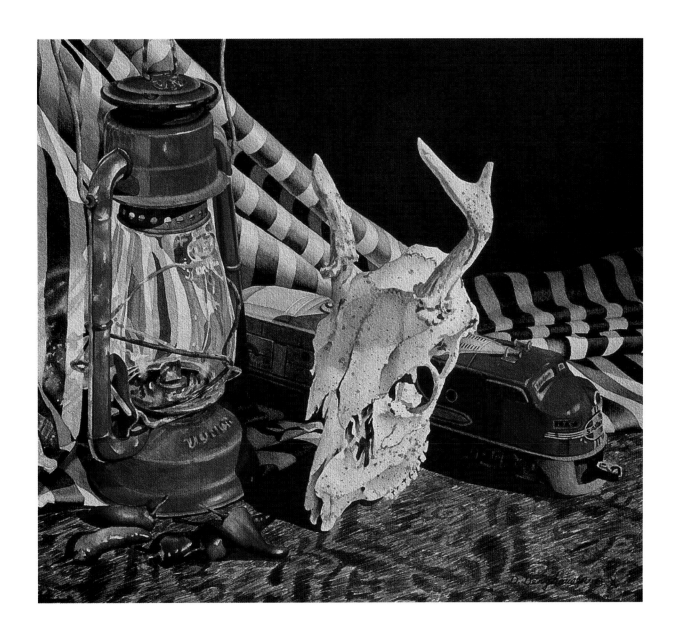

Diane Denghausen

The Santa Fe
14" × 15.5" (36 cm × 39 cm)
Watercolor on Arches 300 lb. cold press

The bold and sometimes eclectic images of the west are found in Denghausen's watercolors. Using contrasting textures and colors, she portrays a dramatic use of light using transparent watercolors. "I like to mix and match the objects in my still lifes. I invoke memories of a bygone era, when things were less complicated and 'life was good.'" Denghausen includes old toys like her grandfather's Santa Fe train. "My grandfather entertained us for hours with stories of train-hopping when he was young and reckless."

Tim Cox

Another Day Gone Forever
20" × 30" (51 cm × 76 cm)
Oil on Masonite

A cowboy scouts the rolling plains of Eagle Creek country near the Mogollon Rim, New Mexico. The cattle roam so far the cowboy must ride from daybreak until sunset, from 5,000 feet to a little over 9,000 feet to locate them. The rangeland varies: in the lower portion, juniper and piñon; on the slopes, mountain mahogany and oak brush; and on the very top, pine and aspen. The country is rocky and rough. Most cowboys wear felt hats and shotgun leggings, and their horses carry double-rigged saddles with breast collars, tapederos, big swells, and high cantles. Cox, an artist and working cowboy, often rides this rangeland and paints the beautiful land he loves.

Bruce R. Greene

Cowboy Cathedral
40" × 30" (102 cm × 76 cm)
Oil on linen

Hearing a song by Red Steagall called "Cowboy Church," Greene was inspired by the lyrics: "The sky is my cathedral, my altar is the ground." The edge of Palo Duro Canyon in the Texas panhandle gave Greene the inspirational setting. Hat reverently lowered, the aged cowboy looks up to the star-studded sky in prayer and wonderment at God's magnificent creation.

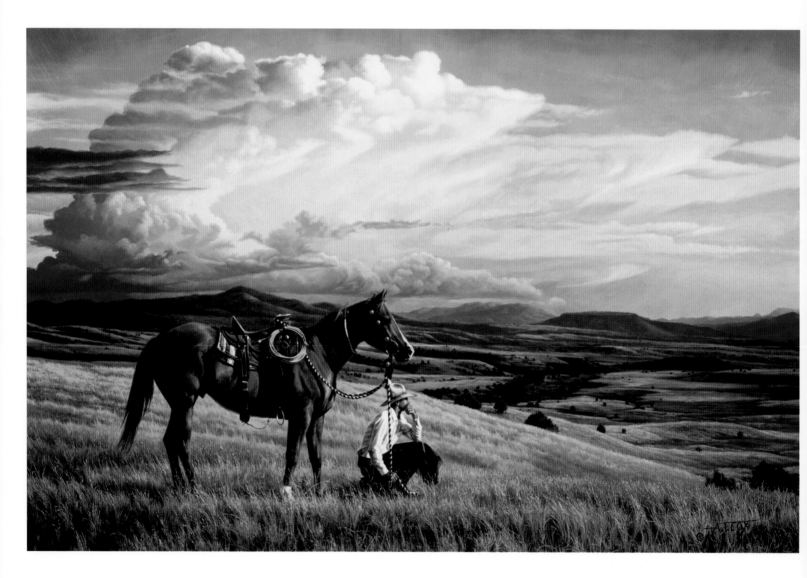

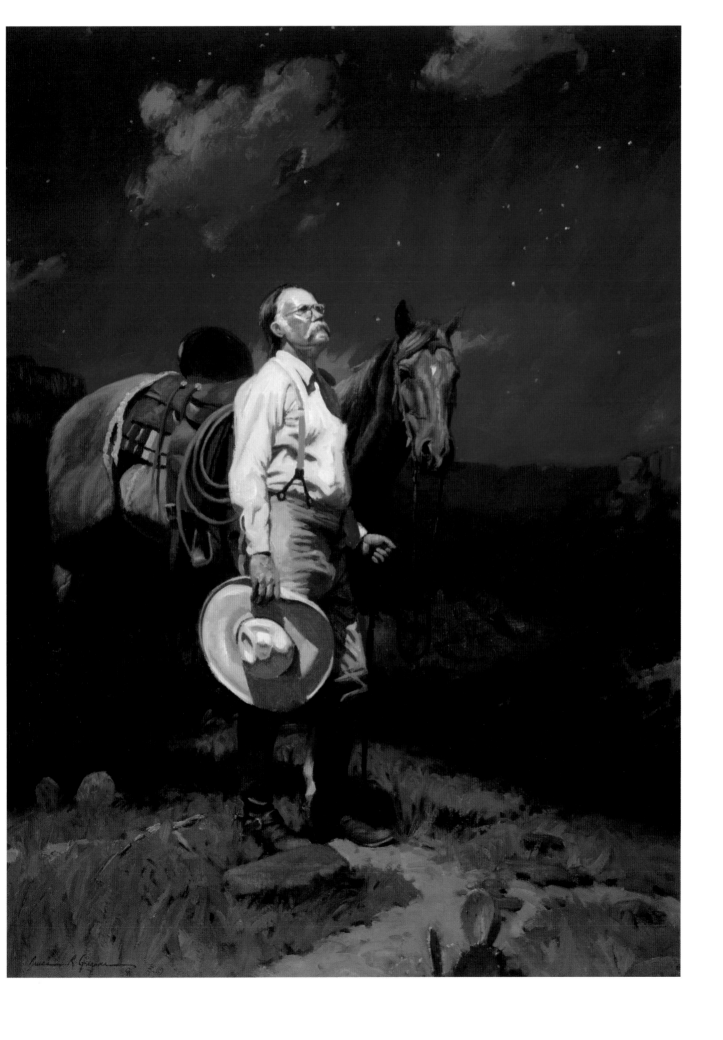

Adele Earnshaw

The Suncatcher
15" × 28" (38 cm × 71 cm)
Watercolor on Arches 555 lb. cold press

The inspiration for *The Suncatcher* comes from an agave cactus seen at the Arizona-Sonora Desert Museum. A member of the century plant family in which some species bloom once every 100 years, the agave cactus blooms every twenty-five years. Earnshaw places a female broad-tailed hummingbird within the cactus almost as a surprise. Working from light to dark, loose to tight, on dry paper, she glazes in transparent washes until the color and value are part of a balanced composition.

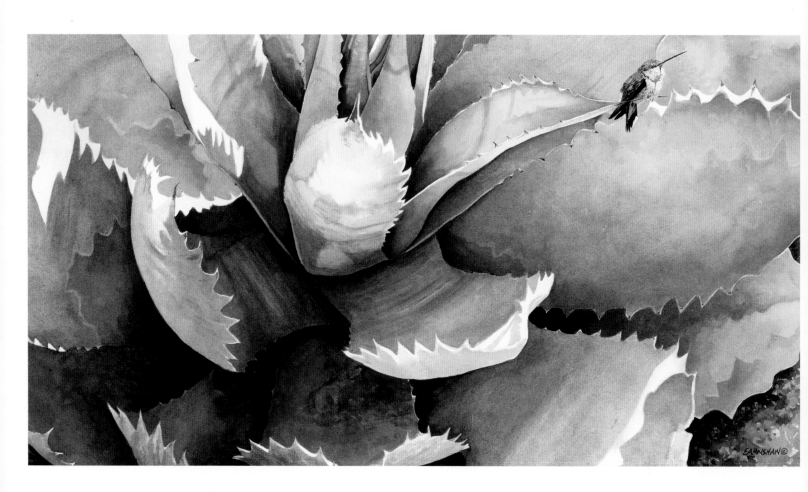

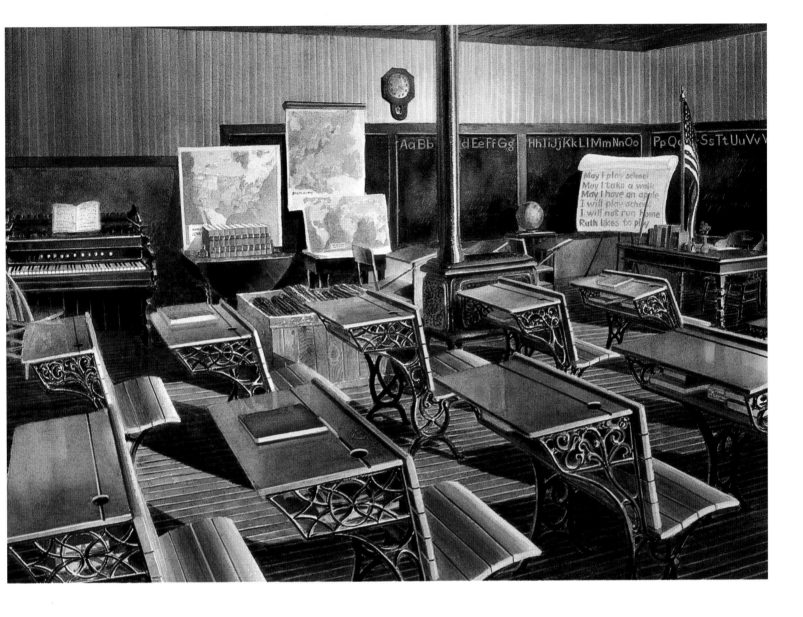

Jack Schmitt

A Proper Education
21" × 29" (53 cm × 74 cm)
Watercolor on Arches 300 lb. rough

Everyone is gone for the day except for
one gray mouse. The schoolhouse is still
intact at the remains of the remote gold
mining town of Bodie, California in the
eastern High Sierras. Long shadows in late
afternoon play on the transparent light
dancing on the empty desks. Schmitt's
detailed rendering and use of transparent
watercolor illuminate a time long past for
the one-room schoolhouse.

Marianne Millar

Weaver's Web
36" × 42" (91 cm × 107 cm)
Acrylic on canvas

According to Navajo legend, Spider Man first taught the people to make a loom from sunshine, lightning, rain, rock crystal, and shell. The Spider Woman taught them how to weave. Long before the Europeans came to America, the southwestern native peoples wove textiles. With the Spaniards' introduction of sheep, wool was used as an alternative to cotton. Simple motifs evolved into the intricate patterns of today. Millar's portrait shows the symbols of nature's original weaver, the spider. The symbols appear on the Navajo elder's bracelet, and Spider Woman crosses are woven into the saddleblanket.

Reita Newkirk

Pow Wow Dancers
48" × 34" (122 cm × 86)
Pastel on sanded pastel paper

Fascinated with the relationship between figures in ceremonial dance, Newkirk sees the space between the dancers as "tension between action and inaction." The elaborate tribal dance costumes dazzle with bold color when the dancer is in motion. Newkirk weaves the color of her pastels in the sculptural form of the dancers. "There is a density and elemental quality to pastels that is matched by this ancient land. Here, the light has solidity and intensity, and there is no veil of atmosphere."

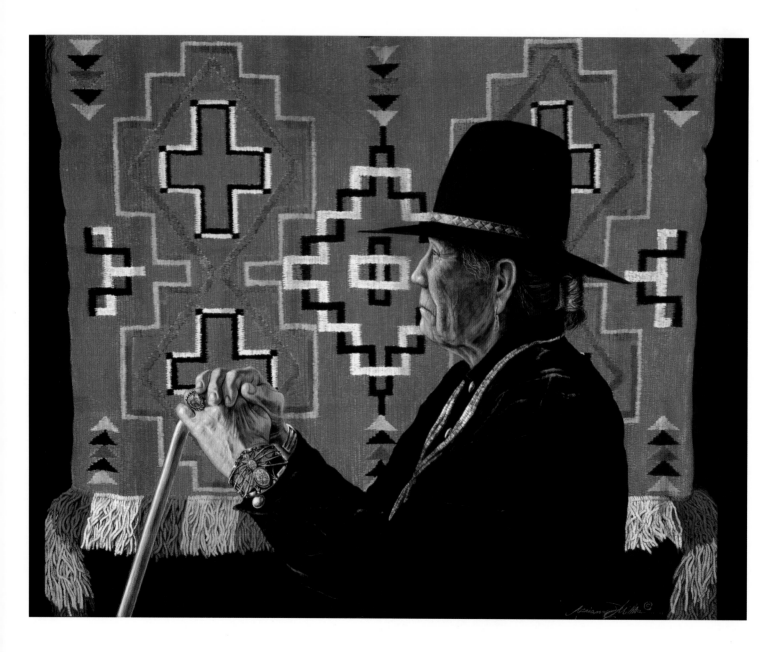

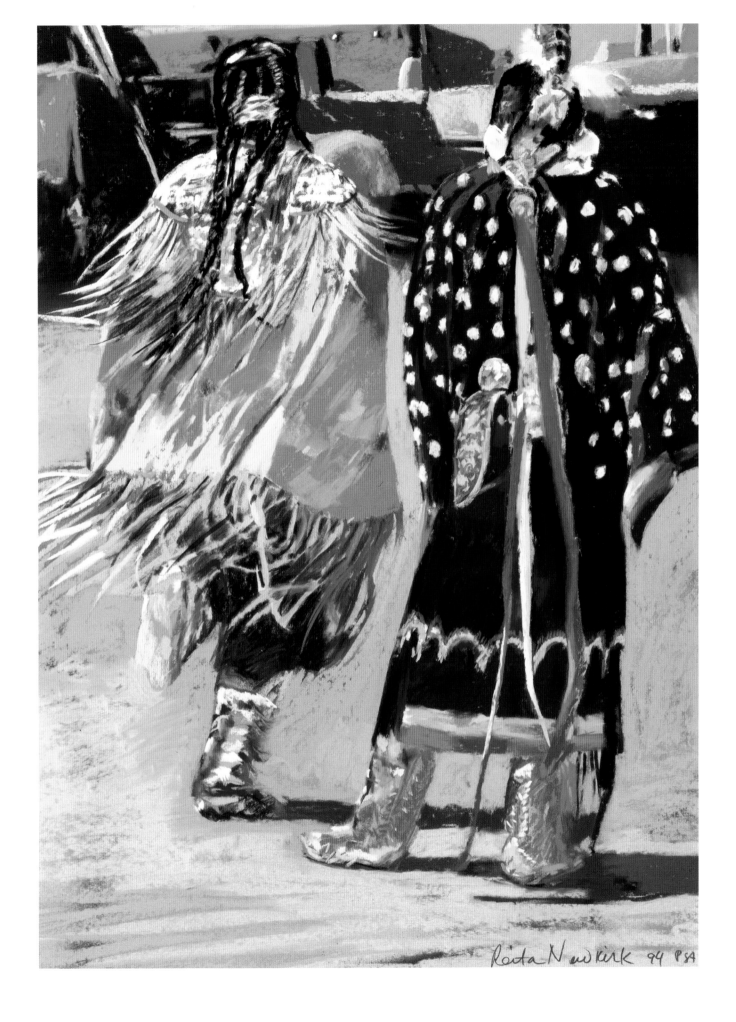

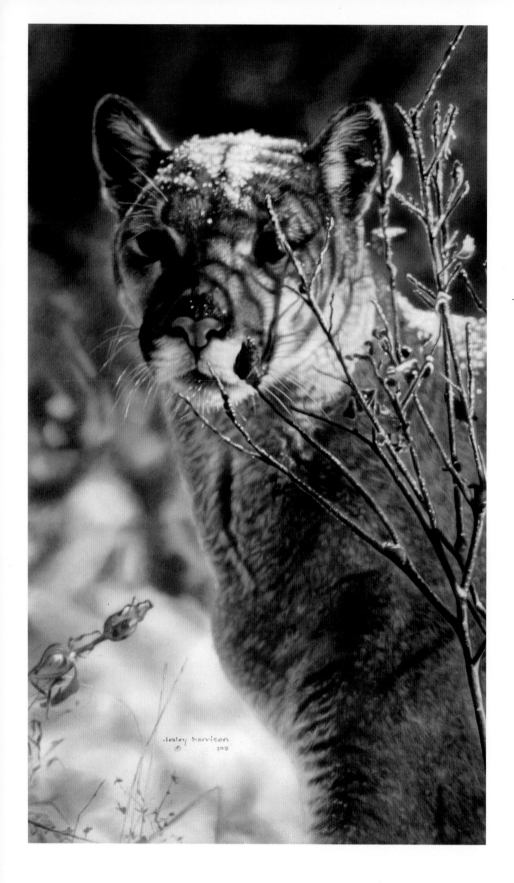

Lesley Harrison

Her Majesty
26" × 15" (66 cm × 38 cm)
Pastel on vellum paper

Mountain lions roam the rugged brushy hills of northern and southern California and other western ranges. Because of man's population explosion, many mountain lions have been forced out of their natural habitat. Harrison captures the dignity of this beautiful animal, using layers of pastel. Her paintings are known for their drama, spirit of life, emotion, and amazing realism.

Bill Drysdale

Route 66
28" × 20" (71 cm × 51 cm)
Watercolor on Arches 140 lb.

Route 66, the great 2,400-mile link between Chicago and Santa Monica is known by many names. In *Grapes of Wrath*, Steinbeck's Joad family travels on the Road of Flight. In better times it is The Mother Road. Driven to subjects that take one to a different locale and time period, Drysdale creates a simpler, slower-paced picture of life. The '30s Chevy in *Route 66* captures the warmth of the desert in the curves and reflections of the auto. What stories could this Chevy tell about its Route 66 journeys?

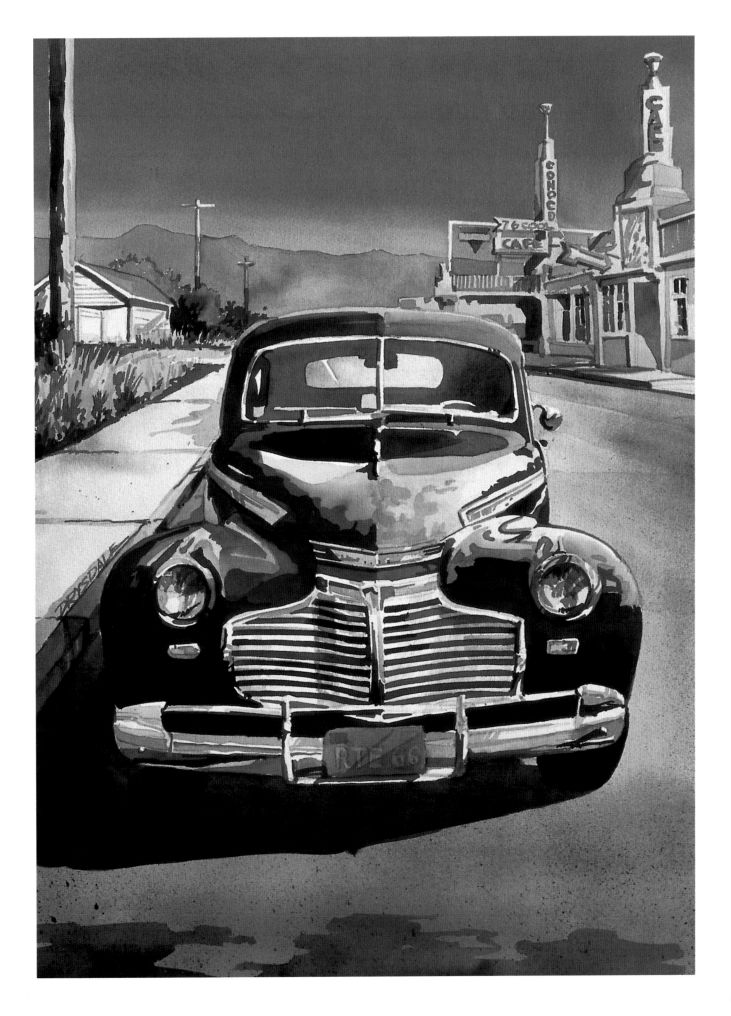

Dott Beeson

Sigh in the Afternoon
21" × 30" (53 cm × 76 cm)
Watercolor and acrylic collage on Arches
140 lb. rough

This patient, wise, leader of men is calm in his confidence. He rests in late afternoon, satisfied with another day's litany, awaiting the peace of the nightfall world. The strength of the Native American permeates the culture of the entire Southwest and brings a spiritual calm. Even chaos (shown through the many line movements and contrast of complementary colors) does not disrupt Beeson's abstract collage of the calm, spiritual man.

K. Douglas Wiggins

Cycle of Life
24" × 30" (61 cm × 76 cm)
Oil on linen

Wiggins was born and raised on a ranch in New Mexico, and *Cycle of Life* represents a difficult time as he watched his father die of cancer. The work speaks of death as well as resurrection. His grandfather's cow skull represents an icon of death on the high plains. The Indian blanket, left to him by his father, is the backdrop. The sunflowers, given by a dear friend during his father's death, represent life.

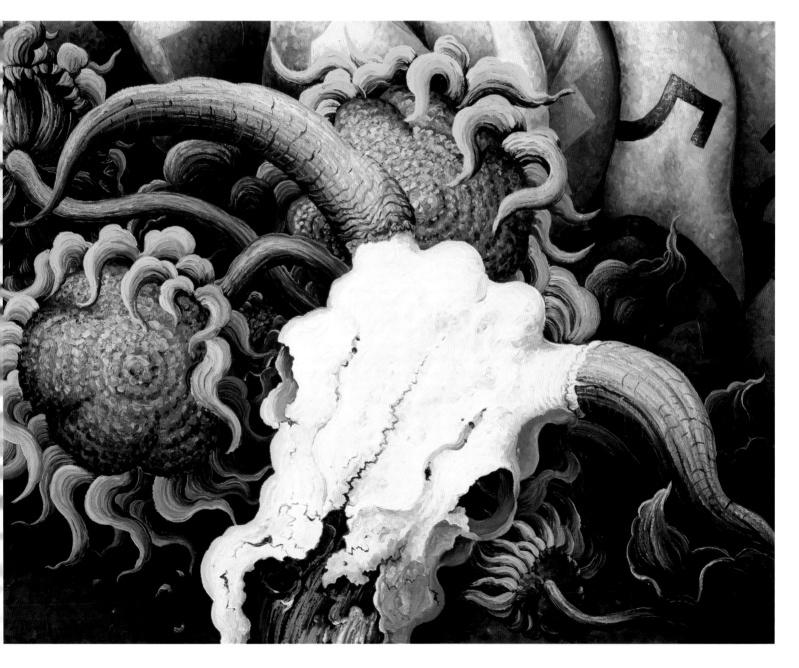

Ron Bausch

Cottonfield
12" × 16" (30 cm × 41 cm)
Oil on canvas

When Bausch saw a mechanical cotton-picker stirring up clouds of white in a field in western Texas, he painted *Cottonfield*. Bausch contrasts the stark red of the "picker" against the soft light of the millions of white cotton balls. The patterns and sharp shapes against the soft cotton make an interesting composition.

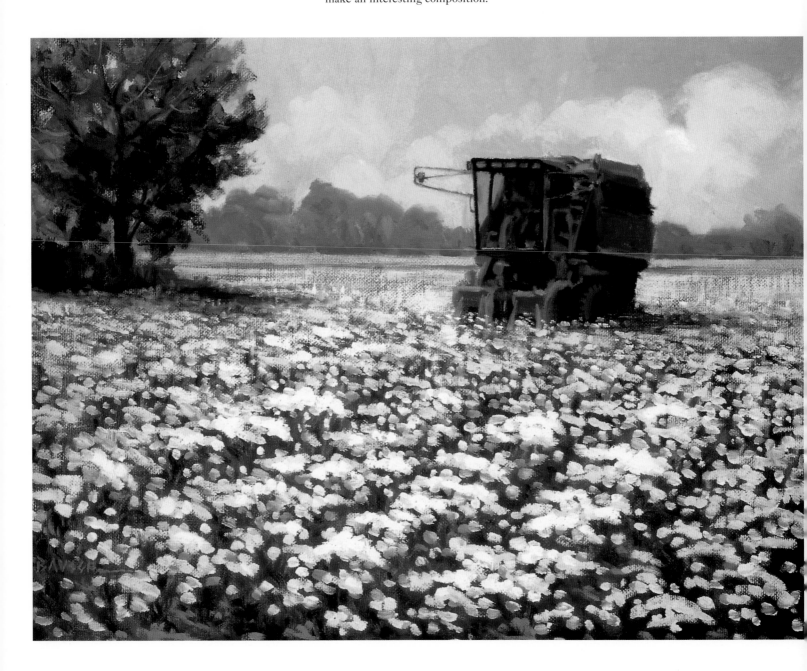

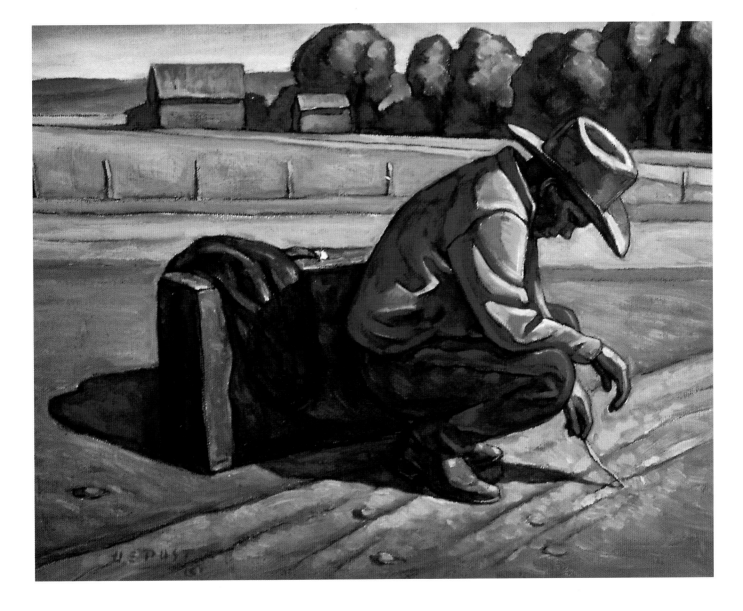

Howard Post

The Rendezvous
16" × 20" (41 cm × 51 cm)
Oil on canvas

The cowboy travels from rodeo to rodeo, to rendezvous with old adversaries and friends. His life is full of adventure, challenge, good times and bad, and sometimes loneliness. Post depicts the cowboy waiting for the next ride, his earthly goods packed in one suitcase, "goin' for the big time." Growing up on a small ranch in Tucson, Arizona, Post often saw these scenes. His stylized vivid composition makes an ironic statement, one with passion and emotion contrasted with the loneliness of the hunched cowboy.

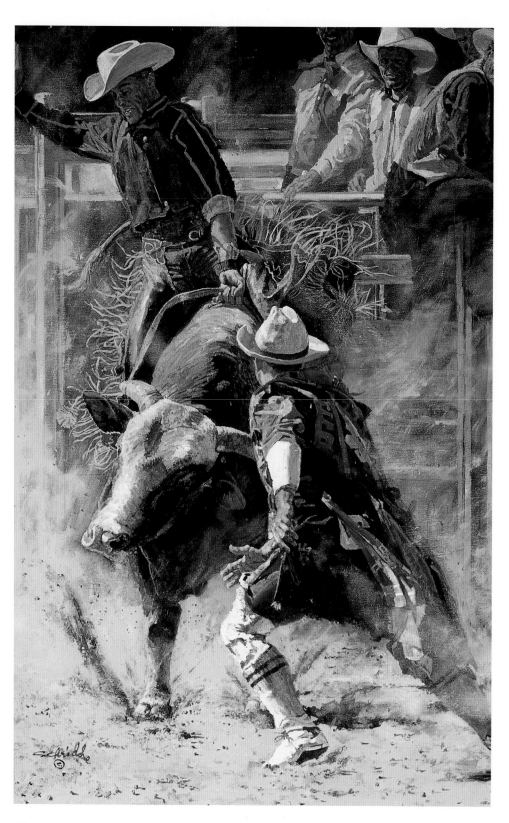

Charles Schridde

If Looks Could Kill
30" × 40" (76 cm × 102 cm)
Acrylic on canvas

After many careers as an engineer, illustrator, photographer, and teacher, 71-year-old Schridde now does what he loves most—he paints. "I loved cowboys as a kid. I've decided to become a cowboy when I grow up." The rodeo depicts the life and times of a cowboy. Schridde has captured the pure animal energy released when the shoot opens and the bull charges. The blue tones of the sky and warm reflections of the earth accentuate the force of the animal, bucking off the cowboy. The bull's power and determination are seen in his eyes as he stares at the clown, his next victim.

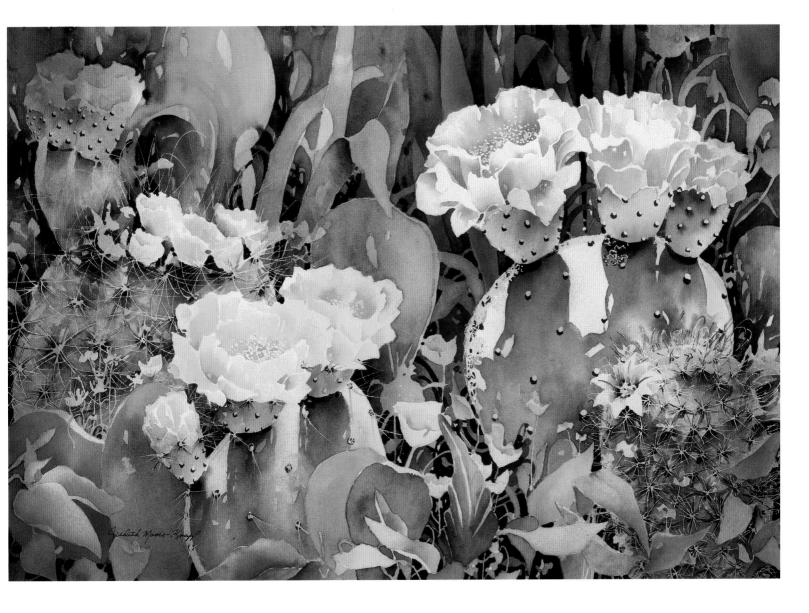

Judith Moore-Knapp

Spring Color
20" × 27" (51 cm × 69 cm)
Watercolor on Lanaquarell 300 lb. cold press

The prickly pear, beavertail, and barrel cactus bloom every spring in the Borrego Springs Desert, California. What once was barren comes to life in a brief but passionate display of flowers. Moore-Knapp intensifies the vibrancy of the bloom by glazing and layering color over color. She uses skillful negative painting to highlight the positive shapes of the cacti and the background images.

Judy Koenig

Corn and Kachina
22" × 30" (56 cm × 76 cm)
Watercolor on Arches 300 lb. rough paper

Corn and Kachina represents the Chumash
Native American harvest in the Conejo
Valley, California. The peaceful Chumash
farmers and fishermen regard the Kachina
doll as a sacred symbol of the Kachina spir-
it of prosperity and good harvest. Koenig
captures glowing, transparent, inner light
in her detailed representation of a
Chumash plentiful year.

Thais Haines

The Favorite Daughter
16" × 12" (41 cm × 30 cm)
Oil on linen

Living in rural Placitas, New Mexico,
Haines is enchanted by the majestic
Sandia Mountains and the Rio Grande
River, which meanders past the mesas and
mountains of the Jemez wilderness.
Working from life, Haines paints this
young Native American girl as she stands
at the edge of a canyon. The youngest of
three daughters of a singer from a local
pueblo, the girl is much loved by her
father and her older sisters. Capturing this
one exquisite moment, Haines paints the
ever-changing magic of light and shadow.

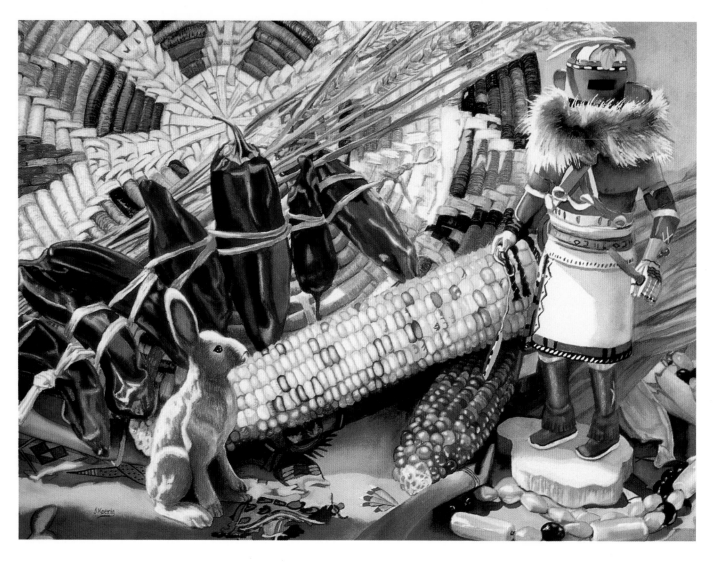

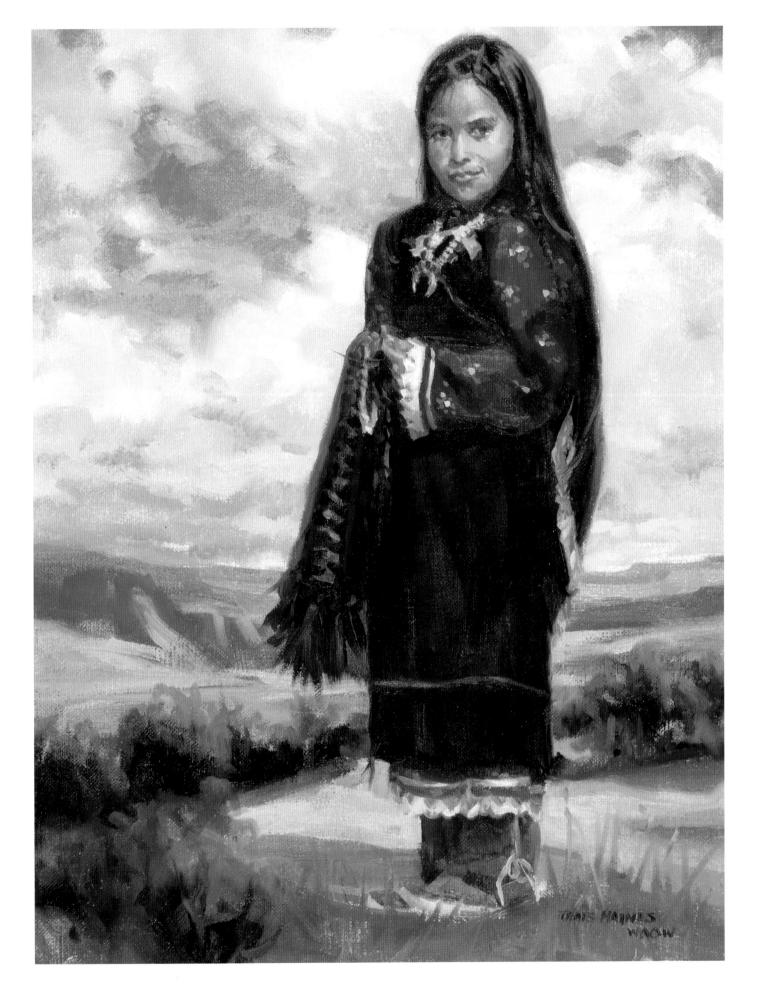

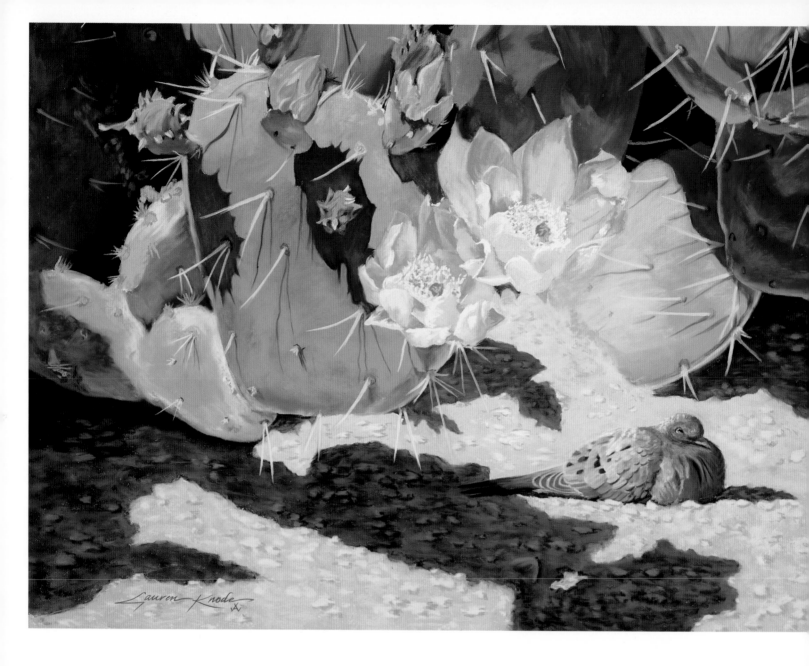

Lauren Knode

Good Mourning, Dove
22" × 28" (56 cm × 71 cm)
Pastel and pencil on sanded pastel paper

"Cactus blooms are exquisite, luminous gems in the desert." The Engelmann's prickly pear, common in the Southwest is named after Dr. George Engelmann, the noted botanist who first described most of the Southwest's cacti. Texas recently designated the prickly pear as its official state plant. Discovered during a trip to southern Arizona, the mourning dove, with its melancholy cooing, is snuggled under a prickly pear and bathed by the warming sun. The painting captures the moment when the dove first opens its eyes. "I find contrast in patterns of light and shadow, in textures, soft and sharp, and in colors, warm and cool, fascinating and inspiring."

Patti Marker-White

The Sculptor
22" × 16" (56 cm × 41 cm)
Pastel on Canson Mi-Tientes paper, black

While living in Simi Valley, Marker-White heard stories about the "good old days" when the Boyles and the Runkles shot up the town on payday. She often visited the sets at the nearby Big Sky movie ranch, where Little House on the Prairie and other westerns were filmed. One melancholy day she and Ken Johnson, the manager of Corriganville, walked the ghostly burnt-down sets. This painting symbolizes an imaginative sculptor making a symbol of a by-gone era. The dark and light passages represent history's brilliant, but shadowed past.

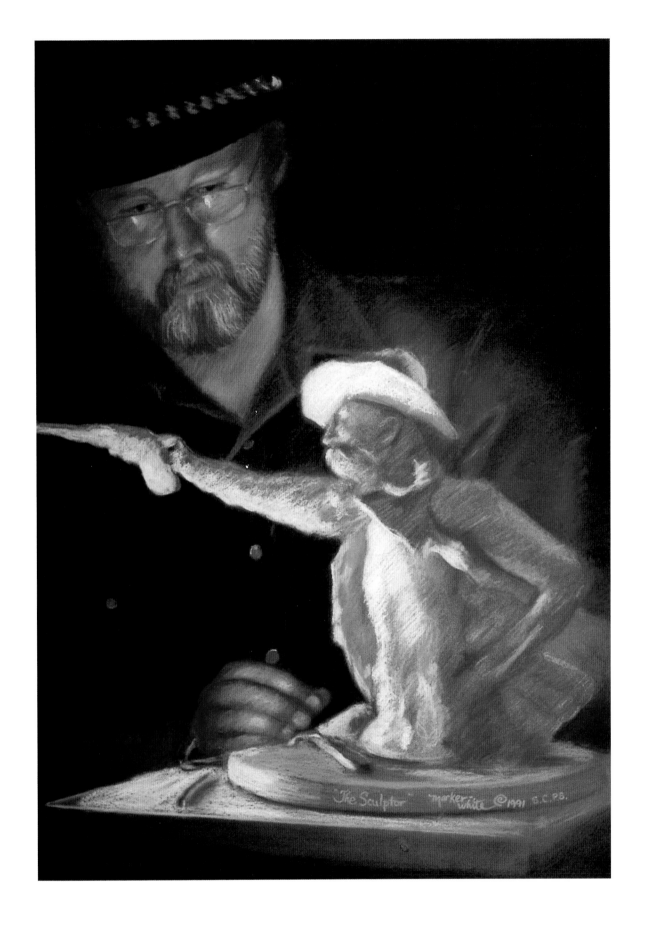

"The Sculptor" Marker/White © 1991 S.C.PB.

William Herring

Orange in the Trees
24" × 36" (61 cm × 91 cm)
Pastel on canvas board, gray acrylic, ground
with ceramic pumice

Herring lives at the Pass of the North,
where Mexico, New Mexico, Arizona, and
Texas join, the lowest crossing point of the
Rockies. Painting passionately, without
restraint, Herring dips freely into his soul
for color and design. "I pay no attention to
'local color,' and never have. I practice
'open color,' and I just cut loose for the
drama of it."

Martha Saudek

Evening Storm
24" × 36" (61 cm × 91 cm)
Oil on linen canvas

Near Taos, New Mexico, Saudek spotted this dramatic scene of an oncoming storm. A band of light shone through the towering clouds in the distance. Awed by the immensity and majesty of the storm, Saudek captured this moment on canvas, conveying her love of landscape and reverence for nature.

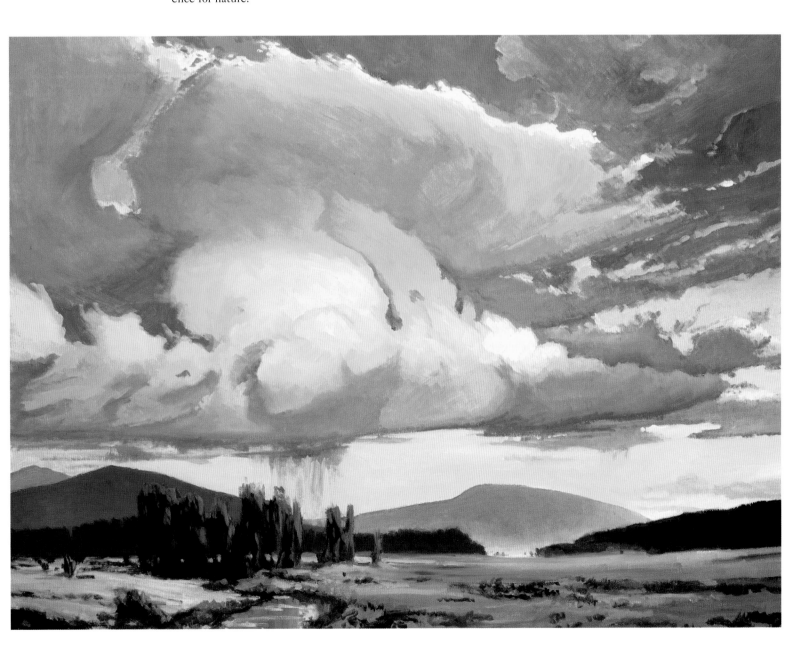

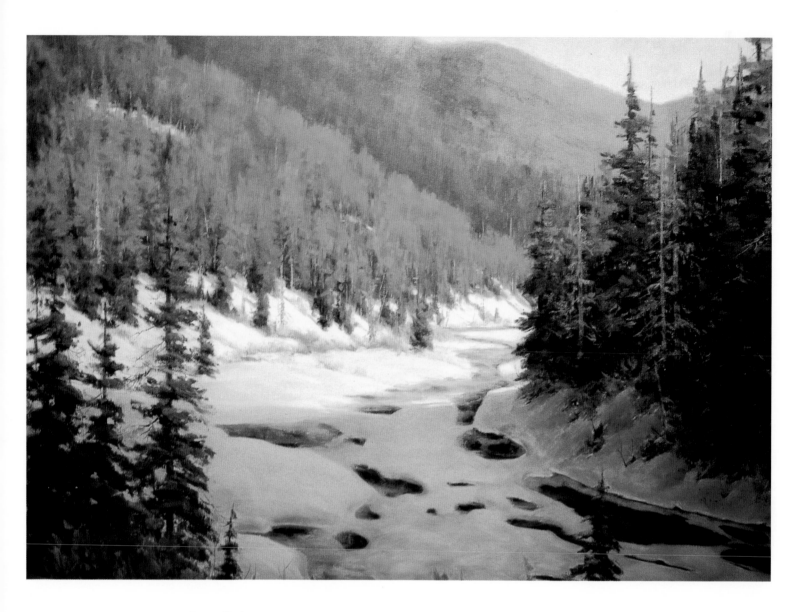

Bruce Peil

Pecos River
30" × 40" (76 cm × 102 cm)
Oil on stretched canvas

In northern New Mexico, the Pecos River flows out of the Pecos Wilderness to the Rio Grande River, part of the National Wilderness Preservation System including 223,667 acres. Highway 63 follows the Pecos River upstream and as the altitude increases, the terrain and plant life changes. With fine strokes of the brush, Peil details the pine trees against the white and cool shadows of the snow, creating a winter scene of depth and dimension.

Judith Hurst Baer

Cinturóns
22" × 15" (56 cm × 38 cm)
Watercolor pencil on Lanaquarelle 140 lb. hot press

The colors and ambiance at the bazaar in Oaxaca, Mexico inspired Hurst Baer to paint *Cinturóns*, Mexican belts. Using Prisma colored pencils she started at the center and developed each belt by burnishing and shading colors in tone and intensity, to create depth. The pencil strokes established the weave and patterns on each belt. Using the directions of line to emphasize the planes and curves of the molded belt, she created a bold and striking image.

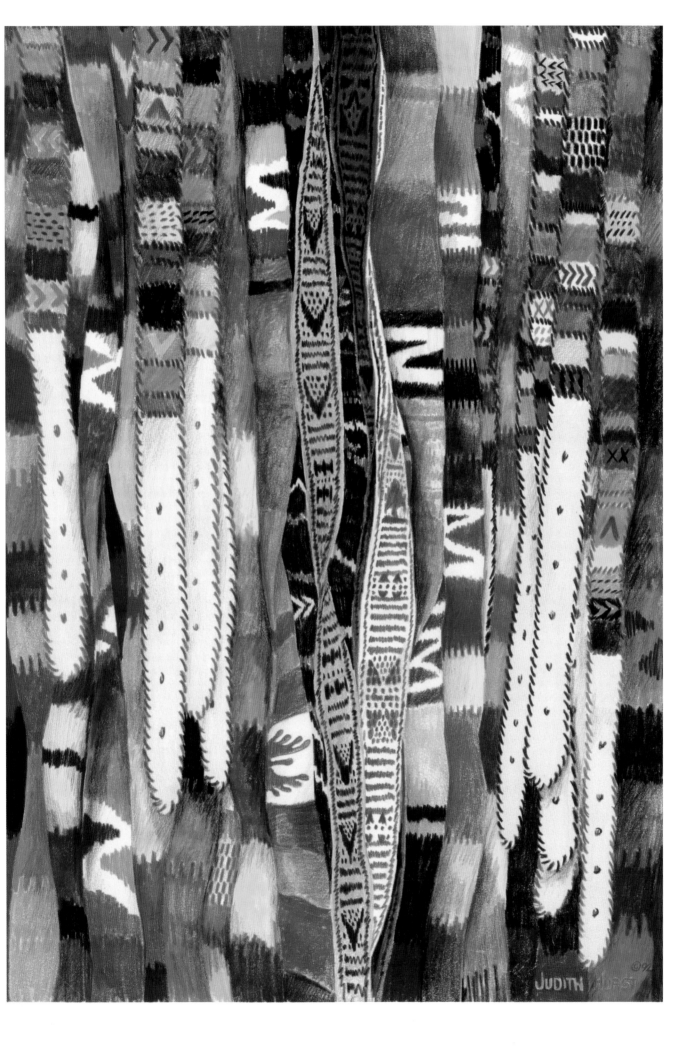

Cyrus Afsary

Onion and Corn
14" × 18" (36 cm × 46 cm)
Oil on canvas

Onion and Corn represents an aspect of
Afsary's love for the Southwest. He uses a
traditional style to paint a variety of still
lifes and landscapes. His compositions
reflect the richness of color and depth of
value often seen in the desert. The com-
plementary Southwest colors radiating
against each other bring a sense of excite-
ment and passion to the still life.

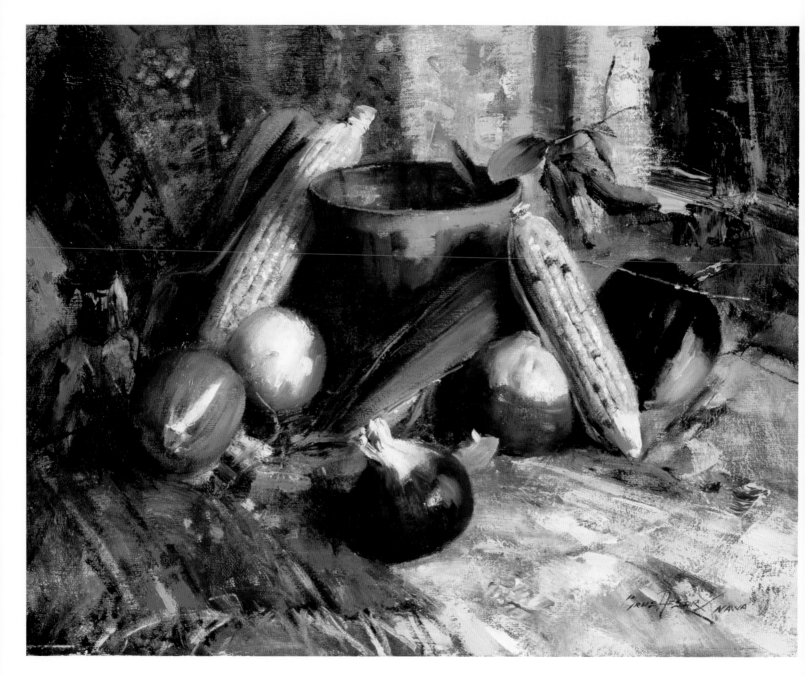

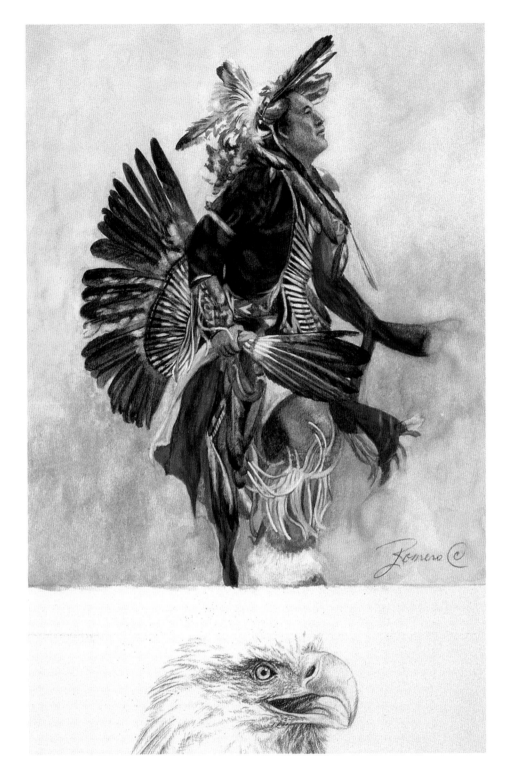

Jo Anne Romero

Traditional Dancer, III
8" × 6" (20 cm × 15 cm)
Watercolor on illustration board

Of Spanish and Navajo (Navaho) decent, Romero paints Native Americans to reflect and preserve her heritage. The "Los Manitos" (everyone's brother) Romero clan traveled a long journey, on foot from New Mexico to Arizona, to settle in Concho, the Enchanted Pearl of Arizona. Wars and depression finally broke the sheep-herding community. Although the language and culture were lost, the heritage lives on, in her father's stories, and her paintings. With the sacred eagle feather as the Creator's messenger, the traditional dancer enters manhood by re-enacting a warrior stalking prey. "....The dance extends one's heart to the bigger circle, regaining trust and wisdom from Mother Earth and all her animals."

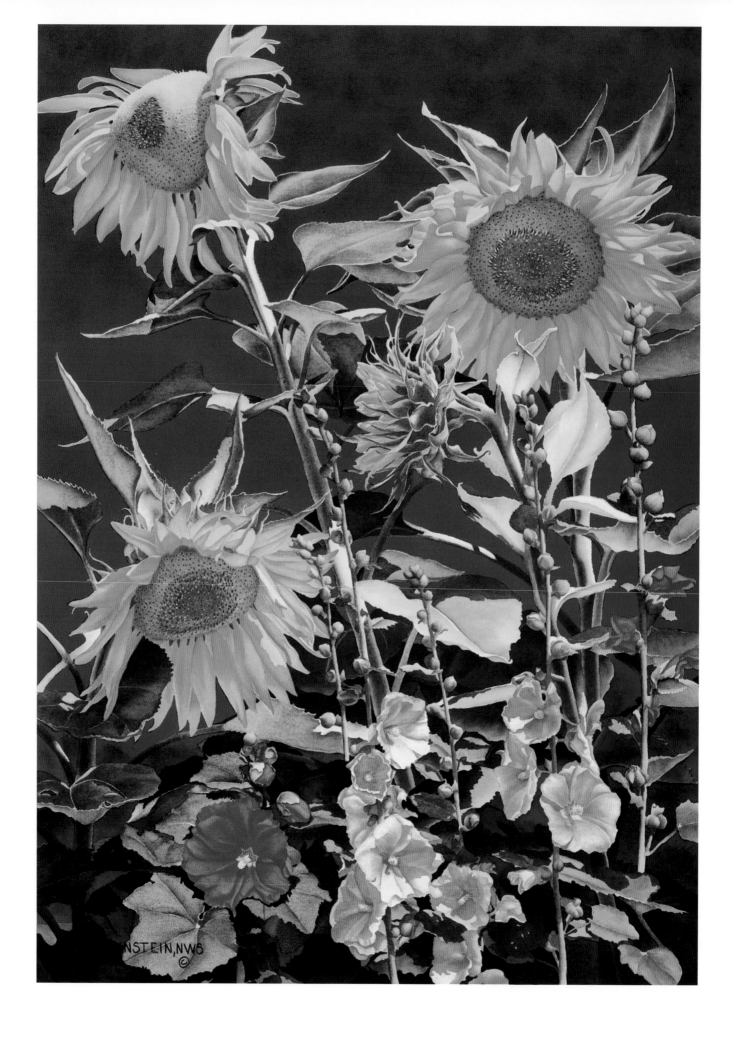

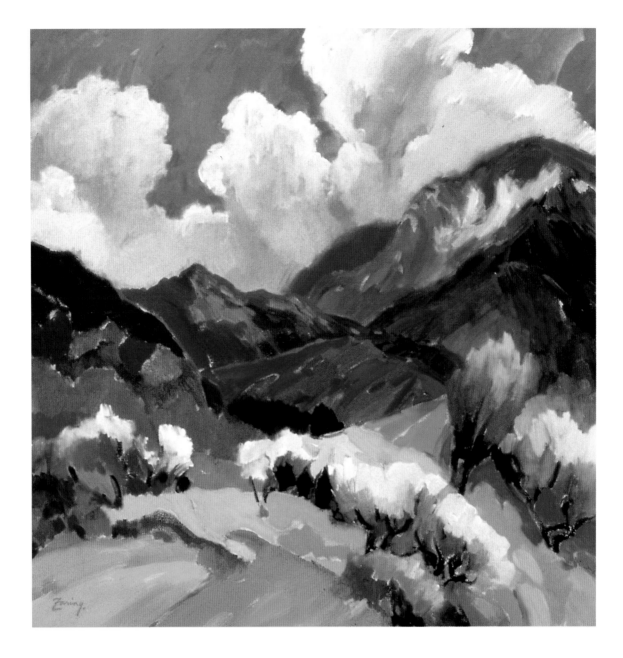

Barbara Zaring

Penumbra
30" × 30" (76 cm × 76 cm)
Oil on linen

Penumbra is a word usually referring to a shadow cast during an eclipse, pointing to the area where shade gradually blends with light. High on El Salto Mountain, north of Taos, Zaring painted this piece on a stormy, sunlit day. Racing the storm, her painting strokes are driven, with only one chance to capture this scene.

Mary Weinstein

Tequilla Sunrise
41" × 29 ¹/₂" (104 cm × 75 cm)
Watercolor and acrylic on Arches 300 lb. rough

On the Canyon Road in Santa Fe, sunflowers and hollyhocks grow wildly at random, inviting bees, hummingbirds, and artists to partake of their beauty. The Plains Indians placed the sunflower seeds on the graves of their dead to provide food for their journey to heaven. The Hurons used its leaves for animal fodder, and its stalks for weaving textiles. The Incas worshipped it as an emblem of the sun. Hollyhocks provided pioneer girls with ready-made materials for homemade fairy dolls, as they journeyed across the country.

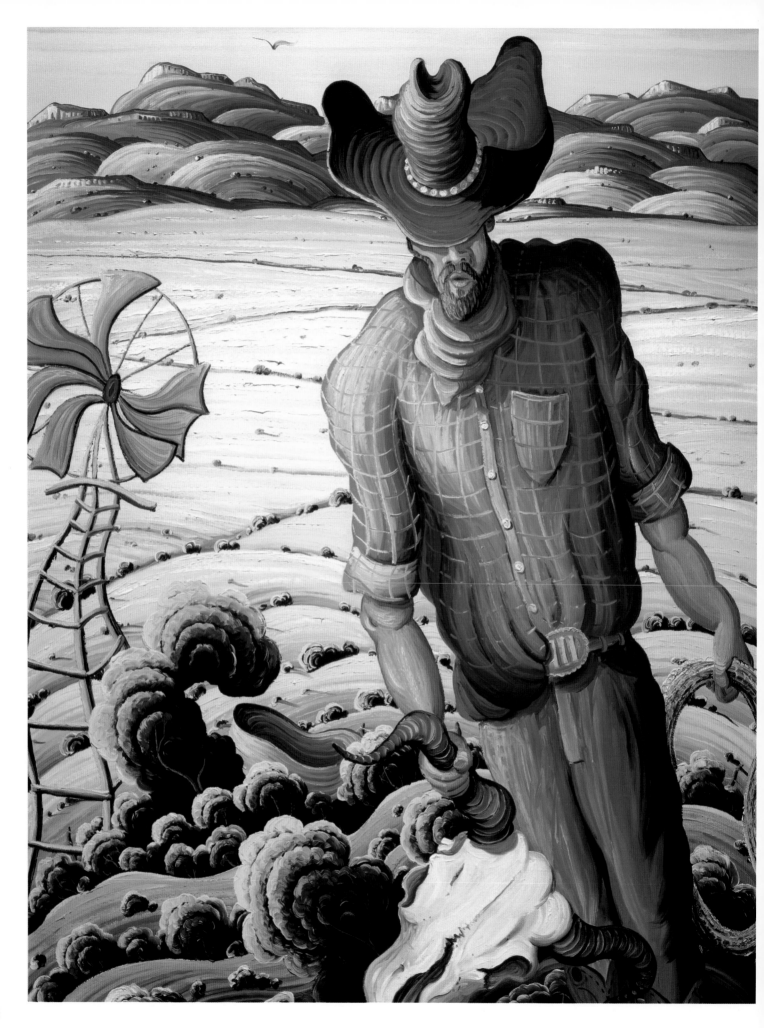

K. Douglas Wiggins

Cain
40" x 30" (102 cm x 76 cm)
Oil on linen

Cain, the first-born of Adam and Eve, was banished to the wilderness "East of Eden," after killing his brother, Abel. Cain led a hard life among the rocks and desert, as does this plain's drifter. Wiggin's grandparents traveled by covered wagon to the barren southwestern landscape near Abiquiu, New Mexico, surviving the harsh reality of a cursed land. In this self-portrait, the cowboy holds two symbolic elements: the rope representing his vanishing livelihood, and the skull, a testimony of the hard land. A broken-down windmill and a vulture overlook the barren landscape.

Geri Medway

Grapevine
30" × 40" (76 cm × 102 cm)
Watercolor on Arches 300 lb. rag paper

The climate of western California is similar to that of Italy. The first carefully protected grapevines were brought by the early pioneers who carried them across the Atlantic Ocean, then across the land by covered wagon. In the vineyards of Temecula, California, Medway took many reference photos, then painted this glowing portrait of America's grapes. Using many glazes, she captures the light and rich color of California's winemaking fruit.

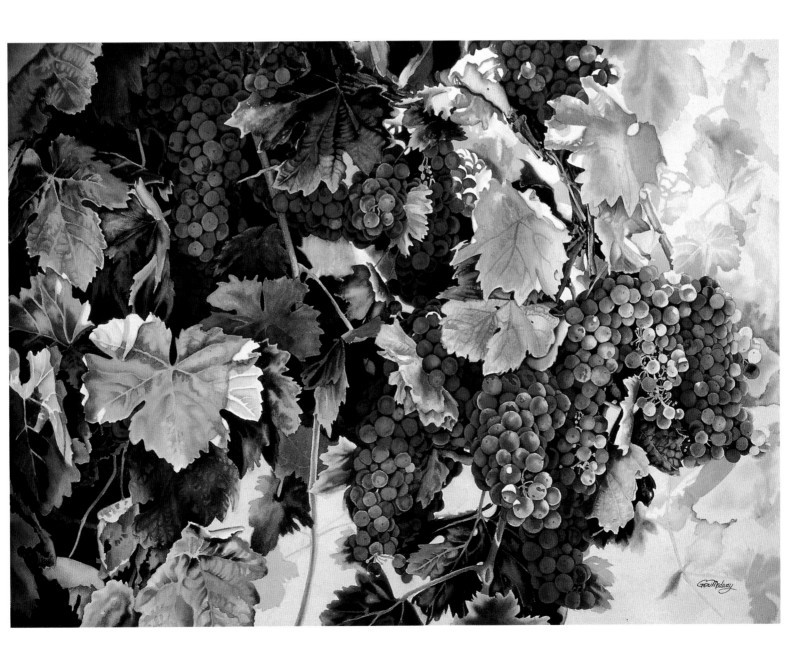

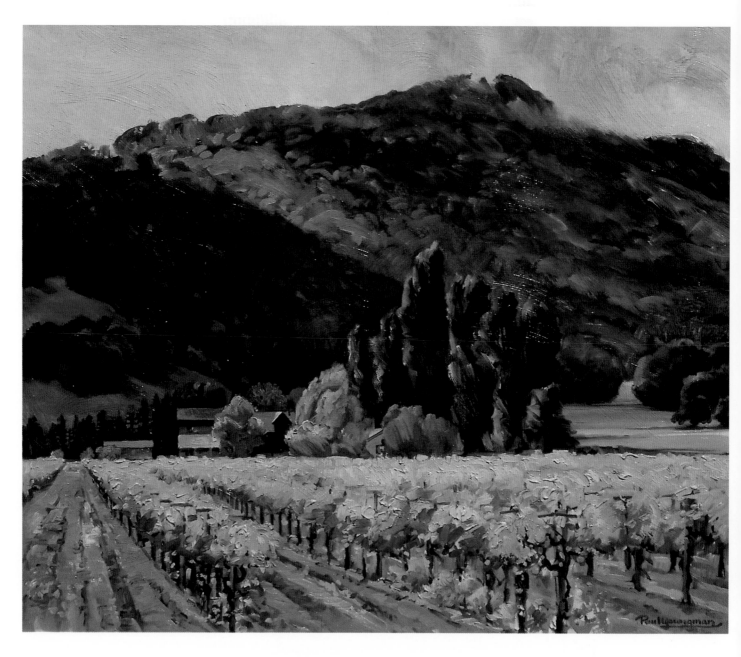

Paul Youngman

Atmosphere of Spring
18" × 24" (46 cm × 61 cm)
Oil on board

On a spring day in Napa Valley near Yountville, California, Youngman was inspired by the afternoon light on the hills and vineyards. He painted the panelled rows of grapevines that led to the owner's house, nestled among the vibrant trees. The yellow-green of the fresh spring plants, laid before the purple-shadowed mountains plays a harmonious song of complementary color contrast.

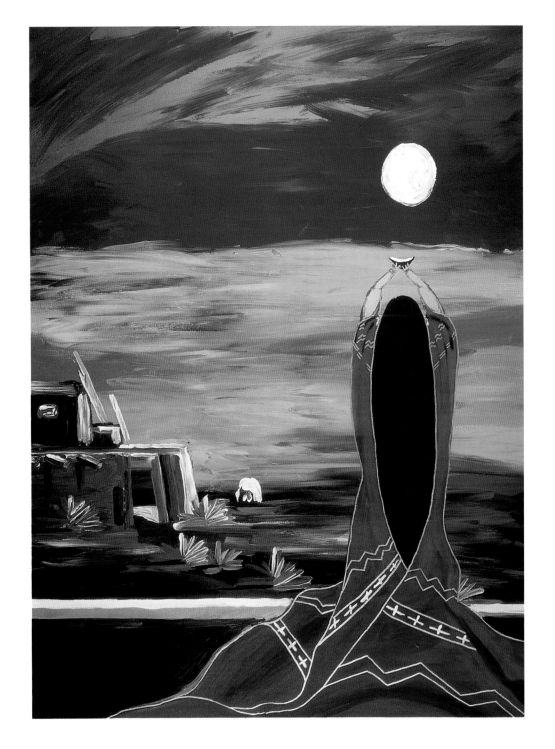

Nicholas Vitale

Offerings
38" × 32" (97 cm × 81 cm)
Acrylic on canvas

Fourth-generation and native New Mexican, Vitale spent his summers on his grandparents' ranch outside the "Old Town" area of Albuquerque. The sights and colors of the Southwest later became the singular focus of his artwork. One sunset evening, on a trip to Taos, Vitale was awestruck by the landscape. This painting symbolizes offerings of gratitude for the sheer beauty of the land, for the foods harvested, and for the replenishment of his spirit.

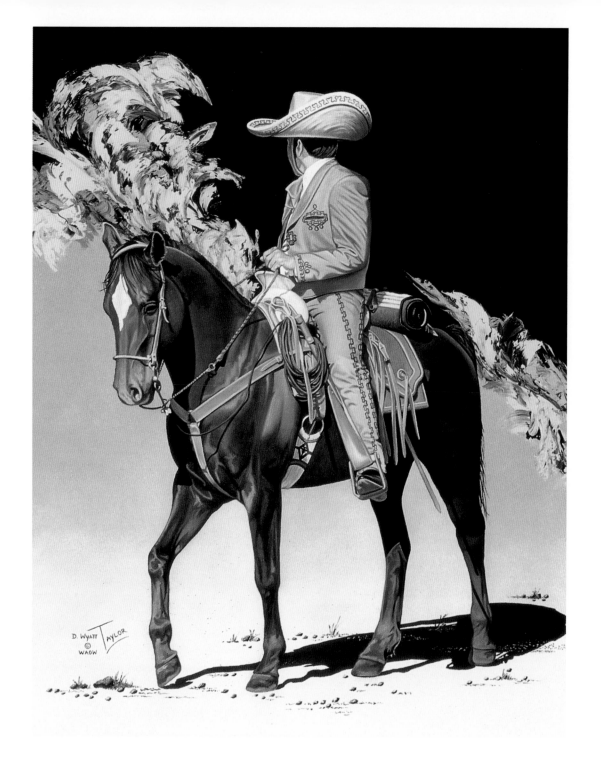

D. Wyatt Taylor

El Cabellero (The Gentleman)
28" × 22" (71 cm × 56 cm)
Oil on canvas

The Hispanic influence in southeastern
Arizona, where Taylor lives, conveys the
commanding pride of the Mexican cowboy,
or vaquero. Using significant detail, from
the embroidery on the gentleman's clothes,
to the intricate design of the horse's sad-
dle, Taylor shows the Mexican heritage of
the Cabellero. Using a palette knife and
heavy paint in the background, she devel-
ops a free-flowing style to focus on the
horse, rider, and elegance of these gentle-
men cowboys.

Ray Vinella

After the Rain
18" × 24" (46 cm × 61 cm)
Oil on canvas

The stormy sky above the sunlit Taos adobes is a true inspiration of exciting color contrast. The darkness approaching the ancient dwelling place of these Pueblo peoples makes a somber symbolic statement about the coming of the white interlopers. Although the storm hovers in awesome power, the warm light still shines on America's original inhabitants.

Jo Sherwood

Cow Creek
16" × 22" (41 cm × 56 cm)
Oil on linen

Wagon wheel tracks scar an old dirt road. A wood barn stands as a resting place for weary travelers. Lush green meadows and fresh blue sky, with billowing clouds suggest a spring day after a storm. When Sherwood came upon this location in Pecos, outside Taos, she did a watercolor study. Returning to her studio she painted in oil, mostly alla prima. Just as the pioneers journeyed on unknown paths, this painting leads the eye past the barn, up the road, to unknown places with new adventures.

Tom Haas

Box Canyon Brand
24" × 36" (61 cm × 91 cm)
Oil on canvas

Branding was brought to North America in the 16th century by the Spanish conqueror, Hernan Cortes. Used as proof of ownership, branding in most cattle states today is required by law, and altering a brand is a criminal offense. These working cowboys, at the 100-year-old Vera Earl Ranch near Sonoita, Arizona are branding a young calf. Haas is committed to quality brushwork, and to creating a sense of place. "I am challenged to create art that is realistic from a distance while allowing the process of painting to show up close."

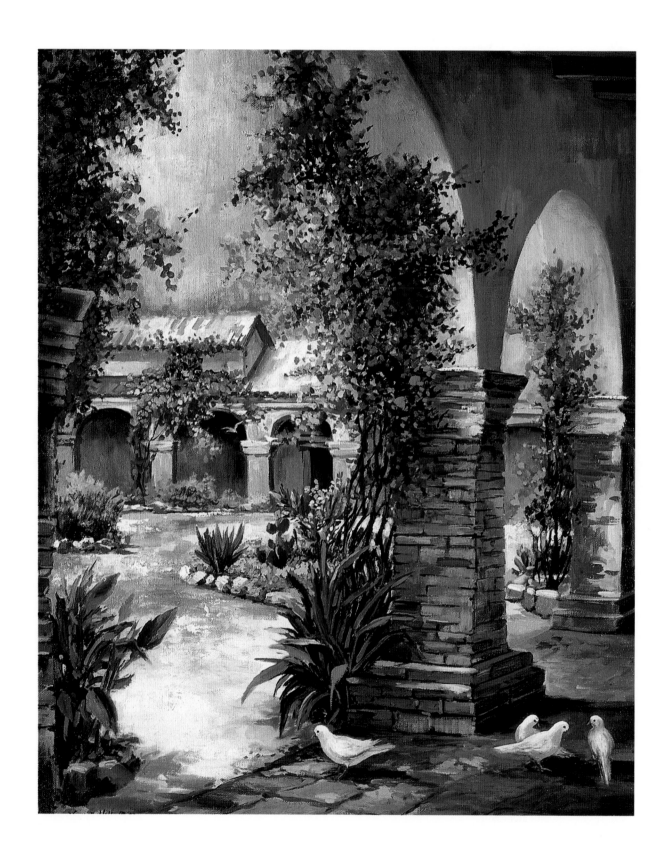

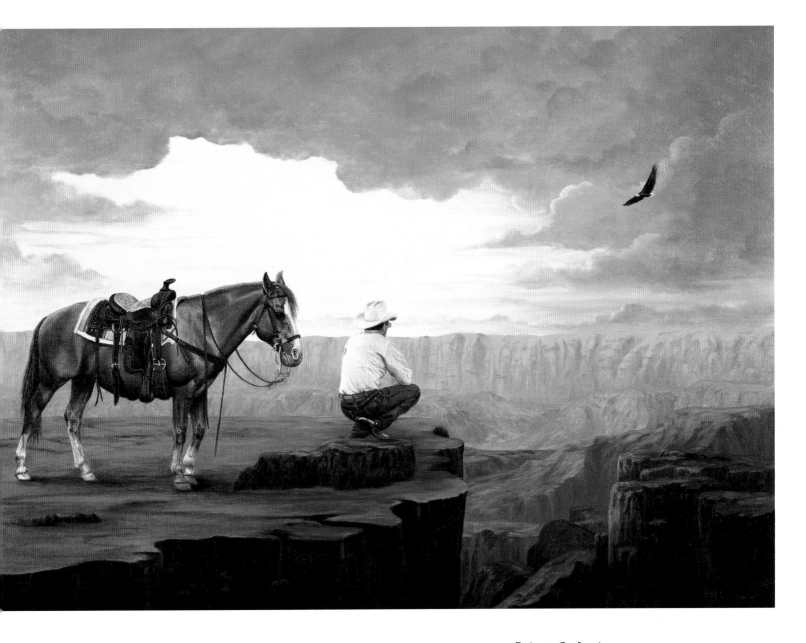

Roberta St. Louis

Canyon View
18" × 24" (46 cm × 61 cm)
Oil on stretched canvas

The stories told by her father of his work in the Grand Canyon inspired St. Louis to paint *Canyon View*. He took care of the mule barns for the tourist trips to the canyon valley. Photos of her brother in Corvallis, Oregon, her father's horse, and the Grand Canyon were integrated in a process of extensive glazing (combination of transparent oils and liquin) to deepen the shadows and enhance the colors. The sunset adds a twilight glow to the beautiful Grand Canyon.

Yvonne Hall

San Juan Capistrano Mission
30" × 24" (76 cm × 61 cm)
Oil on canvas

San Juan Capistrano Mission was founded November 1, 1776, the seventh of twenty-one California missions. Father Serra's church, the oldest in California, is called the Jewel of the Missions. With its beautiful gardens, fountains, and architecture, the mission is renowned for the yearly swallow's return on March 19, St. Joseph's Day. Hall preserves historical landmarks on canvas for future generations.

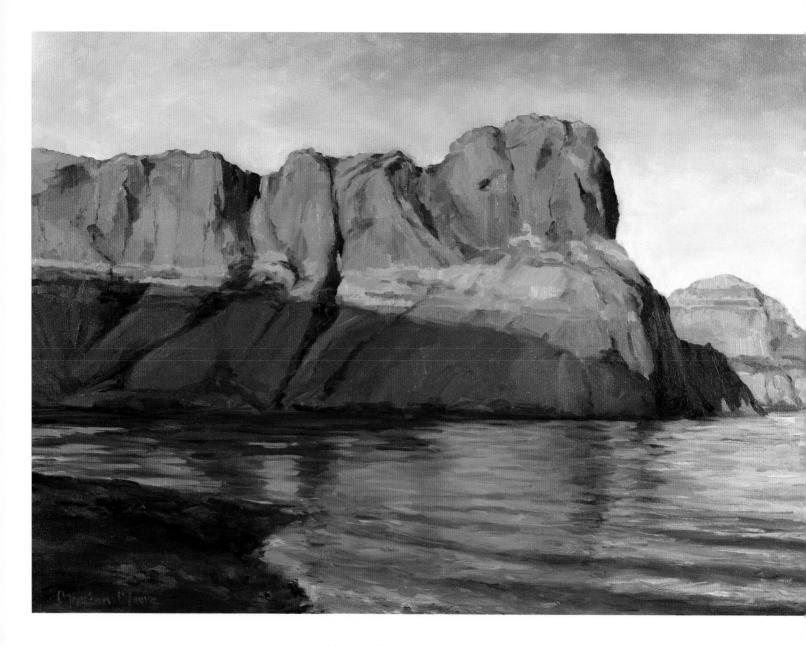

Maureen Moore

Late Day, Lake Powell
18" × 24" (46 cm × 61 cm)
Oil on canvas

Moore and her husband enjoy boating and
camping at Lake Powell. Starkly beautiful,
the primitive rock, water, and sky colors
change dramatically from dawn to dusk.
"Alone with an easel in the beautiful vast
canyon, one must believe in a higher
power." *Late Day, Lake Powell* juried into
the top 100 in the Arts for the Parks
Exhibition in 1995.

Rock Newcomb

Secret Canyon
36" × 24" (91 cm × 61 cm)
Acrylic on clayboard

In the Petrified Forest National Park in northeastern Arizona, a big horn sheep stands before fat sheep petroglyphs on the canyon wall. According to Indian lore, portraying pregnant animals guaranteed a plentiful hunt. The sheep was done entirely in the *sgraffito* process, applying layers of color, then scraping for color and detail. This process was repeated six times to create the sheep. The background and foreground are painted with acrylics.

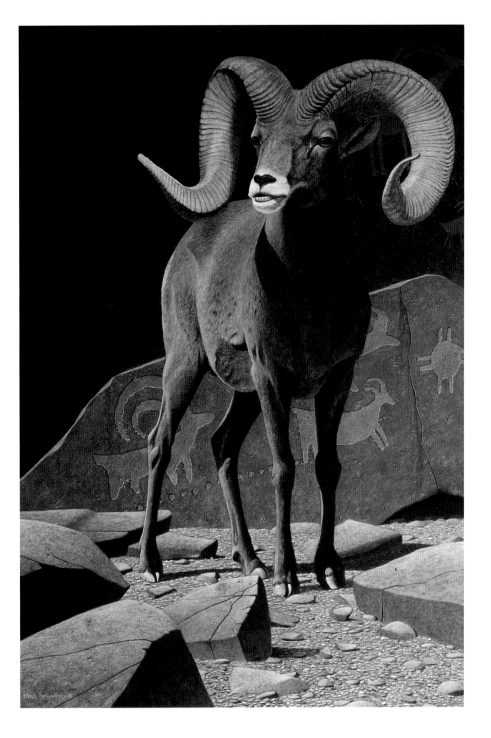

John Farnsworth

Remuda
36" × 48" (91 cm × 122 cm)
Oil on canvas

When the Spaniards brought the horse to America, the life of Native Americans was forever changed. Indian myths named the horse "Sacred Dog." Altering the Plains tribes to a full-time nomadic life, the horse also made buffalo hunting easier, and it brought the Plains Indians to their Golden Age of Great Prosperity, from 1750–1886, which lasted until the last buffalos were killed by white hunters. Farnsworth's love for horses is seen in the larger-than-life *Remuda* (Spanish word for a relay of horses). It was painted by mixing only primary colors: red, yellow, and blue.

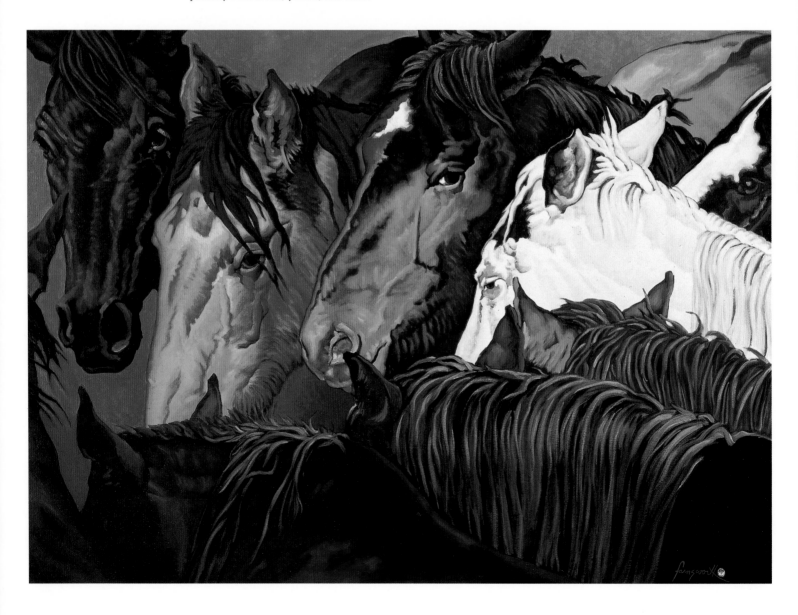

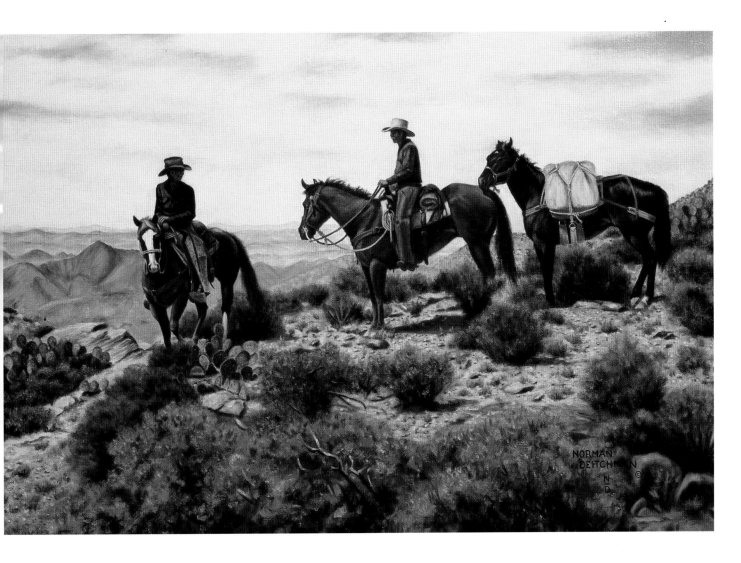

Norman Deitchman

A Chance Meeting
24" × 36" (61 cm × 91cm)
Oil on linen canvas

Deitchman knows his subject matter first hand. He lives in cattle country and rides the trail, including the Desert Caballeros Ride out of Wickenburg, Arizona. "While out riding alone, I occasionally meet someone on the trail, and there is always time to stop, say hello, and exchange tales or information—unlike the people in the big city, always in a hurry and never any time for a friendly 'Hi,' even to neighbors."

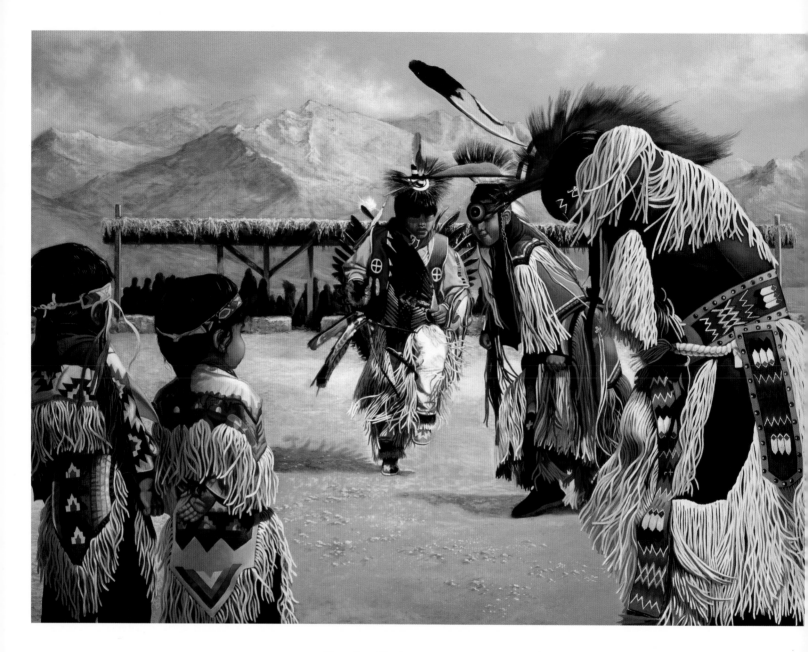

Dana Lea Hindson

Pow Wow
30" × 40" (76 cm × 102 cm)
Oil on canvas

At a powwow, these Native American children learn the tradition of their elders. The Powwow Indian Prayer Ceremony is revered as an important spiritual ritual. As a child in Chattanooga, Tennessee, Hindson often heard stories about her Indian ancestors, told by her full-blooded Cherokee grandfather, who walked the tragic Trail of Tears. In 1838, after Andrew Jackson ordered the removal of 60,000 Cherokees, Chickasaw, Choctaw, Creek, and Seminole, they left their treasured southeastern woodlands, trudging as far as 800 miles to the barren Oklahoma plains. One-fourth died on the journey. Of the Cherokees, 14,000 survived and prospered in their new homeland. Hindson's journey in art is guided by the desire to preserve her heritage.

Arillyn Moran-Lawrence

Lead the Way

30" × 14" (76 cm × 36 cm)

Watercolor with pen, ink, pencil on Strathmore 500 museum board

After riding across a Southwest rancho in the early 1900s, the young woman greets her two faithful border collies who lead the way to meet her father. Moran-Lawrence uses pen and ink first to develop line and unique patterns. She uses dots, varying lines, cross-hatching, and any linear form of line to get the look she wants. Color is added after the ink process. She uses Dr. Ph. Martin's and Rotring inks and watercolor, and Aquarelle watercolor pencils.

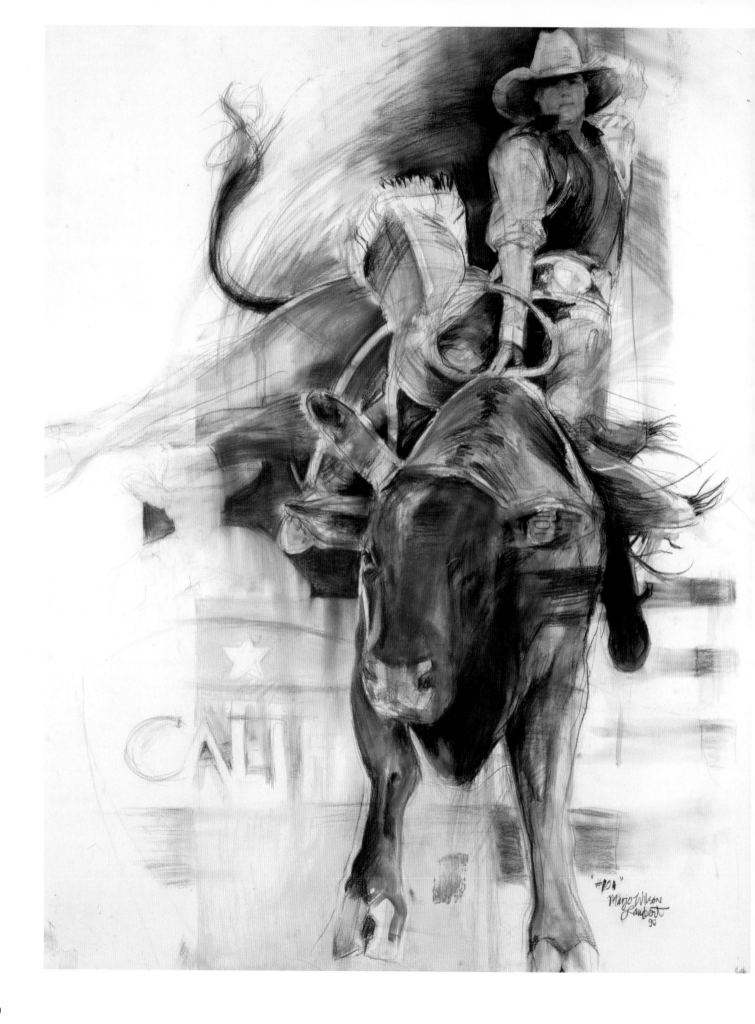

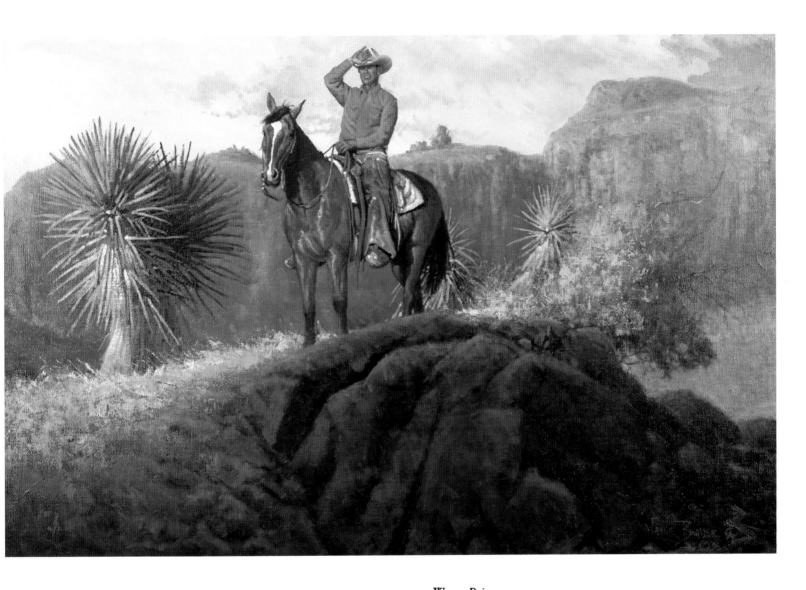

Wayne Baize

Short Days, Long Hours
20" × 30" (51 cm × 76 cm)
Oil on canvas

A cowboy's work is never finished. Scouting the range for lost cattle, mending broken fences, and keeping an eye out for predators and horse thieves, he puts in long hours on the range. He's not on a time clock during the blistering hot summer days and blinding blizzards of winter. Even daylight may come and go, but his time in the saddle is not over.

Marjo Wilson Lambert

Rodeo Bull #101
40" × 32" (102 cm × 81 cm)
Pastel and charcoal mix on Arches 100% ragboard, 4 ply

Born and raised on a cattle ranch in Covelo, California, Lambert documents what's left of the ranch and rodeo life of the Old West. She portrays "ol'one-horn" in a bull riding competition at the Red Bluff Rodeo in California. The ear tag of this prize bull, owned by a local Covelo rancher and old family friend, reads #101.

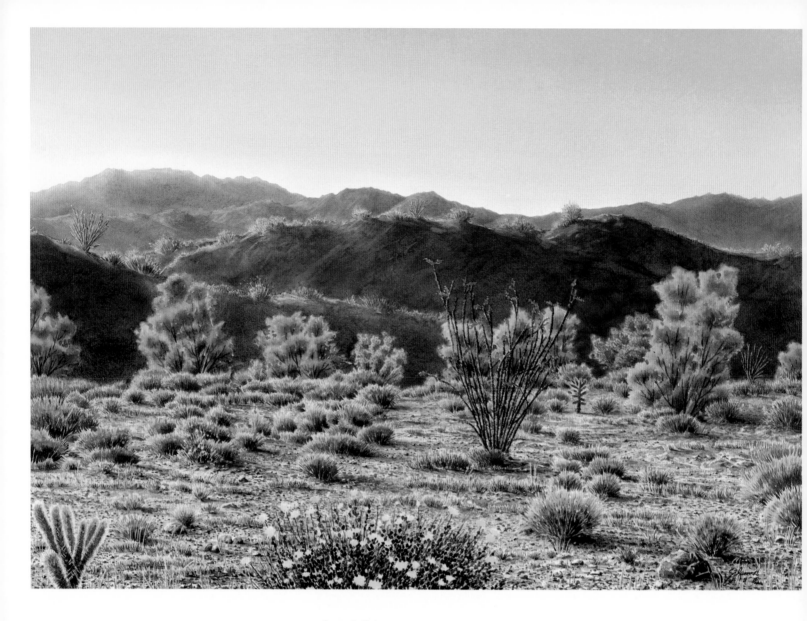

Joseph Salamon

Desert Dawn
19.75" × 28" (50 cm × 71 cm)
Watercolor on Arches 240 lb. cold press

During an extended camping stay in
the Southern California desert, Salamon
rose at dawn each morning to see the
sunlight sweep across the desert. In this
remote box canyon, fifteen miles from
Mecca, the early-morning window of time
inspired Salamon to paint Desert Dawn.
The purple-shadowed hills vibrate in
complementary color harmony against the
yellow-green of the foreground vegetation.
The cacti are teddy bear cholla (lower
left), brittlebush (yellow flowers), and
ocotillo (spiny-armed with red flowers).
Gray-green smoke trees dot the back-
ground.

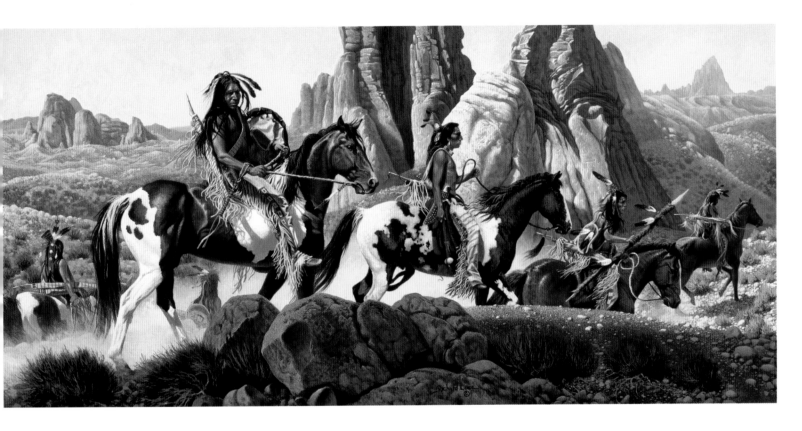

Richard Luce

Comanche War Party
16" × 34" (41 cm × 86 cm)
Oil linen

This Comanche war party rides through the desert to steal horses in Mexico. The Comanches were the most skillful horsemen of the southern Great Plains, extending their forays as far as Mexico. Their pinto ponies were originally acquired by raiding the Spanish. The braves appeased the war spirits by splintering arrows against a ledge. Many Comanche spiritual beliefs centered around forecasting the weather by examining spider webs and listening to the calls of prairie cranes. They finally made peace in 1875, and today 4,000 of the once 30,000 live on private landholdings in Oklahoma.

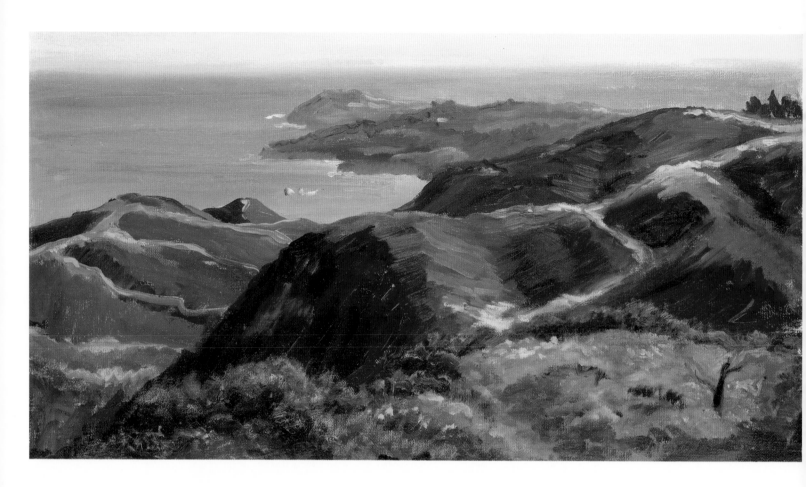

Gwen Meyer-Pentecost

Corral Canyon Overlook
12" × 22" (30 cm × 56 cm)
Oil on canvas

The dream of many pioneers was to reach the farthest point west, the Pacific Ocean. To arrive at this place in the springtime, after the long desert journey scaling the Rockies and the Sierras, must have been breathtaking for the early travelers, as it is today for Meyer-Pentecost. One of her favorite painting spots is the overlook on Corral Canyon, toward Malibu's Point Dune. The wild mustard blooming on the fire road adds a distinctly linear highlight to the vibrant green hills.

Grace Schlesier

Impending Danger
24" × 18" (61 cm × 46 cm)

Oil on cotton canvas

On a spring day near Scottsdale, Arizona, while Schlesier drove through the desert, ominous clouds filled the sky. She parked her car along the road and walked up the wash to do a quick study. The billowing clouds played with the sun, and the landscape was patchworked with light and shadow. As the wind whipped around her and big drops fell, she remembered that a desert wash is often dangerous during a sudden downpour. So she took pictures and painted later, away from the wind and rain. Hence the title, *Impending Danger*.

Joseph Breza

After the Summer Rain
30" × 36" (76 cm × 91 cm)
Oil on canvas

Of Czech descent, Breza approaches life
in a straightforward way, throwing the
details onto the canvas in an impressionis-
tic style. Living in a small New Mexico
village, he walks to "collect impressions
and absorb the 'soul of light.'" Breza
works in the impasto style, using intuitive
mixtures of color, light, and texture. His
brush strokes reveal varied color mixtures
and assorted lines: thick and flat, squig-
gles, quick flashes, and smooth sweeps.
"....The free use of color conveys an emo-
tional response,...shows the quality of light
here [in New Mexico], which is like no
other place."

Paul Youngman

Grand Canyon, Opus I
24" × 36" (61 cm × 91 cm)
Oil on canvas

The Grand Canyon was first discovered by the Spanish explorer, Coronado, in 1540. It wasn't until 1869 that John Wesley Powell, a geologist accompanied by ten companions, made the first passage down the 217-mile Colorado River, inside the two-million-year-old canyon. On a beautiful October evening, at the El Tovar Hotel, Paul Youngman painted several studies of the majestic Grand Canyon. In his studio, he later painted from his studies and reference photos, in oil. Opus refers to a creative work, especially a musical composition. Youngman was inspired by the magnificent canyon, that sang to his creative soul.

N O R T H W E S T

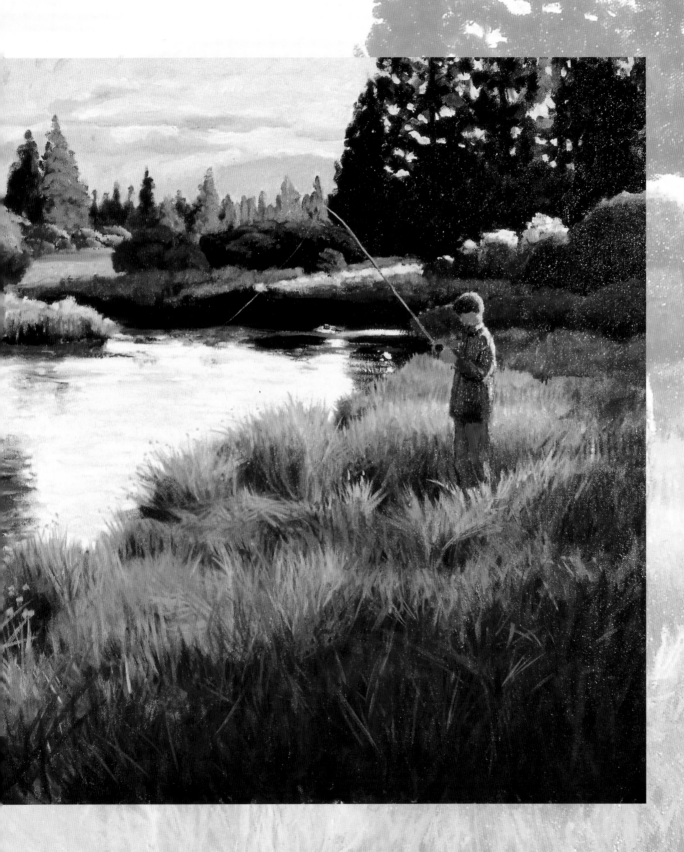

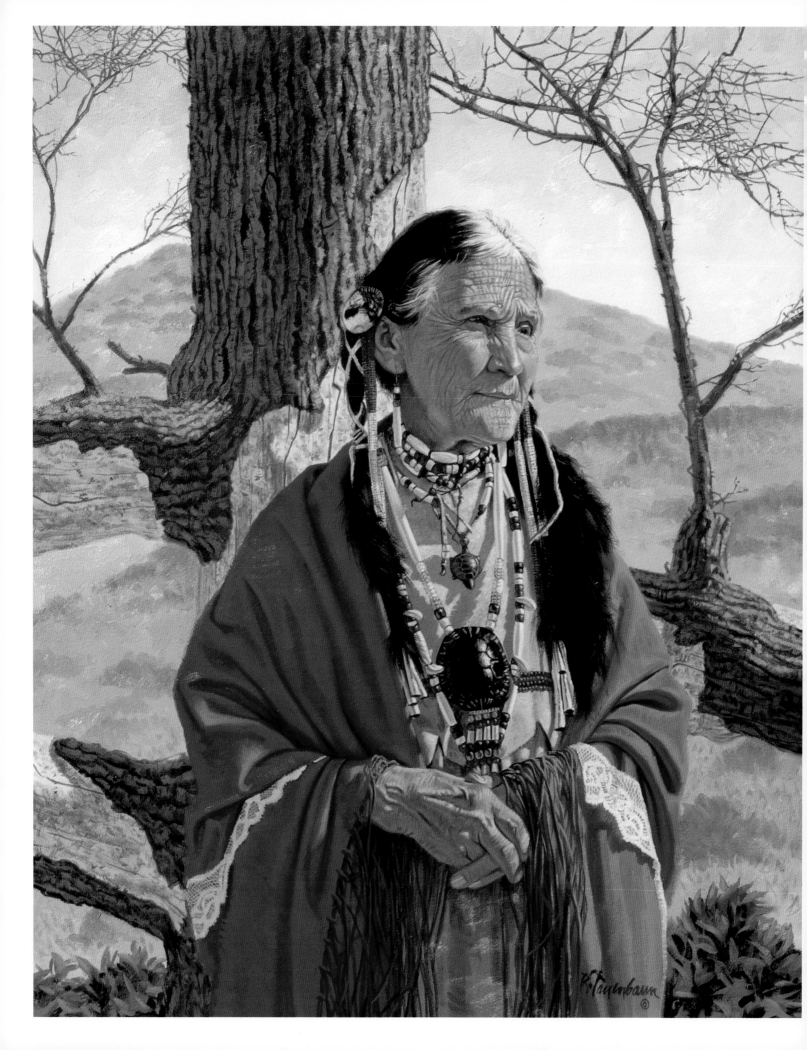

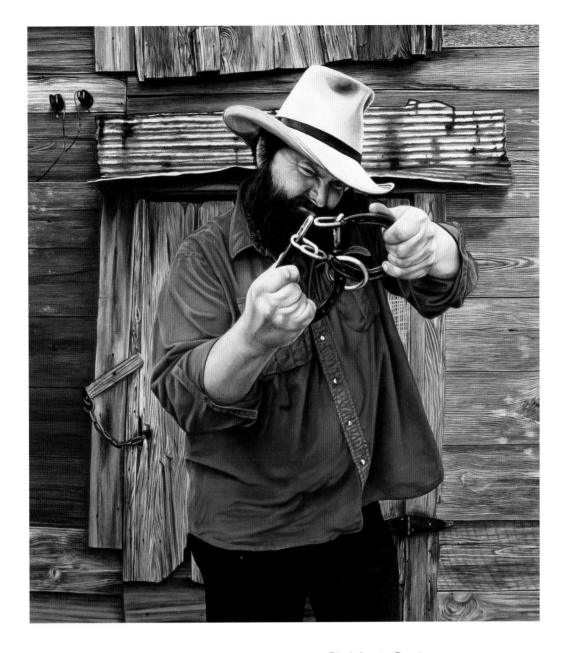

Clark Louis Gussin

Puzzled
26" × 32" (66 cm × 81 cm)
Oil on linen

Clark's early years on his family's tobacco farm in North Carolina led him to appreciate history. While listening to stories of his ancestors, he sanded and oiled his great-great-grandfather's Civil War musket. Today he competes at Rendezvous gatherings where the modern mountain man fires flint and steel in Black Powder Shooting competitions, and throws the knife and tomahawk on Trail Walks. Greatly influenced by the Dutch painter, Jan Steen, Gussin puts a sense of humor in his western paintings. *Puzzled* is a statement about life. The strong blacksmith with huge hands struggles to unwind the simple horseshoe puzzle.

Robert Tanenbaum

Two Winters
36" × 30" (91 cm × 76 cm)
Oil on hardboard

Grandma Willie, an Oneida woman from Montana, is portrayed with dignity and pride in her heritage. The title, *Two Winters*, draws a parallel between her aging beauty and the barren trees, still beautiful though stripped of their leaves.

Bonnie Conrad

Cowboy Heaven
20" × 30" (51 cm × 76 cm)
Oil on canvas

The loop-swinging rider has universal appeal to everyone. Mounted on a stout horse in a sea of tall, waving grass he represents the swashbuckling freedom of cowboy living. West of Parkman, Wyoming, where the south fork of Twin Creek springs from the bosom of the Big Horn Mountains, the cowboy springs from the lush grass ranges. "I salute persons who have the guts to follow their dreams. 'Make ye no little plans for they have not the power to inspire the souls of men.' I hope this quote and my painting will inspire the souls of many."

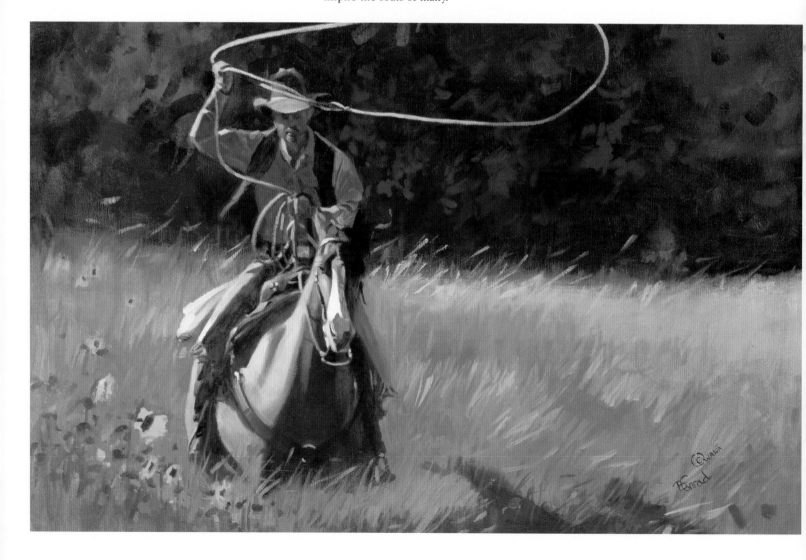

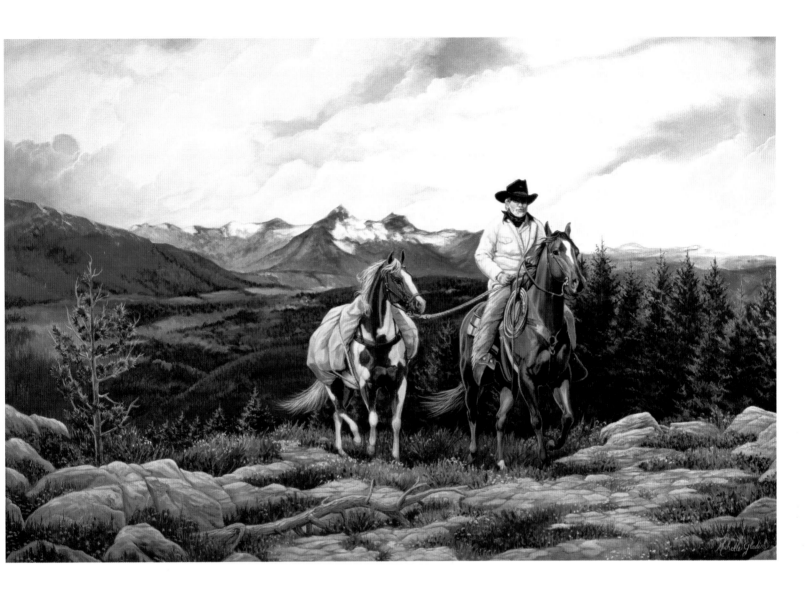

Michelle Gladish

High Country Rider
24" × 36" (61 cm × 91 cm)
Oil on stretched canvas

On the Bear Tooth highway, northeast of Yellowstone National Park, an overview at 11,000 feet inspired Gladish. "The lush blues and greens nearly took my breath away. I stood at that spot, feeling the wind in my hair and sun on my face. I felt like an early pioneer looking at the valley of her dreams." Gladish portrayed a horse and rider bringing supplies to the high country. She wants the viewer to wonder what is beyond in the sprinkling light and shadow. "Each piece of art is a challenge to go deeper into the creative process."

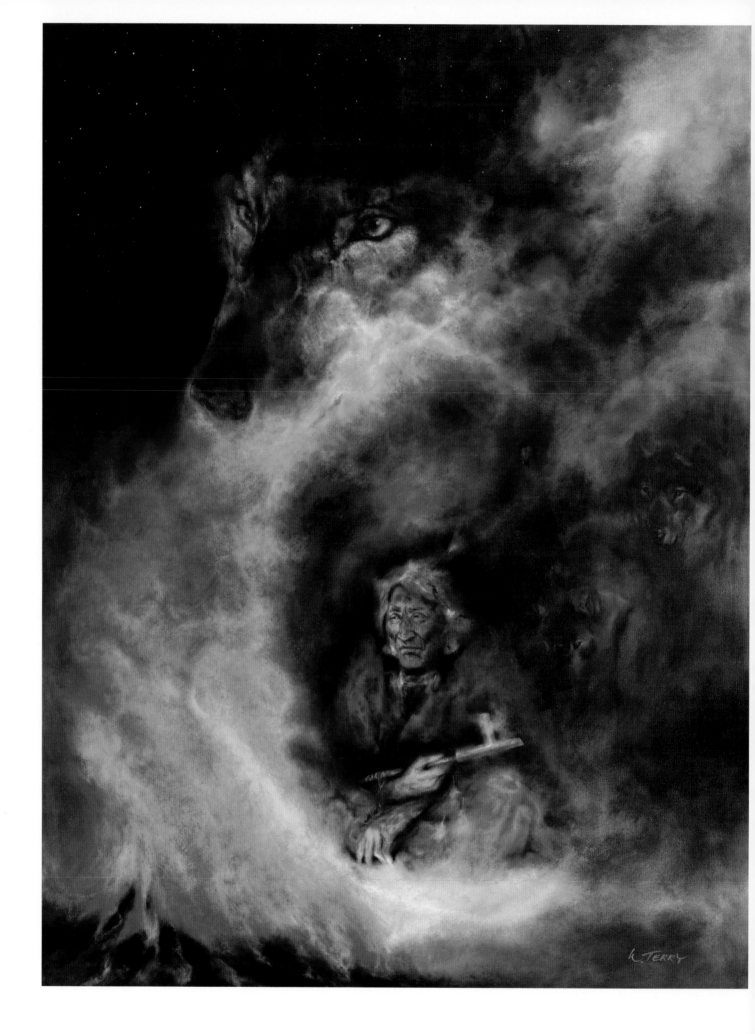

Wayne Terry

When Brothers Speak
48" × 36" (122 cm × 91 cm)
Oil on stretched canvas

Native Americans believe all things have life and spirit. Blessings emanate from the spirits. The spiritual power dwells everywhere, in animal, plant, stone, and water. Apparent in their story telling, this belief brings clarity and vision to their life. On their vision quest, young Natives seek the animal spirit that will become their supernatural helper and guide their life. The wolf spirit is considered potent both in war and curing illness, and guides from a source of wisdom and knowledge.

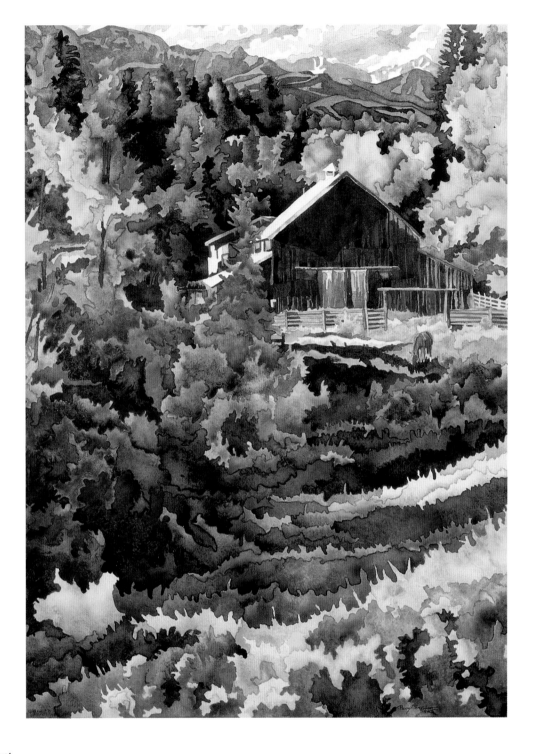

Penny Stewart

San Juan Serenity
30" × 22" (76 cm × 56 cm)
Watercolor on Arches 300 lb. hot press

San Juan Serenity is an early morning view of a secluded, weathered barn in the Colorado San Juans between Ridgway and Telluride. Stewart paints the colors and shadow patterns early each morning in late September, when the aspen glow with glittering gold.

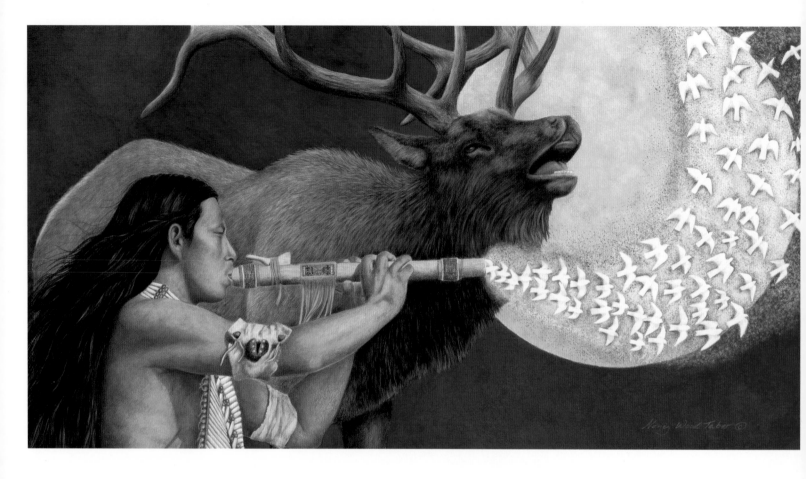

Nancy Wood Taber

Elk Moon Dreamer
15" × 28" (38 cm × 71 cm)
Colored pencil on Crescent rag matboard

Taber was inspired by the Native American custom of courting. The young man courts his romantic prospect with melodies played on his love flute. The bull elk also bugles his love message to the females. Both man and animal represent symbolic romance and love. Together, they share a common urge to sing and dream of a union with their chosen one, filling the air with iridescent birds, symbols of their intent. Taber layers colors of detailed pencil strokes to achieve the rich dimension in her drawings.

Wanda Coffey

Cowboy Coffee
24" × 36" (61 cm × 91 cm)
Oil on canvas

Forty miles from the La Plata Mountains, in the Rocky Mountains of Colorado, Coffey rides on a cattle drive beside the Animas River in below-zero temperatures. When they stop for lunch in front of a warm fire, she photographs and sketches the scene. Later, she draws on a gray-toned canvas. She works from top to bottom using Grumbacher and Windsor-Newton oils, and liquin for the medium.

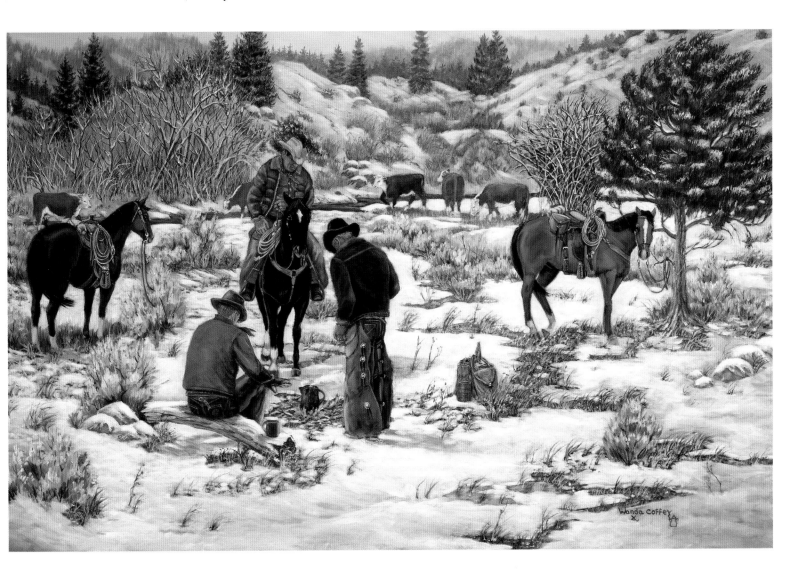

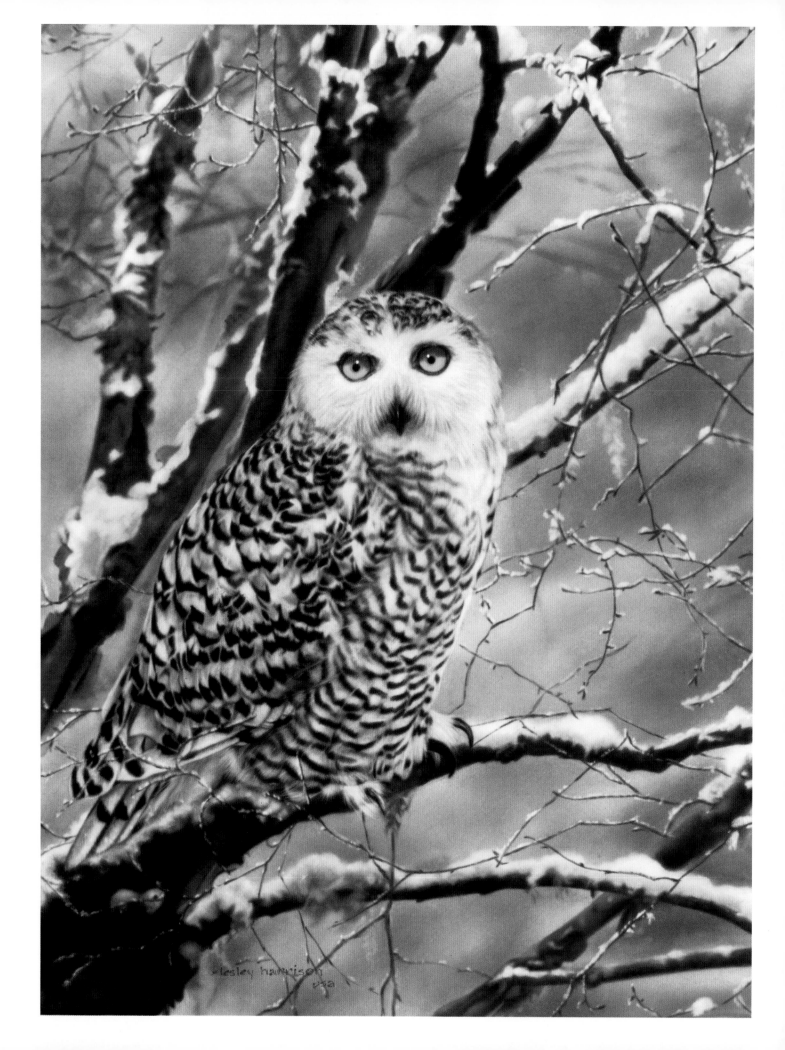

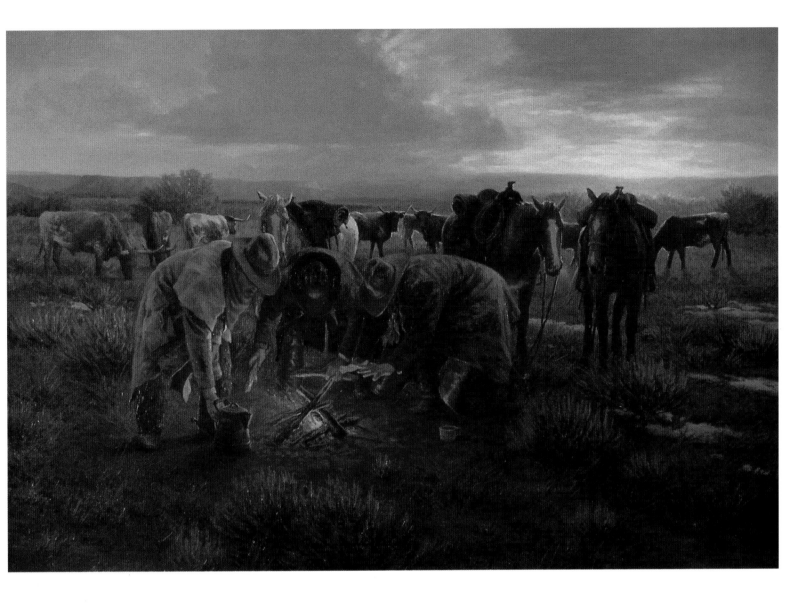

Karin Hollebeke

Breaking the Morning Chill
20" × 30" (51 cm × 76 cm)
Oil on canvas

Cowboying is an all-weather occupation. Before first light, cowboys hit the trail until the first gray light breaks the night's darkness. Frost disappears as the soft morning sun warms a new day, but the crispness and sting of cold still remain. German-born Hollebeke loves the freedom of the west. "Cowboys are a special breed in a special place. How wonderful to spend the rest of my life immersed in beauty creating scenes of the historic west!"

Lesley Harrison

Eyes of the Spirit
24" × 18" (61 cm × 46 cm)
Pastel on vellum paper

Harrison spotted this snow owl at Northwest Trek near Tacoma, Washington. "I love all the birds of prey...such dignity! Snow owls are so stunning with their yellow eyes and white feathers." Owl feathers are sacred to some Indian tribes. Harrison works in pastel to create realistic images. The name *pastel* comes from the French word "pastiche." The pure, powdered pigment is ground into a paste by adding gum binder, then rolled into sticks and allowed to dry. Pastel does not fade or oxidize with the passage of time.

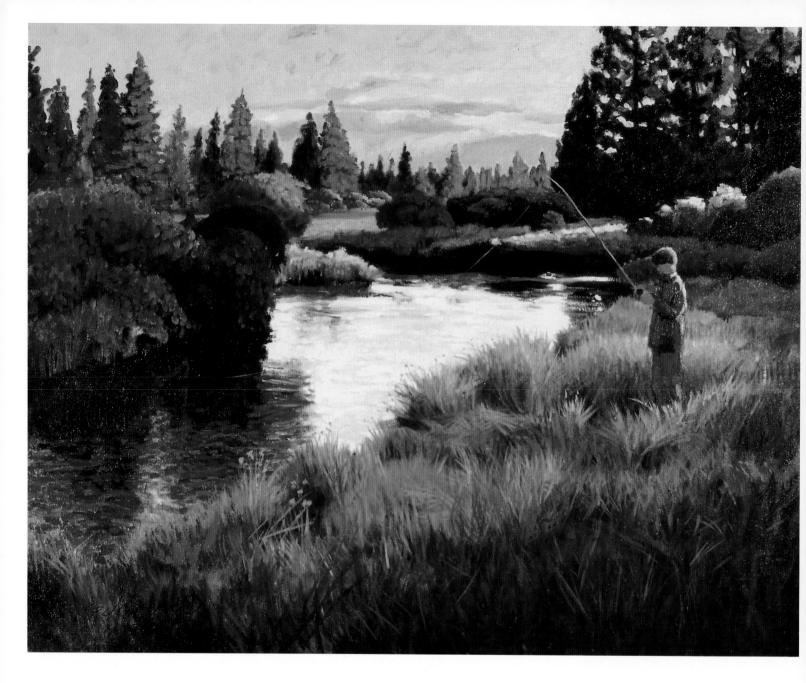

Reverend Robert L. Schwenck

Fishing the Little Deschutes
24" × 30" (61 cm × 76 cm)
Oil on canvas

Reverend Robert L. Schwenck, a UCLA Fine Arts graduate, entered Princeton Seminary to pursue a career as a Presbyterian pastor. His paintings are expressions of his faith in the Creator, present in all of nature. "The artist's responsibility is to illuminate spirituality. From snow-capped mountains, the river rushes through lava tunnels to create fruitfulness for the valley floor. As summer sunlight splashes across Dorance Meadows in a display of God's glory, the quiet waters of the Little Deschutes, Oregon, beckons the fisherman's soul to God." Reverend Schwenck paints in a modified impressionist style, using side-by-side strokes of color that vibrate energy, creating harmonious paintings.

Janet H. Bedford

King of the Pond
36" × 48" (91 cm × 122 cm)
Oil (alkyd) on Masonite panel

A bull moose is a formidable animal with a cantankerous disposition. Some people would rather encounter a grizzly bear than a startled bull moose. So, if he's in a pond, he reigns as king. Bedford shows the largest of the deer family as the solitary and quiet ruler of a tranquil pool, a common sight in the mountains of the northwest. "Too often, a trophy on a wall is all one sees. They have a face only another moose could love, but how beautiful they are alive!"

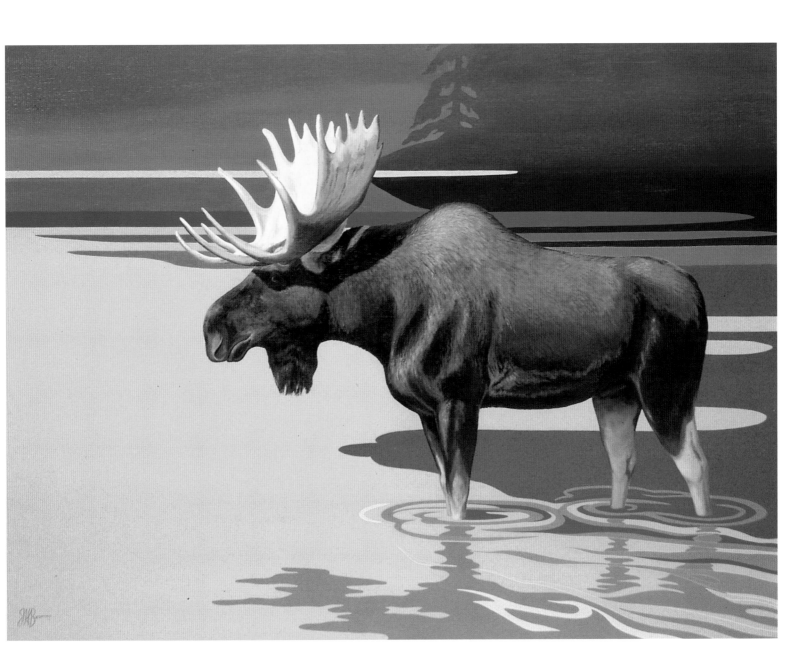

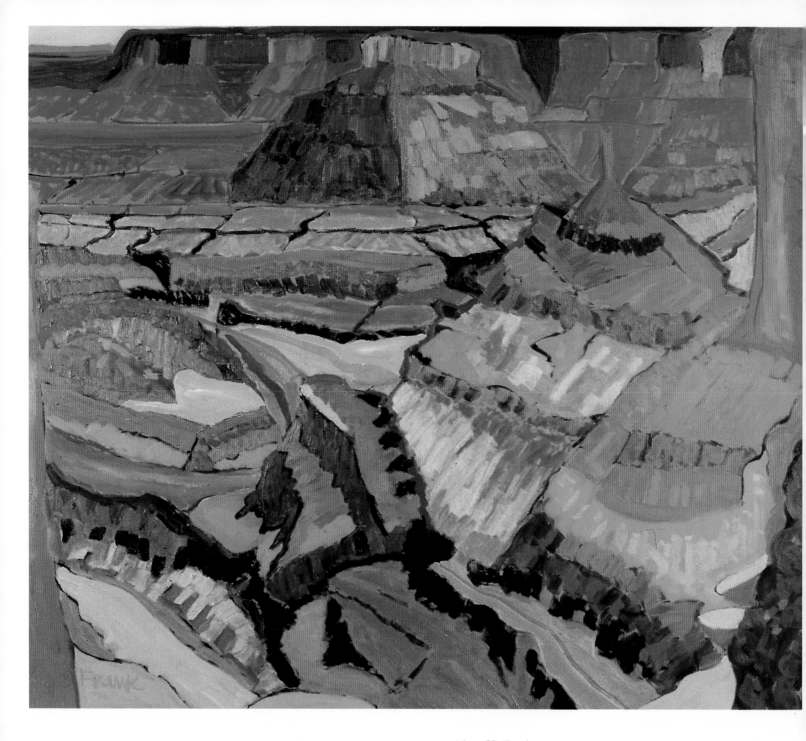

Alyce K. Frank

Dead Horse Point
40" × 48" (102 cm × 122 cm)
Oil on canvas

A band of wild mustangs, herded into a natural corral formed by the rock formations, were inadvertently forgotten. The horses died of thirst—thus the name Dead Horse Point. Located in Canyonlands, Utah this panorama overlooks the Colorado River that carved the pinnacles and cliffs of these canyons. Irony played again when Thelma and Louise drove their car off this point in the final scene of the movie, *Thelma and Louise*.

Lorna Dillon

Western Pleasure
30" × 36" (76 cm × 91 cm)
Oil on linen

Painting on location in the Sierra Nevada foothills, Dillon carefully portrays early California vaqueros. She pays detailed attention to the horse's bridling and rider's equipment. "These horses are like poetry in motion. The beautiful synchronization, teamwork, and partnership between horse and rider result in a fine-tuned relationship." Proper use of the hackamore, bosal, loose-cheek half-breed bits, as well as proper reins are just the exterior part, derived from early horsemen. The time-tested training methods are the badge of the ranchers' dedication to his work and environment.

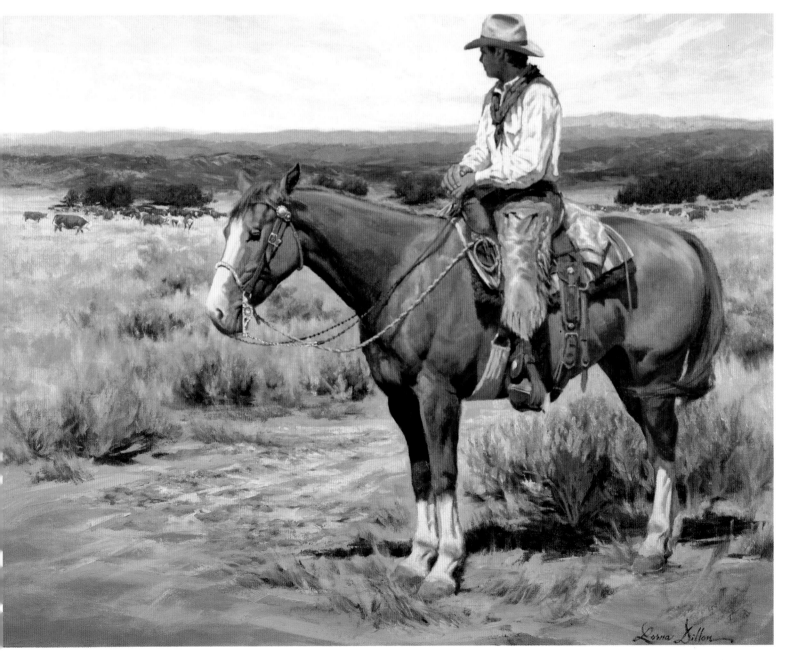

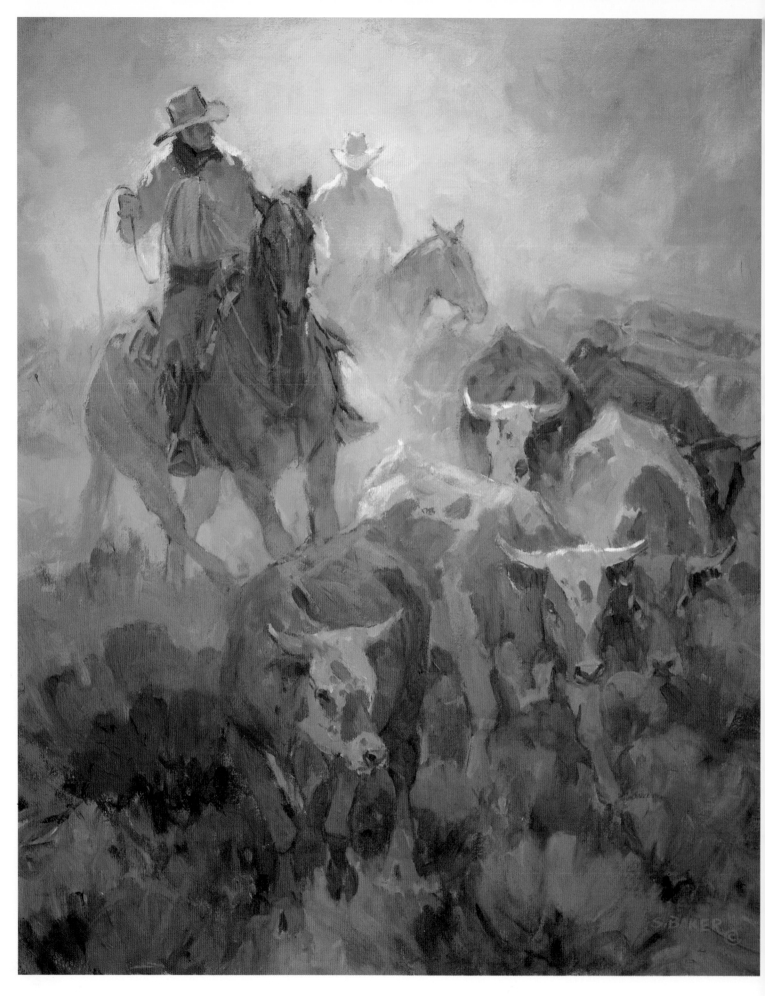

Suzanne Baker

Evening Dust, #3
32" × 26" (81 cm × 66 cm)
Acrylic on canvas

Growing up outside Sequoia National Park, Baker was influenced by ranchers, mountain enthusiasts, and especially her artist mother. Living in the ranch country of the Sierra Nevadas, Baker and her husband also worked as cowboys and trained young stock horses. When moving cows in the evening, the dust whips around these bucharoos that drive the cattle to the corrals. The dust haze blends with the rose of sunset and captures the driving cowboys and their cattle in an ethereal light.

Betty Billups

Heading Home
22" × 28" (56 cm × 71 cm)
Oil on linen

These Crow women of the northern plains head home from an inter-tribal powwow in southeastern Montana. The Crow, who call themselves Absoraka (bird people), adopted the buffalo-dependent Great Plains culture and lived in tepees, practiced sun dances, and grew tobacco for their religious ceremonies. Famous as warriors and as scouts for the U.S. Army, they were moved to a Montana reservation in 1868. The women's "parade dress" dates from the late-reservation to the present. Crow women excel in hair decoration, beading, and especially quilling. Billups's primary focus is on the intimacy between the riders.

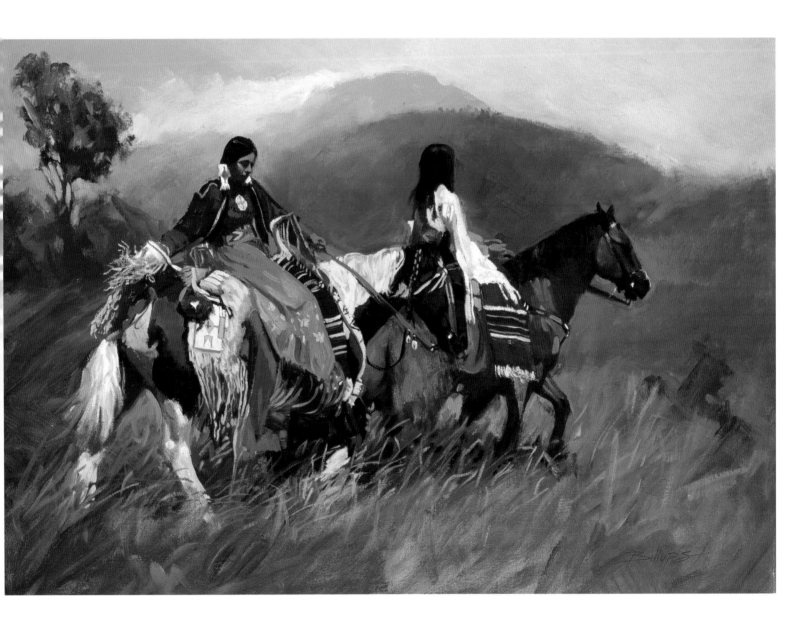

Kip Decker

Moving to Winter Pasture
30" × 40" (76 cm × 102 cm)
Acrylic on stretched canvas

Every late August to early September, cowboys drive the cattle herds from the lush mountain pastures to the warmer river valleys. A snowstorm has already blanketed the Rockies and the nights are below freezing. Decker's objective in this painting is to relate the foreground sage to the middleground cattle, riders, and golden aspen trees, allowing some contrast with the background snow-capped mountain range.

Sarah Woods

September Serenity
22" × 30" (56 cm × 76 cm)
Acrylic on composition board

A crisp fall afternoon in the Rockies illuminates the oldest German homestead in southern Colorado. When they saw this valley 130 years ago, they were awestruck by it's beauty and built it into a ranching community. Woods lives in this unspoiled county, without a stop light, where cattle outnumber the people, and deer, elk, and antelope abound. "I am so lucky to live in an unspoiled area that truly exemplifies the west. It is my daily inspiration."

Karen Noles

Tepee Tender
24" × 28" (61 cm × 71 cm)
Oil on linen canvas

Living on the Flathead Indian Reservation for twenty years, 100 miles from the Blackfoot Reservation, near Glacier National Park gives Noles her inspiration for Native American art. When a friend told Noles she was caring for several fox kits, she chose a favorite three-year-old child (a full-blooded Salish, Kootenai, and Blackfoot) as her model. The girl, dressed in a Blackfoot beaded-buckskin dress, related naturally to one of the captive-born kits. With a parfleche nearby, the other kits were nestled on a Hudson Bay blanket. The Blackfoot-designed tepee liner, beaded backrest, and the fur hide created an authentic background.

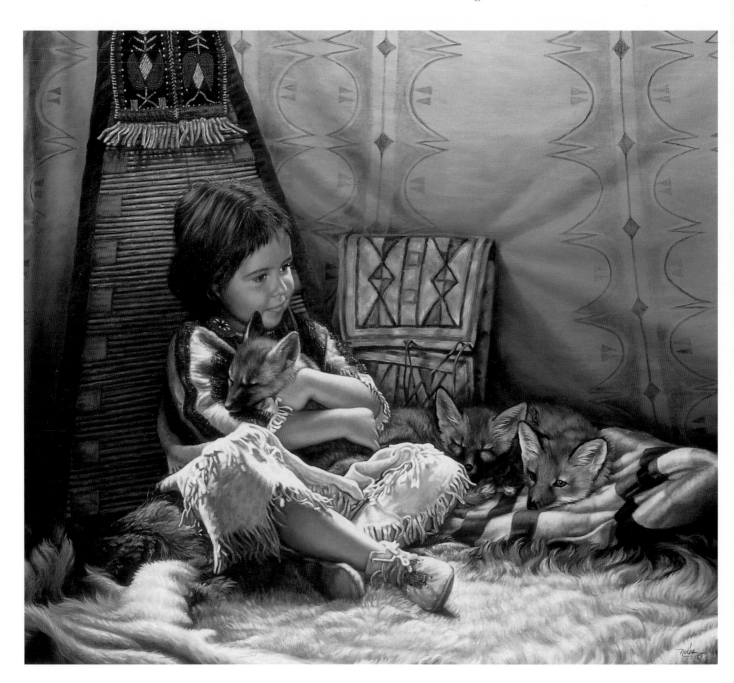

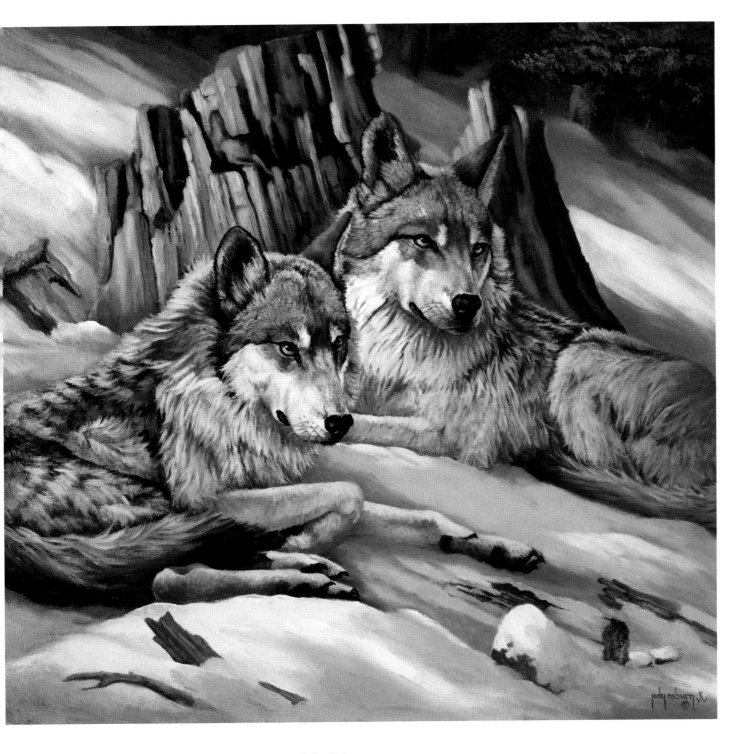

Judy Osburn

Wolves in Winterland
16" × 16" (41 cm × 41 cm)
Oil on Masonite board

Wolves were re-introduced into
Yellowstone National Park, Montana and
Wyoming after near-extinction in America.
Settlers, and later, ranchers encroached on
their territories, and they were regarded as
dangerous, yet few ever attacked humans.
After a series of thumbnail sketches,
Osburn transferred the final composition of
this painting to a gessoed board, using
alkyds mixed with oil. She underpainted in
values to block in the painting, then fin-
ished by building up the oils to achieve
the final detail.

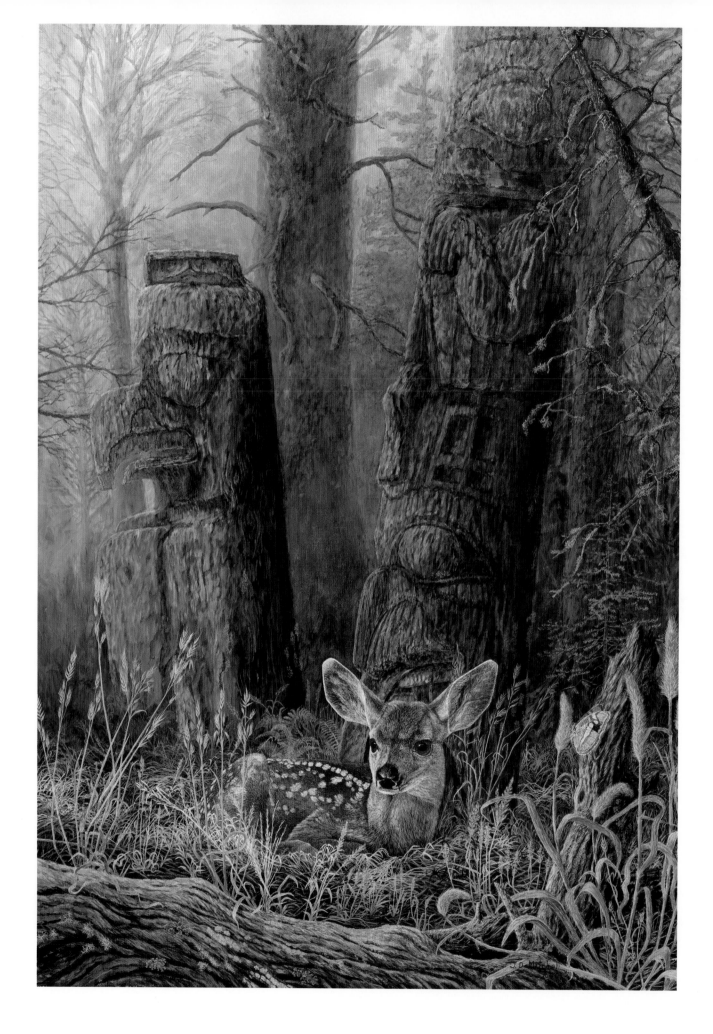

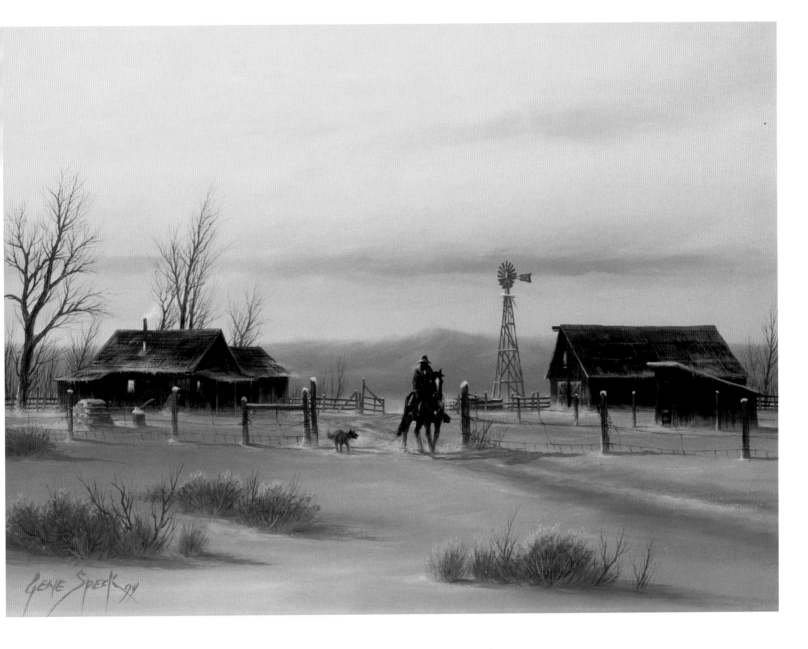

Jerry D. Mitchell

Spirit Guardians (Fawn and Totems)
40" × 28" (102 cm × 71 cm)
Acrylic on stretched linen canvas

The word totem comes from the language of the Ojibwa, a northern Native American tribe. This eagle totem was sacred to the early northwestern native peoples as a source of supernatural power. The individuals of a totemic group attached spiritual mysticism to the totem. They served as symbolic guardians that personified and protected that particular society. They told the story of the family's life events (great success in hunting, death by accident, or war), a memorial to let both the spiritual and physical life know who and what they were about.

Gene Speck

Nevada Winter
9" × 12" (23 cm × 30 cm)
Oil on board

Living on his ranch among the sagebrush and wildlife of western Nevada, Speck likes the privacy of his rugged mountain home. "I wish it was 100 years ago....In the past, there was rugged individualism, a freedom to be what you wanted to be. It was a simpler time to live." The peacefulness in Speck's paintings reveal a serenity and sensitivity to detail. The warmth of the humble, prairie house illuminates the cold, winter evening and brings comfort to the cowboy and his dog.

Marilyn Crocker

Sierra Foothills
24" × 30" (61 cm × 76 cm)
Oil on canvas

In 1848, gold was accidently discovered in California by a pioneer named John Sutter, during an excavation for a sawmill. Gold fever ran high and in 1949 the Gold Rush began. The forty-niners (gold seekers) rushed the Sierras in northern California, and during the next five years, gold valued at more than $285 million was discovered. The area's turbulent past has given way to cattle and sheep ranching in the beautiful Sierra foothills. "Today, time stands still in these hills, slowing our pace, giving us time to meditate and appreciate the beauty which surrounds us."

Margot Lennartz

Autumn in Bishop
18" × 24" (46 cm × 61 cm)
Oil on canvas

On an autumn day in the foothills of the Sierras near Bishop, California, Lennartz set up her French easel to paint some small sketches. The cottonwoods and poplars were ablaze in stunning hues of yellow, orange, and ochre, while the complementary blues of the Sierra Nevada and the sky presented a beautiful backdrop for the trees. Rather than sketch, she completed the plein-air painting on location in three hours, with a wet-into-wet technique.

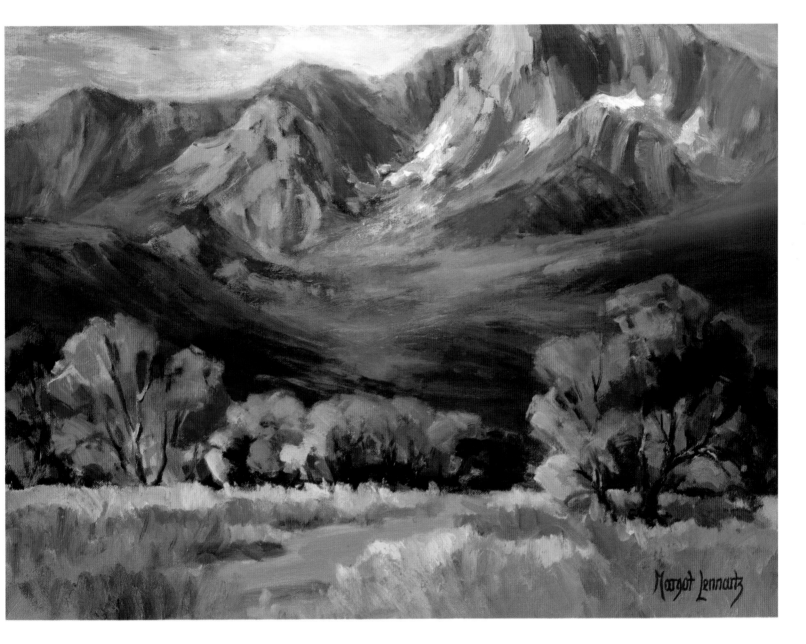

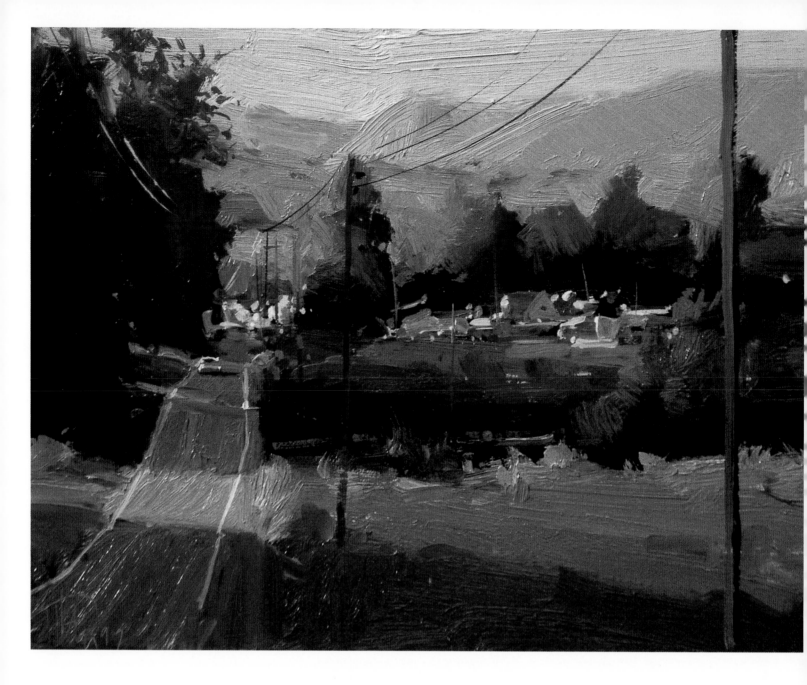

Ken Auster

Road to Reyes
16" × 19" (41 cm × 48 cm)
Oil on panel

The small town of Point Reyes Station is one of the last treasures of California's past. North of San Francisco and inland from Point Reyes National Seashore, its surrounding, rolling, grassy hills greet the blunt headlands of the Pacific Ocean. Auster's quiet road, which leads to this sleepy town, takes the viewer back to a more peaceful time.

Lynn Thomas

Rocky Mountain Laundry Day
20" × 24" (51 cm × 61 cm)
Oil on canvas

On a ranch with her husband, in the Wind River Mountains, Wyoming, Thomas paints the life she lives. For 18 years she ran a pack outfit at the Big Sandy Lodge in the Jim Bridger Wilderness. After washing the laundry in a hand ringer, she often hung it to dry on a rope between two aspens, as did the early pioneer women. Thomas paints in an impressionist style, layering first with a cadmium red wash to give the painting a rich underglow. "The subjects I find around me in my daily life are personally inspiring, moving, and beautiful."

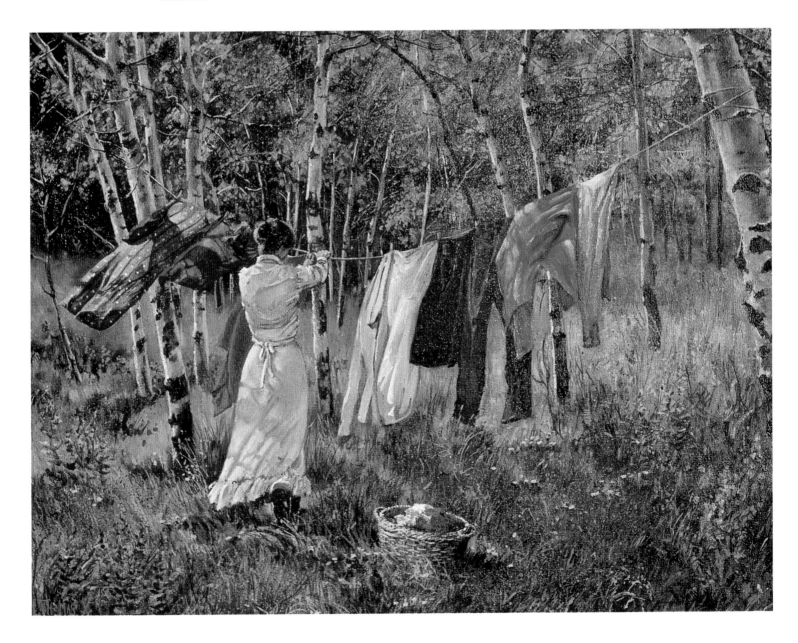

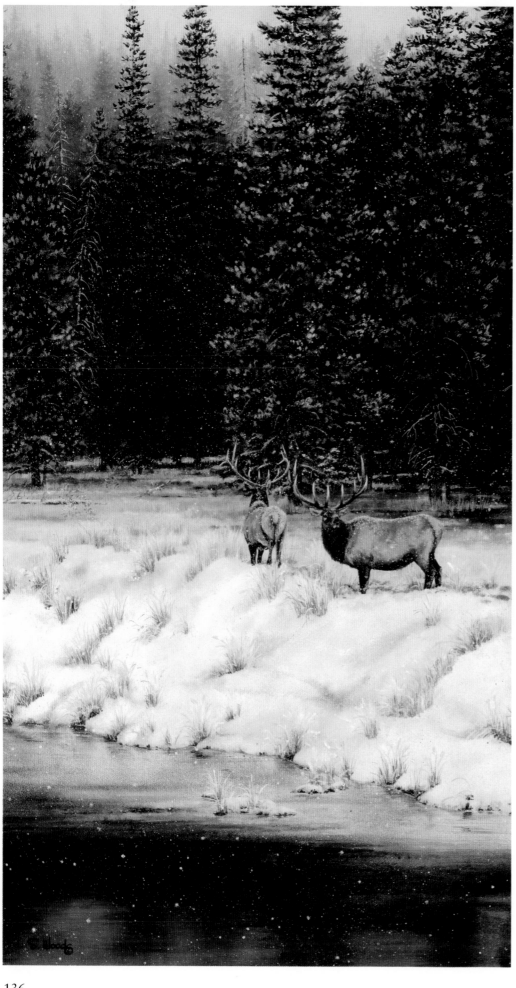

Sarah Woods

Royal Retreat
28" × 17" (71 cm × 43 cm)
Acrylic and gouache on composition board

Tucked away in the mountains of southern Colorado, Woods lives in one of Colorado's most diverse wildlife areas which supports elk, deer, pronghorn, bighorn sheep, and black bear. She also serves on the board of directors of a wildlife sanctuary for the wolf. Using mixed media with gouache, acrylic, and pastel in her wildlife paintings she blends strong lighting, color, and design. "One of the greatest pleasures of living in the west is seeing and hearing the majestic elk. I tried to capture that special, fleeting moment when we can appreciate the strength and grandeur of a bull elk."

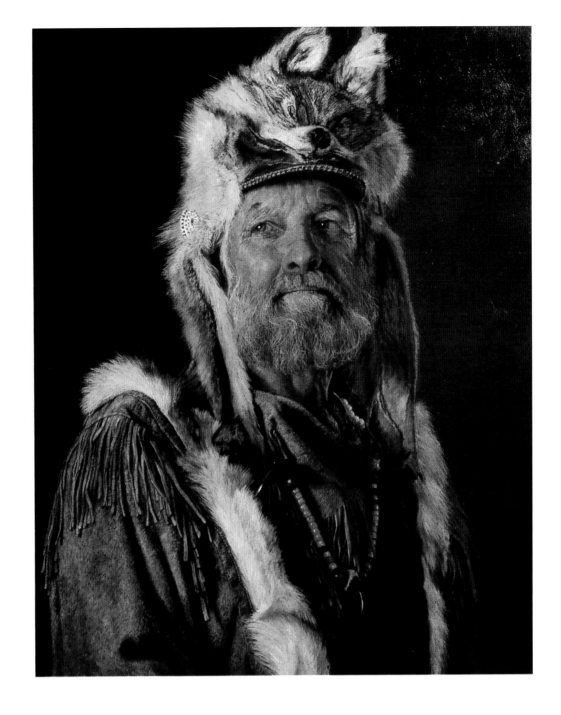

John Bruce

Looking West
30" × 24" (76 cm × 61 cm)
Oil on canvas

Bruce painted this portrait at a Mountain Man Rendezvous at Railroad Flats in northern California. Dressed in authentic late-1700s handmade clothing, the men sleep in tents or under the stars, and cook outdoors over fires. The rendezvous lasts for a weekend, or as long as two weeks, at camps deep in the forest wilderness where knife-throwing and musket-firing competitions take place. They trade for their handmade crafts and lead life as it was 200 years ago.

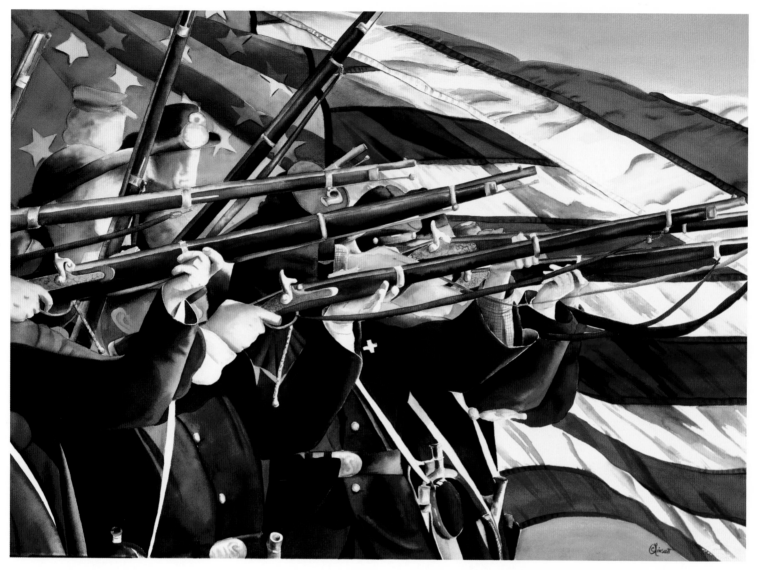

Gone But Not Forgotten
22" × 30" (56 cm × 76 cm)
Transparent Windsor & Newton
watercolor on 140 lb. cold press

CAROLINE LINSCOTT

Of Scottish and Cherokee lineage, Linscott grew up in a rural
Missouri town. Her full-blooded Cherokee great-grandmother left
a legacy that is deeply rooted in Linscott's respect for nature. As a
young child she studied color, and even the veins of a single leaf.
When her father led her deep into the Ozark hills to search for
arrowheads, she first experienced her Cherokee roots. Her fondest
memories of living in the west were of Saturday nights,
Gunsmoke, and local rodeos. A professional artist for ten years,
Linscott founded Artistas Gallery, San Juan Capistrano, California,
is president of Women Artists of the West, and exhibits at the
prestigious Festival of Arts, Laguna Beach, California. In her Civil
War re-enactment, she was struck by the faces not shown, symbol-
izing the men who sacrificed themselves to preserve American
freedom.

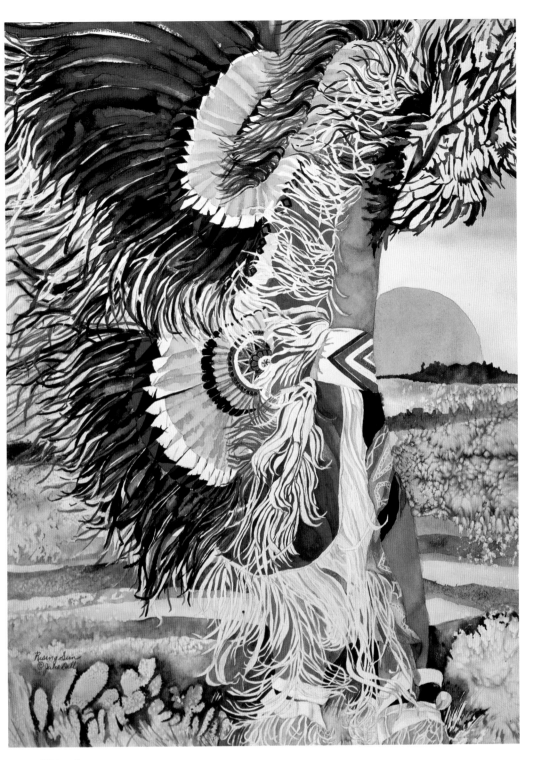

JULIE CHRISTIANSEN-DULL

As a child, Christiansen-Dull heard stories about Uncle Frank's adventures with the Blackfoot, and his travels on Colorado cattle drives. In her maternal grandmother's house, especially haunting was her great-uncle Frank Tenney Johnson's painting of a lone Indian overlooking a valley. At their small farm, her Norwegian paternal grandparents stirred her love for literature through their storytelling. Today she writes and illustrates children's fiction, and paints Native Americans, flowers, still lifes, landscapes, and children. "God gave me creative gifts. I want to share them, to let them sing and dance to the rhythm of His spirit." The Navajo man in her painting greets the rising sun for a day of creative expectations, as does Christiansen-Dull.

Rising Sun
22" × 30" (56 cm × 76 cm)
Watercolor on Arches 300 lb.

DIRECTORY

Cyrus Afsary 80
1247 E. Barbara
Tempe, AZ 85281

Ken Auster 134
2405 Laguna Canyon Rd.
Laguna Beach, CA 92651

Judith Hurst Baer 79
24702 Via Valmonte
Torrance, CA 90505

Wayne Baize 101
HCR 74 Box 53
Fort Davis, TX 79734

Suzanne Baker 124
37644 Willow Creek Ranch Rd.
Raymond, CA 93653

Ronald L. Bausch 68
2705 Club Meadow Drive
Garland, TX 75043

Janet H. Bedford 121
858 Lane 4
Powell, WY 82453

Dott Beeson 66
685 So. La. Posada Circle
#1701
Green Valley, AZ 85614

Betty Jean Billups 125
P.O. Box 102
Sandpoint, ID 83864

Luann K. Bond 11
16 Lattimer Rd. W.
Shiloh, OH 44878

Joseph Breza 106
1629 Camino de la Canada
Santa Fe, NM 87501

Bernice Brown 49
1103 Hidden Valley Road
Wimberley, TX 78676

John A. Bruce 26, 32, 137
5394 Tip Top Road
Mariposa, CA 95338

Julie Christiansen-Dull
31851 Via De Linda
San Juan Capistrano, CA 92675

Donna Clair 54
Box 4195
313 Santistenan Lane
Taos, NM 87581

Wanda Coffey 117
P.O. Box 1066
Farmington, NM 87499

Bonnie Conrad 112
675 So. Woodland Hills Drive
Woodland Hills, UT 84653

Cat Corcilius 10
P.O. Box 1023, 31928
Wrightwood Road
Bonsall, CA 92003

Tim Cox 58
891 Road 4990
Bloomfield, NM 87413

Marilyn E. Crocker 132
P.O. Box 580
Copperopolis, CA 95228

E. (Elaine) Manning Crook 40
42 Nantucket Place
Port Townsend, WA 98368

Kip Decker 126
P.O. Box 366
Meridian, ID 83642

Norman Deitchman 97
P.O. Box 681
Chino Valley, AZ 86323

Diane Denghausen 57
P.O. Box 11844
Costa Mesa, CA 92627

Lorna Dillon 123
P.O. Box 418
Columbia, CA 95310

William E. Drysdale 65
25482 Calle Jardin
San Juan Capistrano, CA 92675

Adele Earnshaw 60
P.O. Box 1666
Sedona, AZ 86339

Esther Engelman 33
22525 Cass Avenue
Woodland Hills, CA 91364

Judy F. Fairley 37
622 10th Street
Clarkston, WA 99403

John Farnsworth 96
P.O. Box 2081
Ranchos de Taos, NM 87557

Alyce K. Frank 122
P.O. Box 290
Arroyo Hondo, NM 87513

Joseph B. Garcia 45, 46
P.O. Box 2314
Julian, CA 92036

Michelle M. Gladish 113
7611 Madison Avenue
Hammond, IN 46324

Bruce R. Greene 59
Route 2, Box 42
Clifton, TX 76634

Linda Gulinson 28
5663 Southmoor Circle
Englewood, CO 80111

Clark Louis Gussin 20, 111
2521 Nightingale Drive
San Jose, CA 95125

Susan Guy 8
18230 Hillary Lane
Fenton, MI 48430

Tom Haas 91
1219 E. Glendale Avenue #3
Phoenix, AZ 85020

Thais Haines 73
7 Calle Montoya
Placitas, NM 87043

Yvonne Hall 92
25247 Jaclyn Avenue
Moreno Valley, CA 92557

Ann Hanson 19
P.O. Box 188
Shell, WY 82441

Lesley Harrison 64, 119
P.O. Box 376
Carmel Valley, CA 93924

Carol Heiman-Greene 44
10351 Duke Way
Stanton, CA 90680

Clyde Heron 13
1309 East 43rd Street
Odessa, TX 79762

William Herring 76
340 Higley Circle
Horizon, TX

Dana Lea Hindson 98
17601 E. 17th Street
Tustin, CA 92780

Harold T. Holden 31
Route 1 Box 49
Kremlin, OK 75753

Karin Hollebeke 119
P.O. Box 221
Vernal, VT 84078

Molly Hutchings 24
103 Terraza Vista Bahia
San Clemente, CA 92672

Becky Joy 25
18675 N. 90th Way
Scottsdale, AZ 85255

Stephen Juharos 50
2855 Highway 179
Sedona, AZ 86336

Lauren Knode 74
5805 Huckelberry Lane
Tillamook, OR 97141

Judy Koenig 72
1152 Rambling Road
Simi Valley, CA 93065

Caroline Linscott
155889 Rancho Valencia Way
Valley Center, Ca 92082

Marjo Wilson Lambert 100
25500 Poonkinny Road
Covelo, CA 95428

Margot Lennartz 133
3844 Franklin Street
La Csrescenta, CA 91214

Linda Loeschen 18
602 W. Sopris Cr. Road
Basalt, CO 81621

Richard Luce 47, 103
4801 N. Camden Lane
Crestwood, KY 40014

Denton Lund 21, 29
154 Butte Drive
New Castle, WY 82701

Juan de la Cruz Machicado 42
P.O. Box 16048
Santa Fe, NM 87506

Patti Marker-White 75
31061 Via Limon
San Juan Capistrano, CA
92675

Geri Medway 85
24851 Via Princesa
Lake Forest, CA 92630

Gwen Meyer-Pentecost 104
1534 15th St. #2
Santa Monica, CA 90404

Marianne L. Millar 14, 62
42 West Lemon Drive
Camarillo, CA 93010

Jerry D. Mitchell 130
1504 Montecito Road #9
Ramona, CA 92065

Lanford Monroe 36
P.O. Box 2347
44 Maestas Road
Taos, NM 87571

Maureen Moore 94
P.O. Box 2161
Aspen, CO 81612

Judith Moore-Knapp 71
18471 Ramona View Drive
Ramonda, CA 92065

Arillyn Moran-Lawrence 99
33181 Paseo Blanco
San Juan Capistrano, CA
92675

Caroline Linscott
15889 Rancho Valencia Way
Valley Center, CA 92082

Patricia Jolene Nelson 35
23715 70.10 Road
Montrose, CO 81401

Rock Newcomb 95
103 North Bryce Circle
Payson, AZ 85541

Reita Newkirk 63
Pastel Society of America
634 Canyon Road
Santa Fe, NM 87501

Karen S. Noles 128
1787 Jette Lake Trail
Polson, MT 59860

Judy Osburn 129
2136 Blue Creek Drive
Norman, OK 73071

Bruce Peil 78
P.O. Box 43474
Seven Points, TX 75413

Tom Perkinson 41
P.O. Box 724
Corrales, NM 87048

Margot Petterson 27
P.O. Box 6968
Big Bear Lake, CA 92345

Howard Post 69
2573 Southwood
Queen Creek, AZ 85242

Linda Tuma Robertson 55
2328 NW 29
Oklahoma City, OK 73107

Gregory Rodriquez 23
2116 S. 77th Street
West Allis, WI 53219

JoAnne Romero 81
67 Hunter Point
Pomona, CA 91766

Roberta St. Louis 93
3551 17th Court
Forest Grove, OR 97116

Joseph Salamon 102
31501 Shrewsbury Drive
Laguna Beach, CA 92677

Martha F. Saudek 77
7216 Kentwood Avenue
Los Angeles, CA 90045

Grace Charlotte Schlesier 105
Schlesier Fine Art
P.O. Box 219
El Cajon, CA 92022

Jack Schmitt N.W.S. 15, 61
P.O. Box 1761
San Juan Capistrano, CA 92693

Charles Schridde 70
124 Sunset Terrace
Laguna Beach, CA 92651

Reverend Robert L. Schwenck 120
33341 Sea Bright Drive
Dana Point, CA 92629

Jo Sherwood 90
1401 Camino Cruz Blanca
Santa Fe, NM 87501

Mian Situ 16
2231 Colla Violeta
San Dimas, CA 91773

Nathan Solano 30
113 W. Evans
Pueblo, CO 81004

Gene Speck 131
Silver State Gallery
Carolyn P. Barnes, Owner
719 Plumas Street
Reno, NV 89509

Oleg Stavrowsky 43
1204 Galisteo arkway
Santa Fe, NM 87505

Penny Stewart 115
6860 Cedar Ridge Court
Colorado Springs, CO 80919

Dorothy May Strait 53
1299 East Canyon Street
Apache Junction 85219

Sherry Blanchard Stuart 56
8402 Country Club Trail
Scottsdale, AZ 85255

Hal Sutherland 12
15244 118th Avenue
Buthell, WA 98011

Nancy Wood Taber 22, 116
P.O. Box 996
Tijeras, NM 87059

Robert Tanenbaum 110
5505 Corbin Avenue
Tarzana, CA 91356

D. Wyatt Taylor 88
278 N. Fenceline Drive
Tucson, AZ 85748

Wayne Terry 114
12 Roxborough Street W.
Toronto, Ontario, Canada
M5R IT8

Lynn Thomas 135
House on Muddy
2105 Richie Road
Boulder, WY 82923

Carol Lee Thompson 34
415 Gittings Street
Balto, MD 21230

Valerie Trozelle 9
40-601 Starlight Lane
Bermuda Dunes, CA

Paul VerBurg 48
936 W. Catalina
Phoenix, AZ 85013

Ray Vinella 89
414 Camino De La Placita #9
Taos, NM 87571

Nicholas Vitale 87
206 East Palace Ave
Santa Fe, NM 87501

K.M. Walizer 17
P.O. Box 13035
Oklahoma City, OK 73113

Mary Weinstein, N.W.S. 82
P.O. Box 639
Yucaipa, CA 92399

K. Douglas Wiggins 67,84
6 El Arco Iris
Roswell, NM 88201

Pamela Wildermuth 51
4070 Apricot Road
Simi Valley, CA 93063

Sarah Woods 127, 136
578 Drunk Horse Lane
Westcliffe, CO 81252

Joan Wright 52
14037 Rex Street
Sylmar, CA 91342

Paul Youngman 86, 107
1316 Lincoln Ave.
Calistoga, CA 94515

Barbara Zaring 83
Box 4534
Taos, NM 87571

GLOSSARY OF ART TERMS

acrylic: a water-soluble paint, in which the vehicle is an acrylic resin

alkyd: a paint in which the vehicle is an alkyd resin, a blend of alkyd and acid

alla prima: a quick application of paint; the first impressionist paintings exhibit this style of painting

Arches: manufacturer of fine artist supplies and watercolor paper

background: part of the painting against which designs or figures are viewed

balance: harmonious distribution of shapes and colors in a painting

Bristol board: a stiff durable cardboard made in plate and vellum, with thickness of one to four plates.

Bristol paper: a slick-surfaced paper

burnt sienna: a color of paint, earthy orange-brown

Canson Mi-Tientes: colored paper used for pencil and pastel drawings

canvas: cloth, usually cotton, used to stretch over a wood frame to form painting surface

classical realist: traditional realistic painting style

cold press: medium texture watercolor paper or board

collage: an artistic composition of varied materials, such as cloth and paper, glued on a surface

complementary colors: opposite colors on the color wheel; when mixed they form shades of gray

composition: a unified arrangement of artistic parts

cross-hatching: brush strokes applied at intersecting angles to create contrasting tone and density

dry brush: technique using the brush and paint in a more dry state

eclectic: consisting of components from diverse sources or styles

fan brush: a brush whose bristles are shaped like a fan

foreground: the part of the painting that appears closest to the viewer

gesso: a mixture of finely ground plaster and glue used as a sizing for canvas, linen, or paper

glaze: a thin layer of paint applied over another layer

gouache: opaque watercolors that have been ground and mingled with a preparation of gum

graphite: black, lustrous form of carbon used in pencils

hot press: a smooth-surfaced watercolor paper

hue: a gradation of color

impasto: paint applied in thick, quick strokes

impressionistic: a style of painting; an attempt to depict transitory impressions

layered canvas: thin paint layers applied to canvas to buildup depth of color

linen: cloth made from the fibers of the flax plant, preferred for its strength and luster, stretched over a wood frame to create painting surface

liquin: a medium used to mix or thin oils

local color: true color of an object as seen in ordinary daylight

Masonite: fiberboard made from steam-exploded wood fiber

mineral spirits: a medium used to thin oil paint

mixed media: more than one medium, used in a painting or other work of art

montage: artistic composite of juxtaposed elements

negative painting: pertaining to the spaces between and behind the subject

opaque pigment: pigment that is neither translucent nor transparent

open color: not following the traditional use of colors; for example, purple trees

palette: range of colors used by an artist

palette knife: blunt-edged tool used to apply thick paint, or mix colors

pastel: a crayon made of ground pigment and a gum-based binder; from the French word *pastiche*

plate finish: a smooth-surfaced paper or board

plein-air: French term meaning painting outdoors or on location

ply: layer or thickness of paper or board

rough: a rough-surfaced paper or watercolor board

scratchboard technique: layering a china clay-coated board with ink, watercolor, or gouache; the picture is rendered by scratching through the colors with a sharp tool

sgraffito: scraping or engraving an image through layers of color

tint: a gradation of color achieved when white or water is added

tromp l'oeil: *to fool the eye* in French; a painting that gives an illusion of photographic reality

two-ply plate finish: thickness and finish of a paper or board that is two layers thick with a smooth surface

underpaint: colored layer of paint, applied as base

value: relative lightness or darkness of color

vellum paper: soft, velvet-like paper, primarily for pastel drawings

wash: broad application of watercolor paint

wet-into-wet: adding wet paint to a wet surface, allowing for colors to mix on the surface with a soft edge

GLOSSARY OF HISTORY TERMS

Absoraka: or *bird people*, the chosen name of the Crow peoples

American Prairie: another term for the Great Plains

Anasazi: means *ancient ones*; the Pueblo peoples are present day descendents

Andulsian: a usually gray, also bay, black-chestnut, or roan horse

animism: belief in animal spirits

Apache: indigenous peoples of the Southwest; most spoke dialects of the Athabascan linguistic family which includes Kiowa, Lipan, Jicarilla, Mescalero, Chiricahua, and Western Apache. They live from northern New Mexico to eastern Texas and southeastern Arizona. Cochise and Geronimo were famous chiefs.

Apache Sunrise Service: celebrates a girl's puberty

barb: a bay, brown-black, chestnut, or gray horse that resembles the Arabian horse

Blackfoot: so-called because they often wore black moccasins, indigenous peoples who roamed the northern plains between Missouri and Saskatchewan; Algonquin language spoken; now live on a northern Montana reservation and in Canada.

Black Hills: mountainous region in northeastern Wyoming and western South Dakota; considered sacred by Native Americans

breast collar: strap around the horse's neck that fastens to the front of a saddle between forelegs and girth, stops saddle from slipping

brittlebush: *Encelia farinosa*, spiny desert bush, native to Mexico and the Southwest, blooming with bright yellow rays in January

cabellero: Spanish name for gentlemen, usually a skilled equestrian

Cherokee: indigenous peoples of the Southeast who spoke an Iroquoian language. They considered all men as brothers and were driven from the Allegheny and Appalachian mountains to Oklahoma in the Trail of Tears, in 1838, by Andrew Jackson. One-fourth perished through hunger, disease and exposure. They reorganized under Chief John Ross and established the first Oklahoma newspaper, set up a public school system, two seminaries, and a three-part government.

Cheyenne: indigenous peoples of the northern plain; name comes from French word *chien*, dog, because of ritual dog-eating. Spoke an Algonquian language. Migrated west to Cheyenne River in North Dakota, then to Black Hills of South Dakota and as far as Colorado. Waged a bitter war that culminated in the Battle of the Little Bighorn, where they annihilated the cavalry of Lieutenant Colonel George Custer. Later surrendered and moved to Oklahoma and Montana.

Chickasaw: indigenous peoples of the eastern woodlands who spoke a Muskogean language; related to Choctaw from northern Mississippi, Tennessee, Kentucky, and Alabama; traveled to Oklahoma on the Trail of Tears.

Comanche: indigenous peoples of the southern Great Plains who spoke a Shoshonean language. This nomadic, warrior people hunted buffalo and lived in tepees. The Comanche war helmet was a buffalo scalp, with horns. Men and women both practiced tattooing.

cinturóns: Spanish for safety belts, Mexican belts

conquistador: a sixteenth century Spanish soldier; conquerors of Mexico and Peru

cookies: slang term for cooks on cattle drives

Crow: indigenous peoples from the Missouri River valley who moved west to Yellowstone River region, and currently live in Montana; adopted buffalo-dependent Great Plains culture; also called the Absoraka.

double-rigged saddle: double cinch rig, devised for heavy roping. The rear cinch provided the saddle with balance.

flint and steel: term used for firing early guns; flint, a hard quartz, sparks when struck by steel

forty-niner: gold seekers in the 1849 California gold rush

Great Plains: high grassland plateau of central North America; extends from northwestern Canada south to Texas. Bordered on the east by the Canadian Shield and on the west by theRocky Mountains

hackamore: bridle with a noseband and no bit, used to break a sensitive horse

half-breed bits: metal mouth bit with a gentler port, shaped like a rounded A; replaced the spade bit; has a chain that acts as a curb

homesteader: a person who cleared, cultivated and lived on free land, granted by the Homestead act of 1872

Huron: Confederation of four North American tribes of Iroquoian family from Lake Huron, Erie, and Ontario. Remaining Huron survivors live at Jeune Lorette, Quebec; Sandwich, Ontario; and at the Wyandotte reservation in Oklahoma.

Incas: (In Quechua=*inka*) The word *Inca* means "king or prince." Name given by Spanish to Quechuan speaking peoples in the Andean empire in South America.

indenture: a legal contract obligating person to work for another for specific time. To obtain passage to America, immigrants indentured themselves, usually for seven years.

Indian: name given by Christopher Columbus to the native inhabitants of the Americas. He mistakenly believed America was part of the Indies. Original population was approximately 10 million. The first peoples migrated to the Americas from Siberia into Alaska in 27,000 BC.

kachina: spirit doll first carved by Anasazi before 1450. They personify ancestral spirits and aspects of nature. The Hopi and Pueblo still honor the 600-year-old tradition.

Kootenai: also *Kutenai;* no linguistic relatives; from Idaho, Montana, eastern Oregon, and Washingtono

Los Manitos: Spanish-Navajo (Navaho) clan, meaning "everyone's brother"

mesa: flat-topped hill or small plateau with steep sides

Moors: North African people of mixed Berber and Arab descent who invaded and conquered Spain during the 8th century

Mountain Man Rendezvous: annual trapper's gathering in which mountain men drank, gambled, raced horses, swapped yarns, and enjoyed the company of Native American women

mustang: a feral horse, descended from Spanish horses, which was domestic but escaped and bred in the wild

mysticism: a spiritual discipline aiming at direct unison or communion with God

Navajo: also spelled Navaho; spoke an Athabascan language. Currently living in northeastern Arizona, New Mexico, and Utah. They live in a traditional Hogan, a conical house of logs covered with earth with a smoke hole at the top. Skillful artisans of turquoise jewelry and woven blankets. Their reservation has grown to 16 million acres, sustaining several Navajo-owned enterprises, the largest Native American newspaper, and a Navajo community college.

ocotillo: (*Fouquieria splendens*): Neither tree nor cactus, this desert plant grows 15 feet tall. Each spiny, spiderlike arm is tipped with a scarlet cone of flame-like flowers.

Ojibway : misnamed by the whites as the Chippewa are in Algonquin family originally from Minnesota. They allied with the French, swapping beaver and other pelts for firearms, which they used to drive the Sioux to the West. They took part in Pontiac's uprising.

Oneida: *people of the rock*, one of the original Five Nations of Iroquois. Originated near Oneida Lake in New York, then moved to Wisconsin and Ontario.

Oregon Trail: a 2,000-mile path of emigration that carried settlers from Independence, Missouri to Oregon City, Oregon.

paint: pinto or horse with patchy markings, usually white and another color

parfleche: indigenous term for carrying container made of rawhide; women painted and hung them over their horse's packsaddle.

petroglyph: ancient paintings on rocks, usually drawn by Native Americans

pictograph: picture representing an idea as a hieroglyph; painted by Indians on tepees, clothing, pots, sandpaintings, parfleche, to tell a story.

piñon: several pine trees bearing edible seeds, of western North America and Mexico

powwow: Native American prayer ceremony

prairie schooner: covered wagon used by pioneers journeying to the West

pueblo: Spanish word for village. A stone house with flat roof, usually built around a central plaza; dwellings of Pueblo, Hopi, Zuni, and other Southwest Indians.

Pueblo: indigenous peoples living in northwestern New Mexico and Arizona, belonging to four distinctive linguistic groups; decendents of the ancient Anasazi (Navajo for ancient ones).

quilling: wrapping, braiding, plaiting, sewing, or weaving porcupine quils; the highest form of female arts for the Sioux, Cheyenne, and Arapaho.

remuda: Spanish word for relay of horses

shotgun leggings: cowboy chaps (leg coverings) with parallel leg-tubes that looked like shotguns

Sierra Nevada: Sierra means rugged mountain range with serrate outline; newest range in North America, in central California, rising to 14,494 feet.

Sioux: The Sioux Nation inhabits the Great Plains; called the Lakota or Dakota, meaning *allies*. The seven tribes fall into three major divisions: agricultural Santee; the Nakota; and the warrior and buffalo-hunter, Teton. Red Cloud and Sitting Bull were two famous Chiefs. Sitting Bull defeated Custer at Little Bighorn, but later 200 Sioux were massacred at Wounded Knee in 1890. In 1973 the Sioux had another confrontation with the U.S government at Wounded Knee to protest US neglect of Native American civil rights. Today, they live on reservations in Montana, the Dakotas, Nebraska and Minnesota.

smoke trees: (Dalea spinosa) desert ghost shrubs with seeds that seem to float on air like a veil of wood smoke

sweat lodge: An oval ceremonial oval structure built for religious communion with God, to heal and cleanse bodies from all bad spirits. Heated stones are laid in a pit, water poured over them to produce steam.

tapederas: leather casings covering saddle stirrups that shield the rider's feet from cactus thorns

teddy bear cholla: *cholla* is the Spanish word for head or skull; the cacti arms are so full of spines they resemble a furry teddy bear

totem: an animal, plant or natural object used as emblem of a Native American clan or family by virtue of an asserted ancestral relationship

vaquero: Spanish word for cowboy